India by Design

India by Design

Colonial History and Cultural Display

Saloni Mathur

UNIVERSITY OF CALIFORNIA PRESS
Berkeley • Los Angeles • London

University of California Press, one of the most distinguished university presses in the United States, enriches lives around the world by advancing scholarship in the humanities, social sciences, and natural sciences. Its activities are supported by the UC Press Foundation and by philanthropic contributions from individuals and institutions. For more information, visit www.ucpress.edu.

The following chapters were previously published in different form and appear here courtesy of their original publishers: chapter 2 as "Living Ethnological Exhibits: The Case of 1886," *Cultural Anthropology* 15, no. 4 (2000): 492–524; and chapter 4 as "Wanted Native Views: Collecting Colonial Postcards of India," in *Gender, Sexuality, and Colonial Modernities*, ed. Antoinette Burton, pp. 95–115 (London: Routledge, 1999).

University of California Press
Berkeley and Los Angeles, California

University of California Press, Ltd.
London, England

Library of Congress Cataloging-in-Publication Data
Mathur, Saloni.
 India by design : colonial history and cultural display / Saloni Mathur.
 p. cm.
 Includes bibliographical references and index.
 ISBN 978-0-520-23417-8 (cloth : alk. paper)
 ISBN 978-0-520-25231-8 (pbk. : alk. paper)
 1. India—In art. 2. East Indians in art. 3. Art, Victorian. 4. Art, Indic. 5. Orientalism in art—England—History—19th century. 6. Orientalism in art—England—History—20th century. I. Title.
N6767.5.V52M38 2007
709.54—dc22 2006037599

Manufactured in the United States of America

16 15 14 13 12 11 10 09 08 07
10 9 8 7 6 5 4 3 2 1

The paper used in this publication meets the minimum requirements of ANSI/NISO Z39.48–1992 (R 1997) *(Permanence of Paper)*. ⊚

Contents

Figures

Acknowledgments

The journey from doctoral dissertation to book manuscript is a long one, and it has taken me through multiple research locales, libraries, universities, funding agencies, job titles, and even—unexpectedly—academic disciplines. I have been fortunate to gain sustenance throughout this journey from countless remarkable individuals, many of whom have contributed in some way or another to the formation of my thinking and research in this book. I am first grateful to the staff of numerous institutions in India, Britain, and the United States who helped me to navigate their colonial collections, including the National Archives of India, the Jawaharlal Nehru Memorial Museum and Library (Teen Murti Bhavan), the Lalit Kala Academy Reading Room, the Oriental and India Office Collections at the British Library, the Victoria and Albert Museum Archives at Blythe House, the National Art Library at the Victoria and Albert Museum, the Royal Library at Windsor Castle, the City of Westminster Archives Centre, the Yale Center for British Art, the Getty Research Institute Library, and the Alkazi Collection of Photography in New Delhi and New York. Funding for various phases of research and writing came from the Social Sciences and Humanities Research Council of Canada, the New School for Social Research, the Vassar College Faculty Research Grant Fund, the International Institute at the University of Michigan, the Yale Center for British Art, and the Faculty Senate at UCLA. I also wish to thank the Clark Art Institute in Williamstown, Massachusetts, and the Center for Museum Practice at the Smithsonian

Institution for offering residential fellowships to support the writing of various chapters of the manuscript, even though I ultimately was unable to accept these opportunities for personal reasons.

The research for this book was nurtured at its earliest stage by many unforgettable conversations and friendships—friendships that I will always cherish—during my doctoral studies in anthropology in New York. Thanks especially to Ayisha Abraham, Jennifer Burrell, Mirhi Cakir, Kamari Clarke, Hugh Crean, Allan de Souza, Wendy Hayton Russell, Marlene Hidalgo, Charles Hirschkind, Michael Howley, Teresa Hubel, Therese Khimasia, Chandana Mathur, Jitu Mayer, Yongsoon Min, and Hyunah Yang for making these years such formative ones. I am particularly indebted to Steve Caton, Faye Ginsburg, Rayna Rapp, and Debbie Poole for their encouragement and intellectual mentorship, which I have valued throughout my professional life. So, too, I am grateful to my colleagues in the Department of Art History at UCLA, who have made the discipline of art history and its communities a place that I now unequivocally call home. Thanks also to colleagues at the University of Michigan and Vassar College, who made my visiting lectureships at these institutions so memorable in many ways.

There are numerous scholars, writers, artists, and friends from whom I have benefited over the years, whether or not they are aware of it. I offer gratitude and special thanks to Naazish Ata-Ullah, George Baker, Tim Barringer, Homi Bhabha, Janaki Bhakle, Rustom Bharucha, Antoinette Burton, Dipesh Chakrabarty, Partha Chatterjee, Deborah Cherry, Julie Codell, Iftikhar Dadi, Vidya Dehejia, Vishakha Desai, Nick Dirks, Carole Farber, Stathis Gourgouris, Tapati Guha-Thakurta, Akhil Gupta, Katherine Hacker, Catherine Hall, Salima Hashmi, Kajri Jain, Barbara Kirshenblatt-Gimblett, Miwon Kwon, Purnima Mankekar, Partha Mitter, Fred Myers, Steven Nelson, Gyan Pandey, Neni Panourgia, Antonella Pelizzari, Ruth Phillips, Chris Pinney, Gyan Prakash, Susan Seizer, Gayatri Spivak, Ann Stoler, Susie Tharu, and the late Edward Said for their inspiration and influence. Thanks also to Urvashi Butalia, Geeta Kapur, Farida Khan, Nivedita Menon, Aditya Nigam, Kavita Singh, Gayatri Sinha, and Vivan Sundaram in New Delhi for extending themselves to me during my visits to their city, and especially Pankaj Butalia and Nilofer Kaul Butalia for their loving hospitality. Kathy Adler, Tom Windross, and Michael Wilson from the National Gallery in London invited me to consult on the exhibition "An Indian Encounter: Portraits for Queen Victoria" (2002–03). It was a pleasure to work with such an accomplished team, and the research I conducted on the por-

traits of Indians by the Austrian painter Rudolph Swoboda for this exhibition became the basis for chapter 3 of this book. Finally, I am greatly indebted to my incomparable editor, Stan Holwitz at University of California Press, for his wisdom, guidance, and good humor in escorting me through the rituals of publishing, and to my talented friend Abra Grupp for her inspired designs for the cover of this book.

For as long as I can recall, my closest family—mother, father, sisters, grandparents, aunts, uncles, and cousins—have been dispersed across many different countries: India, Canada, Great Britain, Switzerland, and the United States. I am grateful for this impressive kin network, and wish to acknowledge all the Mathurs in Delhi, London, Paris, Geneva, San Francisco, and Calgary, my godparents in Vancouver, and my loving in-laws in California and Karachi for offering me homes all over the world. My mother, Veena, and my sisters, Punam and Bindu, themselves spread across three countries, continue to be my closest friends. Despite the distances among us, not a week can go by without the reassurance of a call from one (or all) of these three remarkable women who fortify every aspect of my life. This book is forever indebted to them, and to the memory of my father, Kishan Bahadur, whose life ended, regrettably, at the age of forty-nine, when he was far too young a man. To my little Jalal Bahadur—born the spitting image of *his* father—your arrival into the world during the writing of this manuscript derailed its progress for many months, the most joyous setback I could ever have imagined: baba.

My final thanks, however, are reserved for Aamir, who has witnessed this project from beginning to end, and responded—truthfully—to every aspect of what follows. He continues to amaze me with his uncompromising relation to his craft; an utterly inspiring intellectual presence, always raising the bar in such meaningful ways. A loving thank-you for all of it, Aamir, and for the extraordinary life we have built together.

Introduction

Colonial Patterns, Indian Styles

What will future generations, judging by our works [of art], think of us?

Ananda K. Coomaraswamy, *Domestic Handicraft and Culture*, 1910

SCENE I

The market for contemporary Indian art has turned "bullish and aggressive," according to a recent statement from Sotheby's auction house. In the fall of 2002, a triptych by the Bombay-based painter Tyeb Mehta, *Celebration*, sold for more than a quarter million dollars at Christie's in New York, setting a new record for a painting by a living Indian artist. In 2005, Mehta's large canvas *Mahishasura*, depicting the Hindu goddess Durga in a complicated dance with the demon Mahishasura, sold for $1.58 million, six times the earlier record. A few weeks later, M. F. Husain, perhaps India's most famous living painter, sold his dramatic piece *The Last Supper*, depicting an empty bowl alongside an African woman—typically read as the artist's commentary upon the global politics of food—for two million dollars in an Internet auction. Observers of the phenomenon agree that this new demand for contemporary Indian art has been driven largely by the emergent consumerism of "NRIs" or Non-Resident Indians, that is, Indians residing outside the subcontinent, who, according to one account, are an affluent but somewhat "homesick lot, who want a bit of the motherland to hang in their homes."[1]

Such a portrait of dramatic sales, unprecedented prices, and auction houses packed with homesick Indian buyers has made for good headlines in the media. But the claim that Western museums' and collectors' long-

standing demand for traditional Indian art forms, like Mughal and Rajput miniature painting or early Hindu and Buddhist sculpture, is being replaced by a desire for contemporary Indian art seems premature. In reality, such prices have only applied to works by a handful of modernist painters associated with the Progressive Artists Group, which was formed on the eve of India's independence from British rule and whose members have become emblematic of the formative years of modernism in India.[2] Incredibly, these painters—"the Progressives"—are only a generation or two removed from the first Indian artists to paint with oil, after the British introduced oil painting to the subcontinent in the eighteenth century. The medium was promoted through their new art academies, museums, and art schools, and was gradually adopted by the indigenous elite during the course of the nineteenth century. Ironically, by the 1950s and '60s the struggle for these artists was to create their own mode of expression using the "foreign" medium of oil while confronting, on one hand, the forces of international modernism, and, on the other, folk and classical art from India and the traditions of Indian miniature painting. The modern, for them, was thus a complicated balancing act between the legacies of colonial art education, the Euro-Western avant-garde, and Indian history and aesthetics, an awkward positioning that, nevertheless, in its most subversive moments, had the effect of putting modernism itself "in the balance."[3] The story of modern Indian art is thus full of ironies: it is, in the words of the preeminent critic, scholar, and curator Geeta Kapur, a story of Indian artists "riding on the backs of paradoxes."[4] However, it is not this edgier aspect of Indian modernism, nor this complicated dialectic with the medium of oil, that is being valued in the new red-hot climate of demand for Indian art. Instead, contemporary Indian painting is often praised for its authentic and essential "Indianness," viewed, paradoxically, as both offering a "timeless vision" of India *and* marking a radical break from the traditional Indian art of the past.[5]

SCENE II

In the new sensibilities of global design culture, Indian aesthetics have found a fresh popularity. The publication of a series of books, part of the Dover Design Library, offering "authentic copyright-free designs" from India is an excellent example of this. Their volume *5000 Designs and*

Motifs from India is described as a rich treasury of authentic designs adapted from artifacts of the Harappa culture, coins and pottery from South India, Ajanta murals, Muslim monuments, Buddhist temples, Gujarati textiles, tribal masks, and much more.[6] Other best-selling titles from their list include 250 *Stencil Designs from India, Folk Designs and Motifs from India, Paisleys and Other Textile Designs from India,* and *Mehndi: The Timeless Art of Henna Painting.* Praised for their beauty and simplicity, the motifs and patterns in these books, which are readily available on Amazon.com, are intended as a source of inspiration to artists. Frequently accompanied by a CD-ROM, these small manuals offer user-friendly patterns designers can use to create an Indian "look" for websites or other decorative projects such as textiles, furniture, and wallpaper design.

These digital-friendly Dover Design books do not figure directly into the recent account by Hal Foster of developments in the global culture of design, titled *Design and Crime (and Other Diatribes).*[7] They nevertheless appear to exemplify the concerns expressed in his book about the merging of marketing and culture, and the penetration of design into everyday life. For Foster, the new fashionability of global design may serve to promote cultural diversity to some degree, but it also places us as consumers in a "Megastore," sampling the "signs of our identity from its offerings."[8] The Dover Design series, however, bears an uncanny resemblance to another style manual, published more than a century and a half ago, namely, Owen Jones's *The Grammar of Ornament,* which was reissued in 2001 as a classic text of modern design. When Jones's manifesto concerning the "principles of good design" first appeared in 1856, readers were captivated by his elaborate documentation of Persian, Indian, and "Hindoo" ornament. For Jones, who arranged the exhibits inside the Crystal Palace at the Great Exhibition of 1851, the "gorgeous contributions" from the decorative arts of India could help Victorians improve the poor quality of British craftsmanship, suffering as it was from the damaging effects of industrialization in Europe. Unlike in the Victorian context, as Foster notes, there is no such commitment on the part of contemporary design: on the contrary, "it delights in postindustrial technologies."[9] Thus, while the new prominence of design in culture is not new—indeed, it continually evokes an earlier era, and brings this nostalgia into its fold—it does seem to take on new forms in our "pan-capitalist" contemporary moment. In today's digital economy in particular, the product is, in Foster's terms, "no

longer thought of as an object to be produced so much as a datum to be manipulated—that is, to be designed and redesigned, consumed and reconsumed."[10]

SCENE III

The Indian tear-drop-shaped motif we know as "paisley" is ubiquitous in Europe and America today. Paisley patterns appear everywhere, on such things as jewelry, carpets, furniture, drapery, stationery, gift wrap, haute couture, and hippie-wear. Less well known, however, is that this plant motif called *buta* (bud)—sometimes referred to as the "Kashmiri cone"—that stemmed from Persian and Mughal influences received its name from the Scottish town of Paisley, some eight miles west of Glasgow. The town of Paisley emerged at the end of the eighteenth century as a center for English textile production, in part in response to the growing demand in Europe for Indian shawls from Kashmir with the *buta*. By 1800, Paisley had replaced Edinburgh as the top manufacturer of British shawls "in imitation of the Indian," providing consumers with a cheaper, mass-produced version of the very costly, hand-made shawls from Kashmir. At the same time, the Scottish manufacturers in Paisley undertook to "improve" the traditional designs of the shawls so they would conform more closely to British tastes, incorporating floral patterns into the *buta,* for example, and shortening and fattening its more slender Mughal-era shape.[11]

Such shawls, originally made from *pashmina* (a particularly soft wool found on the underbelly of a Tibetan mountain goat), are in vogue once again. With or without the paisley pattern, they are visible in the pages of high-fashion magazines, as well as available in chain stores like Target and Wal-Mart, which sell colorful, inexpensive, "authentic" *pashmina* blends. The current marketing of *pashmina* scarves, stoles, shawls, and baby blankets depends upon a certain confusion about the origins of the fiber, allowing manufacturers to claim that virtually anything made in India, the United States, Britain, or Tibet, for instance, is "genuine" or "real" *pashmina*. This flourishing economy of fakes would no doubt be different if the attempts made by the East India Company in the nineteenth century to transport and acclimatize the mountain goats to Britain had been successful, enabling the wool to be harvested in England—but the goats generally didn't survive the journey.[12] Nevertheless, just as "paisley," the name of a Scottish town, came to stand for a pattern that epitomizes India, the name "Kashmir" came to stand for a va-

riety of wool-like fibers. What is important here is not historical precision, as advertisers are the first to admit: it is that the term *cashmere*, often interchangeable with *pashmina,* continues to evoke—in the words of one campaign—an image of "wealth, luxury, softness, and warmth."

The red-hot status of contemporary Indian art in the West; the insertion of India into a global design aesthetic; the availability of copyright-free Indian decorative motifs; the enduring popularity and proliferation of paisley; the market for the warmth of cashmere: within each of these seemingly unrelated contemporary phenomena is concealed a broader, 150-year-old complex of meanings generated by the encounter of Indian cultures with the West. Indeed, the notions of Indian art, craft, tradition, and culture entangled in these present-day scenes took shape in an earlier era in which the demand for Indian styles and aesthetics was conditioned by the relations of colonial rule. The paisley or *buta,* for instance, is not just the enchanting motif described in the oversized coffee-table books about the romantic textiles of the Indian subcontinent. The pattern also bears the imprint of the colonial economy, the stamp of Victorian industrial consumption, and the reshaping of ideas about India at the point of their interpellation into Western economies of desire. Similarly, the current fashionability of digital copyright-free designs harkens back to an earlier moment when Victorian art reformers like Owen Jones turned their orientalist lenses to the craft manufactures of India. And today's "bullish" demand in the auction houses of London and New York for painters from India such as Tyeb Mehta and M. F. Hussain recalls the historic introduction of oil painting to the subcontinent, and the transformations to art practice, valuation, and patronage that resulted from the imperial encounter.

European thinkers of the colonial era, as we shall see, typically presented the culture of India as lacking historical development, in contrast to the culture of Europe, which evolved through discrete aesthetic and chronological periods. In turn, this led the nineteenth-century disciplines of archaeology and anthropology to view Indian artifacts as signs of a collective identity: a craft object came to symbolize an entire social system, an Indian artist was seen to index his race. Such ideas were also responsible for producing the particular semiotic structure of the colonial stereotype, a fundamentally ambivalent form of representation, "as anxious as it was assertive," in the words of theorist Homi Bhabha.[13] And yet views of India's objects and people, however skewed, were fashioned gradually over centuries of interaction and exchange with the West, and

through complex acts of translation and travel. Indeed, contemporary displays of Indian culture, whether presented at the museum, the auction house, or the department store, seem unable to escape the residues of this interconnected past, which more often than not appear in the form of enduring clichés about the timelessness of Indian culture and the unchanging nature of its traditional art forms. Such images of India, however, have long been disputed within the discourses of colonialism, and then nationalism, in the Indian subcontinent. What has been eclipsed from our view of the present, I suggest, is this modern complex of historical negotiation in which the very meaning of such categories as Indian "art," "culture," "craft," "ornament," "village," "tradition," and "artisan" was radically played out on the international stage.

This book—while not about the present moment per se—offers an entry into these contemporary entanglements by investigating the history of the cultural display of India in predominantly colonial cultural arenas. It returns us, that is, to an earlier era, the final decades of the nineteenth century, when the foreign demand for all things Indian—Kashmiri shawls, village crafts, ancient Buddhist art, portraits of the Indian maharajahs, picture postcards of caste and ethnic types—was at an altogether different peak. Situated at the convergence of discussions in art history, anthropology, museum studies, and postcolonial criticism, this book offers detailed case studies of several contexts for the display of India in Britain during the height of imperial rule in the subcontinent— exhibitions, department stores, paintings, museums, and colonial picture postcards. By mapping a series of historical events in which a range of Indian objects, images, bodies, and narratives circulated through metropolitan space, I will show how India was folded into an emerging nineteenth-century consumer economy and how images of traditional India became available as commodities in an industrializing world. More specifically, I will undertake to dislodge a stock of popular images of traditional India from the epistemic structures in which they are embedded, and through which they have acquired their representational strength. By exposing the historical frameworks, interpretive contradictions, and conditions of repetition and appropriation behind specific acts of display, I trace the formation of our modern visual understandings of India, and reveal the dynamics of production and reproduction that constitute a set of visual clichés.

In the past two decades there has emerged a wide-ranging interdisciplinary literature that has demonstrated the powerful ideological role of display-based cultural forms—paintings, photography, exhibitions, dio-

ramas, and scientific and architectural imagery, for example—in the knowledge practices of empire.[14] Following the late Edward Said's groundbreaking arguments in *Orientalism* and *Culture and Imperialism*, this literature has also helped to refute the "merely cultural" approach that views the realm of art and aesthetics as relatively autonomous, or existing in a "superstructural" relation to the economic, social, and political spheres.[15] As Said argues, to ignore or dismiss the cultural terrain in which colonizer and colonized "co-existed and battled each other through projections as well as rival geographies, narratives, and histories, is to miss what is essential about the world in the past century."[16] Further, Said's eloquent formulations of the "massively knotted and complex histories" of colonizer and colonized, along with other valuable interventions that have posited the metropole and colony as a single, if conflicted, analytic field,[17] suggest that Western cultural forms need to be removed from the autonomous enclosures in which they have been protected, and placed instead in the dynamic imperial contest in which they were produced. Moreover, Said's methodological imperative that the discrepant experiences of metropole and colony be read "contrapuntally"—in and through and against each other—as an alternative to a "politics of blame, confrontation, or hostility" seems all the more important in the face of present political trajectories and realities, which tend to sustain in the cultural imaginary a conceptual cleavage between a modern West and its traditional, non-Western other, much like the processes we have observed in the past.[18]

In her well-known account of the exhibits of India at the Great Exhibition of 1851, the historian Carol Breckenridge similarly foregrounded the question of the relation between metropole and colony.[19] For Breckenridge, such an analysis served to highlight "the transnational cultural flows that lay at the heart of an imperium," an idea she expanded and elaborated over the next decade or so in the pages of the journal *Public Culture*, coedited with anthropologist Arjun Appadurai. The latter also edited a related volume, *The Social Life of Things: Commodities in Cultural Perspective*, which sought to generate a "new perspective on the circulation of commodities in social life" through a revision of Marxist categories of economic exchange and an earlier anthropology of material culture.[20] The approach in this collection to "things-in-motion" within the differentiated landscape of "regimes of value" offered a fresh methodology and theoretical vocabulary that, significantly, helped to erode the boundaries between anthropologists and art historians.[21] These ideas about objects in motion also laid the

groundwork for Appadurai's later remapping of the international land-
scape through "disjuncture" and "difference" in the emerging global
economy in his 1996 monograph, *Modernity at Large: Cultural Di-
mensions of Globalization.*

The Social Life of Things thus helped to revise the classic anthropo-
logical topic of circulation and exchange by challenging the traditional
opposition between "gift" and "commodity" proposed by such
twentieth-century thinkers as Durkheim, Mauss, Malinowski, and Lévi-
Strauss, and the longstanding division within this intellectual tradition
between "primitive," small-scale societies and advanced capitalist
economies.[22] But it also signaled a broader recognition among scholars
of the relevance of a specifically *colonial* modernity to present-day for-
mations of internationalism. What distinguishes the spread of culture in
the modern era from the more general process of cultural diffusion that
has (arguably) occurred since ancient or premodern times is the exclu-
sionary logic of hard international borders and the forms of policing
these boundaries generate.[23] It is therefore the question of the nation-
state in its colonial and postcolonial forms—its ideological imperatives,
its inclusions and exclusions, and its emergence through dynamics of
imperial rule and resistance—that makes modern forms of cultural mix-
ing distinctive and most pressing today. The issues that inevitably
emerge from this landscape—global capitalism, citizenship, neo-
imperialism, minorities, human rights, refugees, exile, secularism, and
neo-liberalism—speak to the enormous complexities of culture in the
twenty-first century, and mark the urgent, challenging new frontiers for
humanist understanding in the contemporary world.

Few would have predicted a dozen years earlier, before e-mail and the
Internet became ubiquitous, the accelerated rate at which objects, im-
ages, and ideas now circulate through local, national, and international
arenas. In relation to the visual arts, earlier notions of stylistic purity
have been displaced by analytic approaches that emphasize hybridity, in-
tercultural exchange, and transaction: as James Clifford has definitively
stated, our "pure products have gone crazy."[24] The discipline of art his-
tory, for example, has long had a notion of "stylistic influence" to de-
scribe cross-cultural fertilization in the arts, but these forms of borrow-
ing typically assumed the presence of coherent, preexisting homogenous
traditions and a politically neutral field of exchange. Indeed, the burden
of the cultural production of the periphery was that it was always "in-
fluenced" by the dominant center, and these relations were too often per-
ceived as resulting in derivative, secondary, or imitative art forms.

Global and comparative thinking has thus led the discipline to challenge the hierarchy and presumed purity of previous art historical styles and movements, and provided the ground for a productive questioning of related categories such as "high," "low," "art," and "craft."[25] Similarly, in anthropology, the challenge to a unified, bounded notion of culture has affected the stability of an area-based approach to knowledge and generated new modes of ethnographic inquiry that confront the political and epistemological parameters of the "field."[26] In both of these disciplines, in other words, the existing narratives of cultural production have shifted in the wake of transnational realities toward a more complex picture of global interconnections and the shared cultural histories of modern visual forms.

Conceived at the place where art history and anthropology converge to challenge the prevailing Eurocentrism of the modern visual arts, this book will not present an account of a stable, national aesthetic tradition that has transmitted itself from metropole to colony, or the reverse. Nor will it likely satisfy the reader seeking a conventional story about the "influence" of Indian styles on the West. Instead, I aim to construct and investigate a landscape of a different sort, namely, the international arena of colonial visual forms and their cosmopolitan circuits of exhibition and display. Drawing from the explication of "travel" as a theoretical category, one that emerges in the work of James Clifford as both a "figure for routes through a heterogeneous modernity" and a practice that is "*constitutive* of cultural meanings," I undertake in this study to *move* with my subjects through extreme crossings, from India to Britain and back, through different neighborhoods in the imperial city, in and out of department stores, art schools, world's fairs, and museums, and through a range of temporal and spatial formations that map the relationships of colonial rule. I further adopt a mode of exposition that privileges the unfolding of events and circumstances: by emphasizing a series of social dramas and controversies, I bring into view the material and rhetorical processes of imperial spectacle and the specificities of contestation that ensue. The case studies that result from this narrative approach offer a larger picture of interconnections that are necessarily indebted to the work of cultural historians in both British and South Asian studies. At the same time, however, these archival excavations tend to map a new field of investigation that transcends both the conventional disciplinary concerns of art history and anthropology and the constraints of an area-based approach, while highlighting within the domain of visual culture the interpenetrations and historical legacies of India's contested imperial past.

THE VISUAL ARCHIVE OF TRADITIONAL INDIA

The focus of this book is on a formative trajectory in the development of high imperial visual culture characterized by the clash between British colonial power in India and the beginnings of an organized nationalist movement in the subcontinent. It begins, that is, in the 1880s and concludes in the second half of the twentieth century, following the independence of the subcontinent in 1947. By focusing on London as a showcase for India during this period of colonial rule, I seek to highlight the paradoxes and contradictions unfolding in metropolitan space, but these are necessarily formulated with a view toward the interconnected practices and histories of exhibiting, collecting, and display in the colony. What is striking about the 1880s is not only that the British had consolidated their governance in and through the Indian countryside, but that the Indian village had in turn thoroughly infiltrated metropolitan space. By the end of the decade, a Londoner could view a picturesque painting of an Indian village at the Royal Academy in Piccadilly; observe the Indian art and architectural objects housed at the India Museum in South Kensington; purchase village crafts and manufactures from the oriental warehouse of Liberty's department store; or witness a living display of village artisans at the Albert Palace at Battersea Park. With the emergence of the picture postcard in this same period, individuals could also collect, arrange, and exchange mass-produced images of India, all within the privacy of their own homes. Arguably, the vast majority of Europeans in the nineteenth century related to empire not as colonial officers or travelers, but as spectators from this security of home.

While such visual representations of Indian culture thus permeated modern urban space, they also functioned to firmly demarcate the imperial self from its colonized other. Indeed, the very idea of a modern, civilized, Western subject was consolidated through this popular stock of public images of a traditional, uncivilized, Indian other. India's craft manufactures exhibited at the Great Exhibition of 1851, for instance, were praised for their aesthetic value, while the displays of India's machinery (carts, carriages, looms, and tools) were seen as crude and primitive adaptations, in contrast to advancements in Western technology. Such an assessment allowed Victorians to admire Indian cultural objects, and to make distinctions between their aesthetic and utilitarian functions, without challenging the prevailing ideological framework of European dominance and industrial progress. Later, at the Colonial and Indian Exhibition of 1886 in London, India was portrayed as a timeless,

unchanging, ancient land, dotted with jungles, natives, and village bazaars, at once geographically and temporally removed from the hectic pace of industrial life. This latter exhibit presented India as belonging to an idyllic preindustrial past, a projection that depended in part on the contemporary environment of Victorian disillusionment with industrialization in Britain. With the arrival of the picture postcard, which emerged largely as a souvenir of exhibitions, it became possible to preserve these views in an inexpensive and mass-produced form. The postcard transformed the fascination with exotic, traditional life in India into a portable, collectible, and hence more practical, visual form. Often preoccupied with caste and gender-based images, these mass-produced cards, known to collectors as "native views," helped to further illustrate the perceived gulf between colonizer and colonized. Such popular forms were clearly aesthetically pleasing to their viewers, but they also functioned, it is often assumed, to secure the popular support necessary for the continued processes of imperial expansion.

One goal of this book, however, is to demonstrate that, on the contrary, this archive of images of traditional India—timeless, authentic, romantic, exotic—that became so functional and fashionable in the showcase of Victorian London was anxiously constructed, frequently rejected, and incoherent at best. Supported by early anthropological notions about progress, civilization, and Indian history and culture, the spectacular presentation of Britain's Indian colony was nevertheless constituted by internal tensions, growing insecurities about rapid social change, profound contradictions regarding modernization and tradition, and demands for restitution, compensation, and return. Moreover, as the display of India appeared more systematic and more powerfully executed during the second half of the nineteenth century, it also became more politically contested and more fraught with tensions beneath the surface. Indeed, newspaper commentaries published in India demonstrate that the visibility generated for India at the "center" was hardly a neutral matter. Like most aspects of cultural life in the late nineteenth century, these display-based arenas were debated by Indian nationalists, who saw them as what Frantz Fanon once described as yet another "bone of contention in the grandiose battle."[27] As T. J. Clark has argued in another context, the spectacle is never an image "mounted securely and finally in place; it is always an account of the world competing with others, and meeting the resistance of different, sometimes tenacious forms of social practice."[28] A primary concern of this book is thus not simply to establish the spectacular visual stage upon which imperial power was enacted,

but to present the increasing incoherence of this dominant order by high-
lighting its contradictions, tensions, and eventual unhinging, in part by
drawing the reader's attention to some of the historical actors who re-
jected its hegemonic script. I thus treat these colonial forms as "suspi-
cious signs" or strange fabrications that function not only as ideological
texts that serve to affirm imperial power, but also as symptoms of crises
and *dysfunction* in the embattled domain of cultural representation.

Approaching the colonial arenas of signification in this way—as
strange, suspicious, symptomatic, and, at times, also aesthetically pleas-
ing—requires confronting the overlapping arenas of art institutions,
colonial bureaucracies, art reformers, entrepreneurs, museum officials,
"native" subjects, and the developing discourses of anthropology in
nineteenth-century India. Drawing from Tony Bennett's notion of the
"exhibitionary complex"—the ensemble of overlapping disciplinary
knowledges and techniques of display involved in the "transfer of objects
and bodies" from the private domain into progressively more open and
public arenas[29]—this book brings together the world of art, the emerg-
ing science of anthropology, the fashionable culture of the department
store, and the professional practices of painters and museum curators in
crafting a picture of Indian culture. At times, as we will see, it is the ma-
terial artifact—a craft object, a museum relic, a portrait of an Indian
prince—that becomes the marker of difference and cultural authenticity.
But at other times it is the corporal image, the actual, physical body of
the native, that performs the inscriptions of cultural difference. How one
semiotic is privileged over another within these interlinked representa-
tional practices, and what political circumstances underscore each act of
valuation, are recurring threads throughout my analyses. The larger goal
is to connect the emergence of these display-based genres—exhibitions,
museums, department stores, postcards, and oil paintings—to the his-
torical realities of imperialist expansion, the production of colonial
knowledge about "difference," and the discordant forms of subjectivity
and citizenship that found expression in this cultural arena.

FROM THE PICTURESQUE TO THE CRYSTAL PALACE

The image of traditional India that had become so embattled by the
1880s depended on a number of pictorial modalities that can be traced
back to the eighteenth century, when professional artists from Britain
trained in the conventions of European landscape painting, such as
William Hodges and Thomas and William Daniell, first began traveling

to India and illustrating their encounters. William Hodges, after serving
as the official artist on Captain Cook's second voyage to the Pacific, went
to India in 1782 under the patronage of the governor-general of Bengal,
Warren Hastings, and produced an unprecedented number of paintings
and drawings of the countryside and the historical architecture of north-
ern India and Bengal.[30] Capitalizing upon the popularity of these views,
two more professional artists, Thomas Daniell and his nephew, William,
would spend their careers reworking and revisiting the vast collection of
drawings and paintings they produced while traveling in India between
1786 and 1794.[31] Like Hodges's work, the Daniells' paintings were ex-
hibited at the Royal Academy in London and patronized by private in-
dividuals, often those connected to the East India Company. Moreover,
their popular book of images of India, *Oriental Scenery (1795–1807)*,
consisting of 144 aquatint engravings of temples, mosques, tombs, and
palaces, contributed to a growing demand for a "pictorial India" among
European viewers at home.

It is widely recognized that these early renderings of India displayed
a compulsion for the "picturesque," an aesthetic tradition with its own
specific pictorial conventions prevailing in Europe at the time.[32] That
these artists pictured India through the lens of their existing aesthetic
styles and assumptions may at first glance seem a rather innocuous act
of visual assimilation. But the romantic, sublime, heroic views of India's
landscapes and historical architecture they constructed also converged
with imperial discourses of exploration and mapping of the "natural"
world. Postcolonial rethinking of the picturesque lineage has thus at-
tempted to alter our approach to the presumed innocence of these pic-
turesque views of faraway lands, in part by displacing landscape itself as
formal object of art historical inquiry, and resituating it as a technique
or process "by which social and subjective identities are formed."[33]

More importantly for our purposes, the tradition of the picturesque,
and the epic visions of Indian landscape it produced, would have a sig-
nificant influence on the emerging visual regimes of the nineteenth cen-
tury, such as exhibitions, photography, dioramas, and picture postcards.
Here, the picturesque may be seen as a "residual aesthetic," as Tapati
Guha-Thakurta, a leading historian of Indian art, has argued in her ac-
count of James Fergusson.[34] A pioneering midcentury figure in the study
of Indian art and archaeology, Fergusson engaged in scholarly projects
that mediated between a compulsion for the picturesque and a later ori-
entation toward scholarly documentation. Although the rhetorical
strategies of early ethnographers like Fergusson reveal a desire to over-

come the picturesque—to transcend the aesthetic with an objective, scientific view—the tension between the aesthetic and scientific is by no means resolved. The picturesque continued to influence the representational practices of the late nineteenth century, and the Western desire to render the "world as picture,"[35] in spite of its apparent antipathies to the growing authority of scientific classification.

The event that best captures this climate of change in the middle of the nineteenth century is undoubtedly the Great Exhibition of 1851—the world's first international exhibition of its kind—held in the dramatic Crystal Palace in London's Hyde Park, a massive iron and glass structure erected specifically for the six-month event.[36] In Walter Benjamin's famous words, the Great Exhibition offered visitors a "phantasmagoria of capitalist culture" and created a "glitter of distraction around it."[37] It also marked what many Europeans experienced as a sharp temporal disjuncture, geophysical in description. "Suddenly," as the historian of anthropology George Stocking has explained, "ancient and modern were brought into absolute contact, as in a geological fault."[38] This shift, tectonic in nature, rearranged the modern ground for ideas about civilization, savagery, progress, and primitivism, which in turn helped shape the intellectual agendas of the developing discipline of anthropology. Significantly, the Crystal Palace, and the panoptic desire it manifested, was also an embodiment of the foundational epistemologies for art history and museology in the modern era. As Donald Preziosi has stated provocatively in his account of the practices of modern museology, "We've never left this building. . . . [Its] exits have yet to lead elsewhere but to other, identical spaces."[39]

The Crystal Palace thus appeared as several things at once: a monstrous glass curiosity cabinet, a chilling fantasy of Britain's industrial and technological supremacy, and a shining new framework of imperial knowledge and possession. To borrow one historian's metaphor, just as Cinderella was transformed, so too was Britain by its own glass slipper.[40] The building also produced new optical effects for European visitors to the exhibition, who often commented on the way in which sunlight poured in through the glass exterior of the structure and bounced off objects, surfaces, and mirrors. Just as the cinema would later disorient its earliest audiences, the optical world of the Crystal Palace had destabilizing effects on the viewing subject. Rather than producing a simple reflection of a Western self in a non-Western other—or a uniform, reductive colonial "gaze"—the Crystal Palace, in its dispersed refractions of images and identities, in its endless depth as a visual field, and in its sub-

stitution of materiality with the simulacra of things—that is, precisely in its sense of visual overdetermination—provides a metaphor for modernity's visual regimes in which a new portrait of India begins to appear.

Tellingly, the India display at the Great Exhibition was one of the most celebrated sections inside the Crystal Palace, and it transformed an eclectic inventory of some fifteen thousand objects from the subcontinent into a drama of Britain's imperial power (figure 1). Exhibition organizers, critics, and members of the media all praised the Indian section as an exotic Aladdin's Cave, particularly noting its superiority over the American exhibit to one side, which, according to one commentator, "looks more like a store," and the China exhibit to the other, described as an unflattering "mixture of the graceful and grotesque."[41] The display of India's raw materials, in contrast, was cited for its educational value, its art and manufactures admired for their creativity and ingenuity. Indian craftsmen were commended for the delicacy of their workmanship, while the Indian princes were applauded for contributing exotic royal possessions. "India," summarized a review in *The Times* of London, was one of "the most complete, splendid and interesting collections in Hyde Park, instructive in a great variety of ways, the merit of which cannot be too highly praised."[42]

On one hand, such a reception was not too surprising, since by 1849, when the Exhibition was first conceived in London, India was Britain's largest territorial possession and had long been viewed as a source of exotic commodities. From as early as the seventeenth century, when trade relations between Indians and the British began, Indian textiles and spices had been particularly valued for the profits they generated in European and Asian markets. Moreover, as the commercial interests of the East India Company were consolidated into outright political and territorial rule (a transformation generally associated with the capture of Seringapatam in 1799, and the final defeat of Tipu Sultan after a series of wars in the region), new desires, interests, and opportunities were created in the pursuit of Indian "things." By the beginning of the nineteenth century private collectors in India, usually East India Company employees compelled by profit, were increasingly motivated by the necessity for knowledge about the culture and history of the colonized natives. In the words of Colin Mackenzie, a colonel who arrived in India in 1782, they began surveying and mapping sites and collecting artifacts as a means of "entering the portal of Indian knowledge."[43] Significant collections of these objects were then assembled in London, the most famous of which was housed at the India Museum, opened in 1801 at the East India Company headquarters on Leadenhall Street.

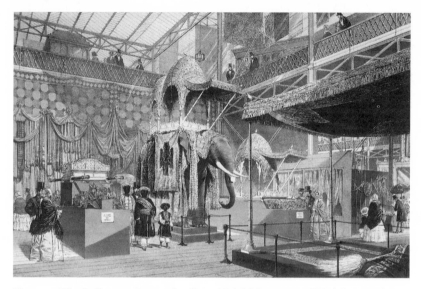

Figure 1. The Indian section at the Great Exhibition, 1851. V&A Images /
Victoria and Albert Museum.

By the nineteenth century, then, the massive documentation project,
driven by a number of what Bernard Cohn has termed "investigative
modalities"—including encyclopedic histories, censuses, mapping, surveil-
lance, surveys, photography, and the practices of collecting and display—
was well underway.[44] Moreover, the activities within India concerning vi-
sual display were inextricably connected to the practices of collecting and
display in Britain. Large collections of cultural objects, for instance, were
amassed in regional centers in India, in part to feed the growing desire for
more spectacular displays of the colony at home. Meanwhile, the pedagogic
"experiments" undertaken in the museums of South Kensington were dis-
cussed with the operations of Indian museums in mind.

Historians of South Asia Gyan Prakash and Tapati Guha-Thakurta
have both demonstrated in recent years how art, archaeology, agricul-
ture, and science more broadly were staged as new fields of knowledge
through such visual arenas in India.[45] The establishment of museums, ex-
hibitions, and art institutions in the subcontinent, many of which con-
tinue to exist today, were central to the project of cultural "improve-
ment" in the colony. And yet, as these scholars have argued, the export
of these modernizing agendas, and the pedagogic project of the civiliz-
ing mission at their core, was continually subverted by the unpre-

dictability of indigenous responses to museums and other visual displays. The perceived "failure" of the Indian Museum in Calcutta—the oldest museum in the country, established in the first decades of the nineteenth century—for example, was generally connected in the eyes of museum authorities to the problem of "inappropriate" native responses to its exhibits, revealing a long-standing and universalist set of beliefs about the proper constituency that is the "museum-going public."[46] In a similar vein, the "irrational" and "frivolous" responses of elite and subaltern Indian viewers at nineteenth-century scientific exhibitions helped to subvert the rationality of science itself.[47] One result has been the shaping of a different trajectory for aesthetic and scientific authority in India, as well as a different formation of disciplinary knowledges that would eventually, in some form or another, come to serve the interests and narratives of the new nation-state.

The value of these interventions, in spite of their differences, is that they have brought a postcolonial analysis into the mainstream of investigations of visual culture, a perspective that foregrounds the different genealogies of exhibitions and institutions transplanted from the metropole to the colony, and a culturally specific understanding of the different publics that visual regimes have served. Such analyses reflect a wider context of changing intellectual approaches to South Asia in the past two decades. They reflect in particular the influential work of the Subaltern Studies Collective, a diverse and highly self-conscious body of scholarship focusing loosely on peasant resistance in South Asia, but ranging widely in theme, topic, and period.[48] As I have argued elsewhere, the work of this collective has had an unusually widespread impact across the disciplines—from literature, art history, and cultural studies to anthropology, history, and feminist studies—with institutional as well as theoretical consequences.[49] The collective's specific emphasis on the interpenetrations of power and knowledge in the colonial archive and "the primacy of the subaltern as the subject of historical and sociological inquiry" has similarly left its mark on the present investigation.[50] In what follows, I highlight some of this influence, and point to a few of the events and discourses that form the basis of my examination in the chapters ahead.

THE PRINCIPLES OF DESIGN

Following the Great Exhibition, the Victorian art reformer Owen Jones—as I noted at the outset—reflected on the Indian section at the

Great Exhibition in an attempt to formulate "correct" and "good" principles of design. In his book *The Grammar of Ornament*, the Victorian precursor to the style manuals of today, Jones argued that the exhibits from India in the Crystal Palace demonstrated an "instinct and perfection" in the area of design that could help elevate the quality of workmanship in Britain as well as the aesthetic standards of the British public.[51] The Great Exhibition was, after all, intended to be a "lesson in taste," an expression that was the title of a prize-winning essay by the art critic Ralph Wornum in a contest inviting critical appraisal of the event. For Wornum, a study of the foreign displays at the exhibition could "advance our national taste" and contribute to the "general elevation of the social standard."[52] Wornum was more critical than Jones of the non-European designs featured at the Crystal Palace: the "best shapes remain Greek," he insisted. But the shawls from Kashmir and Lahore, he conceded, were far superior to anything Europe had produced.[53]

Through the discerning lens of "good taste," the Great Exhibition made India visible in London in an unprecedented way. For the first time India's culture and history were systematically read through its material products. Earlier in the century, the utilitarian philosopher and historian of India James Mill had determined that the commodities of India were a sign of its "lowness"; "a gilded throne, or the display of gold and silver and precious stones . . . does not invalidate this inference," he stated.[54] At the Great Exhibition, however, the manufactures of what had previously been regarded as a vulgar and degraded culture became assimilated into a Victorian aesthetic of refinement, skill, delicacy, and good taste. One result was that India would become fashionable in London, because fashion, according to the exhibition catalogue, "which here is as fickle as the wind, is in the East as steady as their monsoons."[55]

Of course, "fashion" was not an innate property of the East, but was more accurately the result of the rise of mass consumption within the newly industrialized urban space of Europe. The new fashionability of the little-known Austrian artist Rudolf Swoboda, who offered a distinctly different view of India than that of the picturesque tradition of Hodges and the Daniells, best captures this climate of industrial cosmopolitanism at the end of the nineteenth century. In particular, Swoboda's painting *A Peep at the Train,* which was completed for Queen Victoria in the 1890s and exhibited at the Royal Academy in London, exposes several convergent strands of signification regarding "traditional" India at the close of the century (figure 2). In this distinctive village scene, depicting in the foreground an old man and a group of chil-

dren positioned around a wooden fence, we see a specifically anthropological interest in the physical landscape of the Indian village, both temporally and geographically removed from the experience of the industrial present.[56] As I will argue later in the book, Swoboda's painting is therefore of interest not because of its historical claims to ethnographic accuracy, but because of its "peep" at the preoccupations of the European imaginary, the assumptions and misperceptions of colonial knowledge, and the controversies at the national level that it encapsulates and serves to predict.

The anthropological image of traditional India in this painting was undoubtedly linked to the conception of the Indian village developed by the "armchair" anthropologist Sir Henry Maine. For Maine, the significance of the Indian village was its utility as an evolutionary tool within the particular brand of political philosophy he espoused. In the later of his two classic works, *Ancient Law* (1861) and *Village Communities in the East and West* (1880), Maine argued that in the Indian village, "a living, and not a dead institution," one could observe the workings of what he called the Teutonic Township, "the archaic political unit of the earliest English society."[57] Despite differences in the two political systems, Maine believed that their resemblances to each other were "much too strong and numerous to be accidental."[58] For Maine, the Indian village was thus not the site of decay or stagnation, as suggested by social thinkers earlier in the century such as James Mill and his son, John Stuart Mill. Instead, it existed as an earlier, precapitalist stage of Britain's own evolution from tradition to modernity.[59]

The new visual vocabulary articulated by Swoboda was not only a reflection of this emerging anthropology of the Indian village, which itself was gaining popularity as a knowledge discipline as the century progressed. It was also an anxious expression of concerns in Europe about the developing technologies of industrialization and the changes wrought by industrial capitalism in England. An important argument I develop in the first chapter of the book is that the image of the village depicted in Swoboda's painting, and in particular the focus on the village artisans and craftsmen that dot the landscape in this composition, represent a crucial ideological configuration in the historical trajectory of the modern Indian nation-state. The insatiable appetite for images of the Indian craftsman by Europeans in the 1880s, and the subsequent claiming of this image pool by Indian nationalists at the dawn of the twentieth century, is a distinctive and emotionally charged dialectic that I identify in chapter 1 as the "cult of the craftsman." This phenomenon of excess

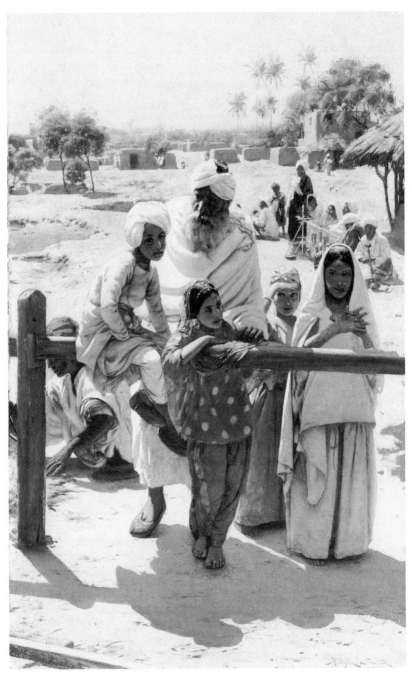

Figure 2. Rudolf Swoboda, *A Peep at the Train,* 1892 (oil on canvas, 90.5 × 55.9 cm). The Royal Collection © HM Queen Elizabeth II.

toward the figure of the craftsman was unmistakably linked to the crises related to industrialization in the colony and the modernizing processes of the period in general. Entangled in the Victorian discourses of ethnology and art reform in both Britain and its Indian colony, the figure of the Indian craftsman acquired a symbolic currency around the question of industrialization that was at times more powerful in the Indian case than the symbolism of the steam engine train, a universal icon for the industrial age also present in Swoboda's composition in the form of the railway track—easy to miss upon first glance, but nevertheless present in the bottom left corner of the painting, cutting through the margins of the scene.

Chapter 1 thus examines the "cult of the craftsman," and situates the phenomenon in a concrete case study that reveals the orientalist underpinnings of the Victorian department store. I focus in particular on Liberty's Department Store, which, like exhibitions, museums, and postcards, captivated the imagination of European consumers when it opened in the late nineteenth century as a fabulous showcase for exotic objects from the East. The store's founder, Arthur Lasenby Liberty, was a successful entrepreneur whose London warehouses full of Indian silks, rugs, shawls, and furniture helped build his reputation in the Victorian fashion world. He shared an interest in Indian design with men like William Morris and John Ruskin, leading figures in the Arts and Crafts movement, but largely ignored the critique of capitalism that provided the philosophical basis of the movement. Nonetheless, Liberty's on Regent Street became an important entrepreneurial space where Indian styles and designs were marketed to the public. Liberty's Umritzar Cashmere, an English-made imitation of a cashmere shawl, was an immediate success when it was launched in 1879. Similarly, the raw fabrics imported from India and locally dyed with pastel tints became known worldwide as "Liberty colors." Although reproductions, such products were marketed as exotic objects from the East, and the store became an elaborate fantasy of the Orient, as well as an outlet for the sale of its supposedly authentic goods.

The discursive entanglements between the department store and the figure of the Indian craftsman became evident in the winter of 1885, when Liberty's undertook a botched exhibition of "living village artisans" in a promotional scheme that brought forty-two villagers from India to perform their craft traditions for audiences in the Albert Palace at Battersea Park. As I show in chapter 1, the exhibition—a dismal failure resulting in legal disputes between the performers and Liberty's—

mobilized Indian nationalists in both India and Britain, who emphasized the irony that a "civilized" culture would participate in the barbarism of displaying human beings. I then situate the department store debacle within the larger historical backdrop of economic concern with the importation of British textiles into India and its impact on the craft economies of the Indian village. By 1904, the nationalist historian R. C. Dutt would challenge such spectacles, and the conditions of economic dependence they concealed, in his classic treatise on the colonial economy, *The Economic History of India*.[60] His account in turn influenced the *swadeshi* (homemade) campaign in Bengal to boycott British goods and promote indigenous products, which reached its apex in 1905. By tracking the repeated return to the image of the Indian craftsman across these historical discourses, from the contested inventions of Liberty's department store to the romantic renderings of a scholar like George Birdwood to the appropriations of the figure by nationalist thinkers like Dutt, Coomaraswamy, Havell, and Gandhi, I argue that—unlike in other societies—in the Indian case the nexus of relationships between modernity and the craftsman was overdetermined by the particular rhetorical and material effects resulting from the colonial economy.

The first chapter thus lays the groundwork for the next, in which I examine an even more visible ethnological display of native artisans in London staged at the Colonial and Indian Exhibition of 1886. Chapter 2 traces the processes by which a group of marginal Indian men—prison inmates from Agra and a homeless Punjabi villager in London—were recreated by exhibition officials as "ethnic specimens" for the purposes of display. By focusing on both the powerful acts of social management and the processes of resistance by the men on display, I show how the event produced a clash between local anxieties and imperial concerns, between colonial and nationalist hierarchies, and between elite and subaltern Indian interests. I then turn to focus on the particular case of a Punjabi peasant, Tulsi Ram, who drove municipal and India Office authorities to distraction by his ceaseless demands to "visit the Queen."

The story of Tulsi Ram that I found buried in the archives is a poignant and distressing tale that shatters once and for all the elaborate fiction of authenticity enacted by the colonial exhibitions: it is, in the words of this destitute villager, the story of a "poor stranger in this strange land." Embarking on a journey for justice over a land dispute in his village, Tulsi Ram found himself homeless in London's East End and was repeatedly arrested for vagrancy before he was recruited for the native artisans display at the Colonial and Indian Exhibition of 1886. By

tracing the movements of this luckless peasant through the trail of offi-
cial correspondence about him, such as police memos, court petitions,
and letters from concerned prison, hospital, and workhouse employees,
I expose the mechanisms of social control behind the spectacle of the ex-
hibition and highlight the subjectivities of the men on display to chal-
lenge the dominant archive of exhibition propaganda. Against the offi-
cial story of the "success" of the display—one that erases the will of the
exhibited subject—this chapter argues that bodies on display have their
own biographies, strategies, journeys, and itineraries that refuse their
containment as mere ethnic objects.

As part of the spectacle of 1886, Queen Victoria commissioned the
young Austrian painter Rudolf Swoboda to produce several portraits of
her Indian subjects on display at the exhibition. Chapter 3 takes as its de-
parture point the tensions between these official portraits for the Queen
and the complex ideological environment in which they were produced.
Based on the success of these paintings, Swoboda was sent to India by
the Queen, where he traveled for two years throughout the subcontinent,
painting a cross-section of Indian society. The body of paintings that re-
sulted—more than eighty portraits—recalls another colonial collection,
The People of India, the eight-volume catalogue published between
1868 and 1875 containing some five hundred photographs of India's
"ethnic types."[61] But Swoboda's pictures were not granted the authori-
tative status of this photographic collection, with its powerful claims to
scientific objectivity and truth. Instead, the Queen was delighted by their
decorative effects, referring to the paintings as "beautiful things," and
she displayed them in her summer residence on the Isle of Wight, where
they hung, largely forgotten, until recent years.

Chapter 3 thus investigates the practices of painting, as distinct from
the operations of photographic portraiture, and offers a "contrapuntal
reading" of this imperial archive by rejecting the narrow histories of for-
mal achievement and national style promoted by connoisseurs of the
Royal Collection. Drawing from Said's vision of "intertwined histories,"
I turn instead to explore the "politics of the colonial palette"[62] and high-
light the discrepancies between European and Indian painters that oc-
curred with the institutionalization of oil painting in the subcontinent at
the end of the century. Swoboda's journey, as I will show, takes us
through the milieu of the newly established colonial art schools in Bom-
bay and Lahore, and the emerging culture of art societies and juried ex-
hibitions that were generated and promoted by British art administrators
in India on the cultural model of the European salon. Swoboda's trip in

the late 1880s thus coincided with the debut of a new kind of Indian artist in the subcontinent, the "gentleman painter," self-consciously trained in the European practices of easel and oil, belonging to the intellectual classes, and earning a living through portraiture commissions. This Indian artist, whose emergence was a source of anxiety and competition for the European painter, was clearly defined by his social distance from the figure of the "native artisan" examined in the previous chapters. By contrasting Swoboda's Indian career with that of the preeminent Indian painter of the period, Raja Ravi Varma, I point to some of the asymmetries built into the history of oil painting, as well as the representational dilemmas that have resulted from this imbalance, many of which continue to persist today.

The immediate impetus for the research in this chapter was an exhibition of these portraits by Rudolf Swoboda, titled "An Indian Encounter: Paintings for Queen Victoria," held at the National Gallery in London between November 2002 and January 2003. The museum invited me to conduct research and lectures and to contribute an essay on Swoboda for the exhibition catalogue accompanying the show.[63] The National Gallery, itself a colonial-era institution established in 1824, and known for its "masterworks" by Botticelli, Rembrandt, Monet, Renoir, van Gogh, and others, in many ways symbolizes the conservative arts establishment in Britain. Their exhibition record revealed little previous experience in South Asia–related subject matter, as the museum is primarily concerned with the history of Western European art.[64] Nor was the National Gallery among the handful of institutions that had begun to situate and understand the place of the colony within a "high" European painting tradition. At the same time, concerned curators at the gallery sought to escape a narrative of "Raj nostalgia," one of the recurring criticisms leveled at London's Victoria and Albert Museum in the politicized context of the British Black Arts movement in the 1980s and 1990s. Some of the issues that emerged in this collaboration, concerning the changing identities of museums and the multiculturalism of their urban constituencies, while not themselves the subject of my chapter, will be taken up more directly in chapter 5, in my discussion of museums and the discourses of restitution in relation to the processes of postcolonial change.

The themes of mobility, agency, and the colonized body on display that are raised in earlier chapters appear again in my fourth chapter, on collecting colonial postcards, because the latter is defined as an object precisely by its ability to travel. Chapter 4 examines the colonial postcard as

a distinctively modern visual form, one that became the object of an un-
usual collecting craze throughout Europe at the turn of the century. By an-
alyzing the production, collection, and circulation practices of the era, this
chapter links the postcard to issues of gender and offers a feminist read-
ing of this visual form. Colonial postcards of India, I suggest, reveal a
complicated economy of gender relationships: they are both very often
stamped with commodified images of women and are thoroughly femi-
nized as "low" cultural forms. Moreover, by foregrounding the role of
European women as consumers and collectors of colonial postcards, I
argue that postcards of India reveal much more about the structure of
gender relations in colonial society than Malek Alloula has suggested in
the case of Algeria.[65] For the images of women that appear on these post-
cards not only show Indian women as sexual objects, but they also depict
European women in the colonies, as well as the meeting *between* women
in colonial society. Rejecting Alloula's nationalist account and the para-
digm of "visual violation" that it proposes, I argue that what these post-
cards instead make visible is a set of differing and hierarchical construc-
tions of womanhood that are defined in relation to each other and
through women's different relationships to the colonial public sphere.

The fifth and final chapter extends this concern with collecting and
travel to the institutional context of the museum, and addresses some of
the difficult challenges facing contemporary museums relating to notions
of acquisition, ownership, belonging, and return. Turning briefly to two
significant paradigms for museological restitution, emerging from the
radically different historical conditions of the Nazi invasion of Europe
and the dispossession of indigenous peoples in North America, I suggest
that the proliferation of disputes over cultural property in the past few
decades signals a set of crises around the shifting systems of value oc-
curring in the context of globalization. I then extend this analysis to the
case of South Asia by recounting a thirty-year struggle, beginning in the
1920s and ending in the 1950s, for the return of two Buddhist relics ex-
cavated in India in the late nineteenth century and relocated to the Vic-
toria and Albert Museum in London. By tracing the competing claims
upon these relics across different social and historical configurations—
from concerned museum officials in London, to members of a local
British Buddhist society lobby, to a wider network of Buddhist groups
in India, Burma, and Ceylon organized in the postcolonial era—I argue
that, against repeated claims to the intrinsic, essential historical signifi-
cance of the objects, their value has been produced and sustained
through these acts of social exchange. The story of this extended custody

battle, one that was settled, for once, in favor of the weaker party, is a compelling parable of postcolonial return. But the reconfiguration of historical conditions, and the new environments for the inscription of meaning that result in the transition from colonial to postcolonial society, also render the idea of "return" to a pure point of origin impossible. I conclude this chapter by reflecting upon how these postcolonial thematics of displacement and belonging come to bear on issues of cultural property in South Asia, and consider in particular the impact of the 1947 partition of the subcontinent into India and Pakistan on the fate of the shared cultural patrimony of the region.

Although the chapters do not claim to offer a historical chronology, the text nevertheless gains coherence through the chronological sequence in which it unfolds. Together, the chapters that follow present India as a visual object constituted in part by discord and distortion, one that has been fashioned and refashioned in multifarious ways, through shifting historical and political contexts. The word *design* in the title of this book is thus intended to suggest the active contrivances, the preconceived schema, and the historically nuanced machinations at stake in these visual and conceptual formations. However, the idea of design also points to the aesthetic sensibilities, artisanal positionings, and discussions on Indian craftsmanship that emerged at the center of colonial modernity in India. What *India by Design* does not offer is a historically "pure" aesthetic result. Instead, by exposing horizons of contestation and by uprooting images from their landscapes of power, this book is an attempt to confront both the enduring legacy and powerful visual basis of our modern paradigms for cultural difference.

The Indian Village in Victorian Space

The Department Store and the Cult of the Craftsman

For the first time in history, with the establishment of the
department stores . . . the circus-like and theatrical element
of commerce is quite extraordinarily heightened.

Walter Benjamin, *The Arcades Project*, Convolute A

Where is our William Morris? Probably the time for his
coming is not ripe.

Ananda K. Coomaraswamy, *The Function of Schools
of Art in India*, 1909

The Festival of India, held in Britain in 1982 and the United States in
1985–86, was an extravagant staging of Indian culture abroad that
brought traveling mega-exhibitions, lectures, films, plays, performances,
department store promotions, and celebrity sightings all into its eye-
catching frame. Two decades later, we view this event as the sign of a
new era in the politics of representation, defined by the influence of eco-
nomic globalization on the realm of culture and the arts. According to
some critics, the Festival of India was a "huge public relations gambit,"
constituting an ever "more aggressive assertion of nationalism."[1] For
others, however, especially curators and cultural practitioners, the exhi-
bitions and performances at its center were the result of a "continual di-
alogue about the nature of tradition, innovation, and adaptation," and
made possible the creation of new cultural practices "in a way that gave
value to the old."[2] More recently, a new generation of South Asian artists

in the diaspora have acknowledged the role of the Festival of India in introducing them to the aesthetic traditions of the subcontinent and, indirectly at least, influencing their work.

At the heart of this contested landscape was a controversial presentation of the "living arts" of India, involving the display of dozens of indigenous artisans demonstrating their crafts in exhibition spaces in Washington, D.C. In the eyes of the critics, this display was generally not connected to the ideological agendas of nation-states, nor to the partnerships created by festival organizers between museums and department stores like Bloomingdale's in New York. In fact, the efforts by Rajeev Sethi, the prominent Indian designer and founder of the Asian Heritage Foundation, to bring Indian artisans to Washington in conjunction with the Smithsonian's Office of Folklife Programs were seen to generate a different set of issues, namely, the problems and "poetics of an ethnographically real exhibition."[3] At issue were actually two exhibitions. The first, arranged thematically around a Hindu life cycle, featured forty folk artists, all craftspeople and performers, working inside the National Museum of Natural History in Washington in specially designed spaces intended to illustrate "their creative role in the life cycle."[4] As curator Richard Kurin described it, "a Baul sang of cosmic fertility, a Warli painter depicted tribal courtship dances, Rajasthani women applied *mehndi* to the hands of visitors . . . [and] magicians, puppeteers, jugglers, and storytellers initiated children into India's history and wisdom."[5] The second exhibit was at the annual Festival of American Folklife and featured thirty-five more artisans from India, all members of a "poverty-stricken, low-caste" cooperative from the subcontinent, performing their trades and selling their wares in a re-created Indian bazaar in the outdoor mall in Washington.[6] Together, these exhibits attracted more than one million people, including a host of politicians and celebrities. When the Indian prime minister at the time, Rajiv Gandhi, visited the exhibit, he praised the group of low-caste performers as "India's foremost cultural ambassadors."[7]

The incongruity of these images of village artisans from rural India performing their trades for urban audiences in America may at first glance appear to express a set of concerns that are unique to our contemporary globalized world. In fact, the phenomenon of the Indian craftsman on display, who represents through his physical presence the meeting between industrial society and the preindustrial modalities of indigenous craft, has an extensive history in modern South Asia, and has long been a source of controversy and crises. In this chapter, I examine

the intersection of a number of discrete discourses and practices—economic, commercial, aesthetic, and ethnographic—that have constituted the powerful symbolism of the Indian craftsman, first enacted during the colonial period, and then reenacted and appropriated in various ways by successive phases of Indian nationalism. I focus in particular on the space of mass consumption that is the nineteenth-century department store, a site where these multiple discourses surrounding the production, export, and display of India's "living" craft traditions converged in a spectacle during the 1880s, a full century before the Festival of India.

Early department stores, as historians have shown, were similar to arcades and museums, but they were also powerful symbols of capitalist modernity in a rapidly changing metropolitan landscape.[8] In what follows, I highlight the role of the colony in the identity of this modern institution by turning to the case of Liberty & Co., which gained a reputation as an oriental warehouse during the 1870s by importing a range of exotic products from the subcontinent. Not only did Liberty's help to popularize and disseminate Indian styles and aesthetics to the metropolitan public, the store also invented entirely new products: that is to say, industrially manufactured reproductions of handmade Indian goods, which were more affordable and deemed more suited to European tastes. Thus, what were in some sense hybrid inventions—English-made imitations of Indian things—were nevertheless marketed as "real" products from India and praised for their ability to rival India's preindustrial, handmade goods.

The department store was therefore a unique stage for the dramatic encounter between industrial society and the preindustrial craft traditions of the Indian subcontinent. And a central protagonist to appear in this show was the figure of the Indian craftsman. In an elaborate, and ill-fated, department store promotion in 1885, Liberty's attempted, as we shall see, to create a living display of Indian village artisans in London's Battersea Park, an event that generated a great deal of controversy in India and Britain. What I argue in the pages that follow is that the image of the village promoted by Liberty's, as well as the figure of the native artisan at the center of this debacle, expresses a crucial historical and ideological configuration in the intertwined trajectories of modernity and national identity in India. For the emergence of a popular European interest in the Indian craftsman by the 1880s and the subsequent claiming of this figure by Indian nationalism—a dialectic I refer to as the "cult of the craftsman"—was a distinctive phenomenon signaling the crises related to industrialization in the colony and the modernizing processes of

the period more generally. Supported by the multiple discourses of an-thropology, ethnology, "good" design, art reform, and art education in both Britain and its Indian colony, the disputes about the labor and worth of the Indian craftsman map a range of economic and political anxieties in the popular arena regarding the passage into modernity from a preindustrial past. If the misfortunes of the craftsmen brought by Lib-erty's to England can be linked to the aesthetic and commercial practices of empire, then, significantly, by the end of the century, Indian nation-alism had launched its bold retaliation on both these cultural and eco-nomic fronts.

GEORGE BIRDWOOD

As I noted in the introduction, the nostalgic conception of a timeless, tra-ditional India with the village community at its center—all of it located in Europe's evolutionary past—had its origins in the work of Sir Henry Maine, but it also dominated the writings of late Victorian art critics and reformers in their preservationist approaches to India's cultural prod-ucts. Among the most prominent of these figures was George Birdwood, a critic, curator, and collector who specialized in the study of Indian art. Along with the work of James Fergusson, another pioneer in the field of Indian art and archaeology, Birdwood's book *The Industrial Arts of India,* published in 1880, would become one of the most authoritative texts in the field, and was frequently cited in various museum, exhibition, and department store catalogues throughout the 1880s. Not only did Birdwood profoundly influence popular knowledge about Indian art practices, but he was also an important figure in the discourse of pro-tectionism, which focused centrally on the survival and revival of the In-dian craftsman, and he argued fervently throughout his career for pro-tective policies where the Indian village was concerned.

Birdwood saw the art of India as inseparable from the Hindu religion and, more specifically, from the sacred text the Code of Manu. The Code of Manu, Birdwood claimed, "has secured in the village system . . . a permanent endowment of the class of hereditary artisans and art work-men, who of themselves constitute a vast population; and the mere touch of their fingers, trained for three thousand years to the same manipula-tions, is sufficient to transform whatever . . . is placed in their hands, 'into something rich and strange' and characteristically Indian."[9] For Birdwood, the Indian village, informed by the Code of Manu, was the repository of an enduring tradition of artisanship that was somehow his-

torically pure. The perfection he saw in Indian art depended on heredi-
tary processes and skills that were, in turn, preserved in the Indian vil-
lage against wars, invasions, and foreign rule. "Every house in India," he
wrote, "is a nursery of the beautiful."[10] And the daily life of the Indian
village, with its potters, weavers, coppersmiths, and jewelers, produced
an essential and "unrivaled excellence" in the area of industrial arts. "In
India," Birdwood explained, "everything is hand wrought, and every-
thing, down to the cheapest toy or earthen vessel, is therefore more or
less a work of art."[11]

Unlike earlier analysts of Indian art (Owen Jones following the Great
Exhibition, for example), Birdwood thus attributed the greatness of
India's cultural products to the social structure of the Indian village. His
picture of this village community was a highly idealized and romantic
one. "In the happy religious organization of Hindu village life," Bird-
wood wrote, for example, "there is no man happier than the hereditary
potter."[12] Indian pottery, for Birdwood, was "truer" than all other artis-
tic practices because of the "directness and simplicity of its forms," and
this was a part of its irresistible attraction.[13] These views were clearly re-
flected in his infamous meditation on watching the potter in his village
environment:

> The whole operation is a constant temptation to the inexperienced by-
> stander to try a hand at it himself. You feel the same temptation in looking
> on at any native at his work. His artifice appears to be so easy, and his tools
> are so simple, that you think you could do all he is doing quite as well your-
> self. You sit down and try. You fail, but will not be beaten, and practice at
> it for days with all your English energy, and then at last comprehend that
> the patient Hindu handicraftsman's dexterity is a second nature, developed
> from father to son, working for generations at the same processes and ma-
> nipulations. . . . He is in truth one of the most useful and respected mem-
> bers of the community. . . . We cannot overlook this serenity and dignity of
> his life if we would rightly understand the Indian handicraftsman's work.[14]

Birdwood constructed the happy primitivism of the village setting in
opposition to the "evil" threat of industrialization in India. He was
strongly opposed to the "mean foreign forms . . . being constantly in-
troduced into the country."[15] "What, however, is chiefly to be dreaded
is the general introduction of machinery," he wrote. The "colossal mills
of Bombay," in competition with those of Manchester, had forced
craftsmen to leave their villages for low wages.[16] This, he objected, was
a dangerous threat to India's 3,000-year-old system of arts. "The worst
mischief," he further complained, was promoted by the British govern-

ment of India. "We therefore incur a great responsibility," Birdwood argued, to preserve India's native institutions and to prevent the erosion of traditional forms.[17]

Birdwood's belief in a righteous policy of colonial rule did not translate, however, into support for the activities of missionaries, which he viewed as "one of the most rueful sights in all India."[18] Birdwood did not hide his contempt for the figure of the missionary "expounding Christianity to the natives" and derided what he called this "muscular worldly wise, and well-dressed self called Ambassador of Him."[19] And yet, Birdwood believed that Indians were "physically a weaker race" due to accidents of geography and climate, "and hence politically . . . a nation disintegrated into its villages, and they never, never will rise into self-organized, self-supported national life, desire it as we may."[20] Birdwood's paternalism did not hold up against the complaints that were increasingly leveled by the new guard of Indian art reformers riding the tide of Indian nationalism after the turn of the century. Birdwood's influence, and the authority of South Kensington more generally, was ultimately displaced in a famous showdown at the Royal Society of Arts in 1910. It was here that Birdwood made his unfortunate quip about a statue of the Buddha being as passionless as a "boiled suet pudding." The comment, part of a larger debate about the definition of Indian art, epitomized his rejection of the existence of "fine arts" in the subcontinent and led to a flurry of public protest against him.[21] Birdwood never really regained face after this incident. The letter of protest to *The Times* that followed, signed by more than a dozen prominent artists and critics who rushed to the Buddha's defense, was like a manifesto of the new nationalist claims upon Indian art, claims that were themselves based on many of Birdwood's earlier orientalist assumptions. Indeed, his final publication, *Sva*, published a few years later, is an eccentric and increasingly idiosyncratic text.

Although Birdwood provided a vocal opposition to the commercial excesses of the British government in India, his position was derived from a preservationist impulse that saw a new and paradoxical role for the British in India: to save India from British rule. The result was, in James Clifford's term, a "salvage paradigm" in which Britain saw its responsibility in India as collecting and salvaging (and inevitably displaying) those forms of traditional culture perceived to be threatened by imperial contact.[22] Yet whatever critique of the processes of empire his account may have generated was built on an idealized projection of tradition as "good" and modernity as "bad." In this Birdwood simply reflected the wider climate of disillusionment with industrialization that

characterized the medieval revival in the visual arts in the second half of the nineteenth century.[23] This revival, culminating in the Arts and Crafts movement, intersected with anthropological discourses on the Indian village to assist in setting the ideological parameters for the commercial intervention of the Victorian department store.

ARTHUR LIBERTY AND HIS STORE

The history of Liberty's, like that of many department stores, tends to be narrated as the story of the heroic capitalist, a mythic tale of entrepreneurial success at the center of which stands the self-made man.[24] The man in this case is Arthur Lasenby Liberty, who began his career in the early 1860s working at Farmer and Rogers's Great Shawl and Cloak Emporium on Regent Street, a store that specialized in importing Kashmiri shawls and other textiles from India. After managing the Oriental Warehouse at Farmer and Rogers for more than ten years, in 1875 Liberty opened his own shop directly across the street, forcing his former employer out of business. He named the new store East India House, a self-conscious reference to the former East India Company and the adventurous merchant-explorer spirit that it represented. Liberty continued to expand the operation, and by the end of the 1880s his enterprise employed hundreds and encompassed multiple premises, including a shop in Paris called Maison Liberty and temporary exhibits at most of the world expositions (see figure 3). An American visitor to London in 1884 described the store there as an exotic "Aladdin's Cave" and a "sumptuous establishment," with beautiful crowded rooms where "the air is faintly perfumed with sandal and other scented woods."[25] Its fashionable clientele included prominent members of the Pre-Raphaelite movement, such as Dante Gabriel Rossetti, Frederic Leighton, and Edward Burne-Jones, and key aesthetic figures and art reformers like James McNeill Whistler, John Ruskin, and William Morris. Indeed, Liberty himself did much to promote these high-profile associations, often citing Birdwood and other authorities at the India Museum in the pages of his department store catalogues.

The history of Liberty & Co. thus stands in stark contrast to the more pragmatic history of the Army and Navy, the cooperative society established in the 1870s to serve the officers in the British military, and whose stores in Bombay, Karachi, and Calcutta became important retail outlets for the British in India.[26] Liberty's specialized in the space of fantasy; it offered an oriental "dreamworld" for the metropolitan consumer and constructed an imaginary experience of the colony through its elabo-

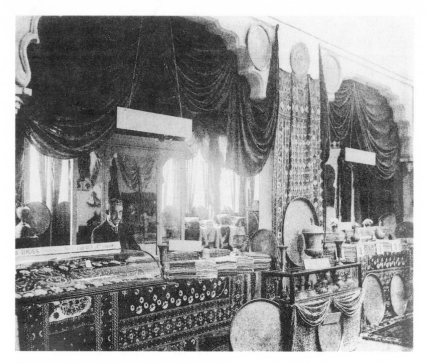

Figure 3. Liberty's Bazaar, Paris Universal Exposition, 1889. V&A Images / Victoria and Albert Museum.

rately staged commercial displays.[27] Its rooms were packed with Indian furniture, coffee tables from Damascus, antique carpets and rugs, incense burners, imported silks, Kashmiri shawls, Persian dishes, Benares brass work, Chinese lanterns, and exotic peacock feathers (figures 4 and 5); indeed, a stylized version of the latter became the primary logo associated with the store. "You wander through the numerous rooms of their great store-houses as in an enchanted dream," explained a journalist in the *New York Mail*.[28] "It is a positive art education" about the East, wrote another.[29] In other words, Liberty's specialized in the fashioning of "otherness." It fabricated difference for the European consumer to fit the needs of the changing modern. It constructed an eclectic image of the exotic East through its elaborate and seductive displays. And it offered an exciting encounter with all that contrasted with Britain's own industrial realities. In the words of one contemporary, Liberty & Co. stood in the end for everything "quaint, Eastern, and unlike modern everyday life."[30]

Although Arthur Liberty inhabited the same social circles as major

figures in the Arts and Crafts movement, he mostly ignored the critique of capitalism that was the philosophical basis of that movement. Instead, Liberty had his own eccentric brand of philosophy grounded in the commercial realities of the store, in which the twin goals of art and commerce were like two sides of the same coin. Commerce, one of the store's catalogues explained, had "deteriorated, cheapened, and vulgarized imports from China and India" in recent years.[31] It is for this reason that Arthur Liberty stepped in, to "arrest this decline," with two principal objectives: first, to achieve commercial success, and second, to conserve as best as he could the beautiful and unique in the art of the Eastern world. These two objectives, the catalogue continued, were interrelated: by encouraging the "right things" Liberty not only was doing "good work," but in time it would also prove to be commercially successful.[32]

The Liberty & Co. catalogues also displayed a distinct, if contradictory, set of aesthetic principles in relation to the exotic products of India (see figure 6). An Indian shawl, for example, should be avoided when it is inspired by the latest fashions of Paris and not its original wearers in the valley of Cashmere. Indian carpets, on the other hand, should be "selected and valued" according to their fit with European tastes. An Eastern carpet should contain patterns that the foot can touch "without a feeling of instinctive recoil." Patterns with "flowers or beasts," for instance, should be "conventionalized" to avoid "the possibility of any unpleasant impression." Designs with dogs, lions, tigers, and other "ferocious nondescript beasts" were "unrestful" and "glaring." The most valued carpets, in other words, were not those that retained their Eastern purity, but rather those that were—in the words of the catalogue— better "assimilated to the styles and designs of Europe."[33]

product morphed to fit w/ European taste

Thus while the copy of an Indian product in some cases symbolized a loss of purity or individuality, in others it stood for improvement and innovation. Indeed, this deep contradiction would come to inform much of Liberty's India-related activities. The famous Liberty Fabrics, for example—raw materials imported from India and then locally dyed in colors that were "reproductions of the finest examples of ancient art work"—were praised for "revolutionizing the whole colour scheme" of Indian fabrics.[34] Similarly, Liberty's Mysore Silks, imported raw silk with English colors and patterns, were promoted as "exact reproductions of old Indian prints" and noted for their precision and authenticity (see figure 7).[35] And yet, the names of these Mysore silk patterns—Rangoon Poppy, Poonah Thistle, and Allahabad Marigold—seem to convey most clearly what they actually were: idiosyncratic and hybrid blends. Indeed, the most popular of Liberty's "Indian"

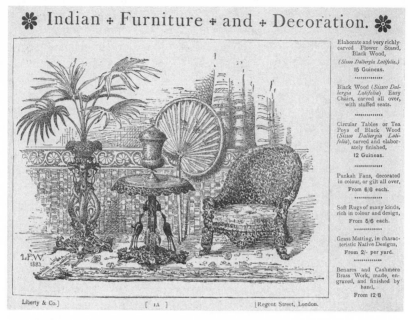

Figure 4. "Indian Furniture and Decoration," Liberty & Company Catalogue, 1883. V&A Images / Victoria and Albert Museum.

products in the 1880s, a shawl known as the Umritza Cashmere, was an English-made imitation of an "authentic" Indian shawl, the name Umritza itself a fictional word notable for its exotic sound. Far more affordable than an actual Kashmiri shawl, the Umritza was an immediate success and received rave reviews from women's magazines that praised this "fashionable, attractive and innovative material" for its "very foreign appearance."[36] Liberty & Co. thus not only introduced new products, materials, and ideas, but the store also *invented* them, and, in doing so, it created a demand for such goods and crafted a popular desire for the colony at home.

A FAILED PROMOTIONAL CAMPAIGN

Of course, some of Liberty's inventions were more successful than others, and the failure of one project in light of the success of others exposes the ideological parameters of the store's operations. I now want to turn briefly to a rather unusual case of a "failed" promotional campaign by Liberty's. In November 1885, Liberty & Co. brought a group of forty-two villagers from India to London to stage a "living village of Indian ar-

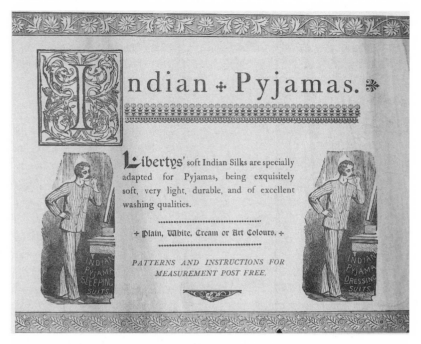

Figure 5. "Indian Pyjamas," Liberty & Company Catalogue, 1883. V&A
Images / Victoria and Albert Museum.

tisans" in the heart of the Victorian metropole. The group of Indians that
Liberty's imported for this "taxing undertaking" included two women,
a mother and daughter pair of *nautch* dancers, as well as forty men, in-
cluding jugglers, acrobats, carvers, weavers, embroiderers, and other
craftsmen (see figure 8).[37] They were to perform for the crowds in an In-
dian village setting at the Albert Palace in Battersea Park. The purpose of
the exhibit was to generate publicity for the store and to increase the sales
of its Oriental Antiques and Curios Department. Its main goal, Liberty's
claimed, was "to facilitate the manufactures of this country by showing
what could be done in India by natives with their own appliances."[38]

The event proved to be a total disaster, both commercially and in
terms of the publicity it generated. "All who touched it went straight-
away into bankruptcy," reported *The Indian Mirror*.[39] The Indians who
appeared in the village were "grossly deceived" by a recruiting agent who
had not given them the food, salary, housing, and clothing specified in
their contract. The two women in the display, described as "bewitching"
objects of sexual curiosity, were subjected to even greater humiliation.

Figure 6. "Handkerchiefs, Sashes, &c.," Liberty & Company Catalogue, 1883. V&A Images / Victoria and Albert Museum.

Many visitors were reported to have tried to "touch the *nautch* girls . . . in doubt as to whether they [were] the real article."[40] The group sought the help of Mr. Nanda Lal Ghosh, "a fellow countryman not known to have any connection with them."[41] Mr. Ghosh became the chairman of a committee "composed of a few English and Indian gentlemen" to "advise and assist" the unfortunate troupe. Legal proceedings commenced on their behalf. The *London Daily News* reported that they were not dissatisfied with their treatment but were simply "homesick" and "wanted to get home as fast as possible."[42] Their dispute was widely publicized, and a relief fund to facilitate their return was advertised in the Bombay newspapers. In March 1886, the *Times of India* reported that

> the members of the "Indian Village," numbering forty-two, one having died, will reach Bombay by the next mail steamer. They come back in a very helpless and miserable plight. The "show" was a failure from the first; and even before it started, the financial arrangements of the original promoter of the scheme broke down. . . . No food had been supplied to the members of the company for a week, and their salaries were in arrears. . . .

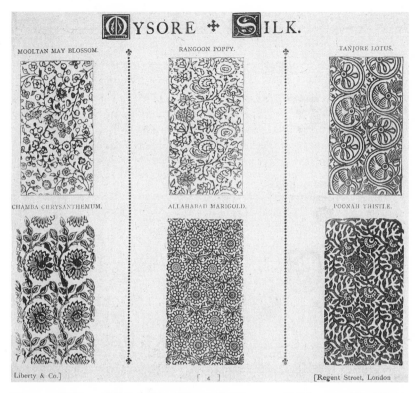

Figure 7. "Mysore Silk" designs, Liberty & Company Catalogue, 1883. V&A Images / Victoria and Albert Museum.

He is now sending them back to Bombay, but no one is in charge of them, and they are penniless as the result of their English adventure.[43]

To add to their misfortune, the Indians had arrived in London during the bitterest months, November and December, of a winter that had been especially severe, with the coldest temperatures recorded in thirty years. Elsewhere in London the below-freezing temperatures had brought outdoor work to a virtual standstill, creating much distress among unemployed dock and building workers.[44] With the breakdown of the hot-water pipes in the Albert Palace, the Liberty's group found themselves, along with the rest of London's urban poor, struggling to survive the cold. Fires were kept going day and night, and a physician was brought in to see them. Thirty cobras and rock snakes belonging to the snake charmer Sheikh Imam were killed by the temperatures, so a "fresh batch was ordered from Bombay."[45] For their European spectators, the struggle

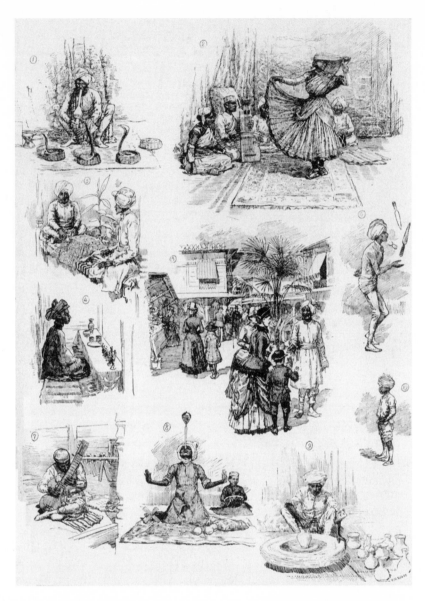

Figure 8. Liberty's Indian Village at Battersea Park, *Illustrated London News*, November 1885. Courtesy of UCLA Libraries.

against the cold became a notable, if inauthentic, part of the display. "It was odd to see the Indians in European garb," observed one English-woman in a newspaper account. "The management had been obliged to supply them with overcoats, trousers, mufflers and boots on account of the cold. A few of them wore English hats; and you cannot imagine how thoroughly a 'billycock' can vulgarize the Asiatic type of head and face."[46]

The Liberty's experiment had thus failed as both a commercial venture and an exercise in cultural display, and it received much attention in India as a result. In a climate of growing nationalist discontent with the British treatment of Indians more generally, a dissatisfaction that had escalated that year with the recent annexation of Burma and the confidence gener-ated by the newly formed Indian National Congress, there was outrage at the botched exhibit. Newspaper editorials emphasized the irony that a "civilized" culture would participate in the barbarous act of displaying human beings. "Strange that the idea of public exhibition . . . be conso-nant with European Civilization," suggested the editors of the *Hindoo Pa-triot*.[47] "There is no knowing where the mania for shows and exhibitions is to end in civilized society."[48] Meanwhile, London writers offered their opposing arguments: if the exhibit in any way displayed the "inherent ap-titude of the mild Hindu" for local self-government, wrote one, then "the sooner the Indian village is abolished the better."[49] The practices of the department store in the metropole thus emerged, like most aspects of cul-tural life by the 1880s, as a profoundly contested set of representations in the nationalist challenge to colonial knowledge in India.

Years later Arthur Liberty would acknowledge that he deeply re-gretted the "importation of Hindoos," which brought him into consid-erable "disfavour in high quarters" at the Home Office of the Indian government.[50] Unlike George Birdwood, Liberty never retained any long-term commitment to the preservation of India's aesthetic tradi-tions. Instead, he became increasingly committed to the local arts and promoted his store as a source of nationalistic and patriotic pride.[51] In-deed, by the 1890s exhibits of British products with names like Victo-ria Brocade or Hercules Silk (made with Spitalfield or Yorkshire looms) were increasingly common in the store's Indian sections, which pro-moted and celebrated "the great advance made in the British silk in-dustries" more than anything else.[52] Meanwhile, the devastating eco-nomic consequences of such a shift and the conditions of dependence it entailed for India did not go unnoticed on the Indian subcontinent. For the import of British manufactures, especially cloth products made of cotton, wool, and silk, into India and the ensuing destruction of Indian

handicraft production—what Marx called "the corrosive influence of British commerce" on the village communities of India—became *the* key themes of Indian nationalism by the first decade of the twentieth century.[53] In particular, as the difference in price between European industrial products and handmade Indian textiles became greater, the practices of the indigenous artisan were seen to be increasingly under threat of extinction. If nationalist historians like R. C. Dutt, influenced as he was by the writings of Marx, displayed a twinge of nostalgia for the plight of the craftsman in their economic arguments against British rule, their vision for the future was at least very different from the one implicit in the spectacle at Liberty's.

NATIONALISM AND THE INDIAN CRAFTSMAN

It is telling that in 1904 R. C. Dutt began the preface to volume 2 of *The Economic History of India,* his great treatise on the commercial policies of the British government in India, by dismantling the picture of a London exhibition, which was, he wrote, "like a scenic representation of the unity of the British Empire" surrounded by "an outburst of enthusiasm" and loyalty that had seldom been seen on such a scale.[54] "One painful thought, however, disturbed the minds of the people," Dutt continued. India's great poverty and economic distress were nowhere visible in this elaborately staged scene of progress and prosperity. "Tens of thousands," for example, "were still in relief camps when the Delhi durbar was held in January 1903," he noted, due to the devastating famines of 1897 and 1900, during which millions of Indians had perished. From Dutt's perspective, it was time to unmask the cruel disparity of the widening economic gulf between Britain and India, a disparity that "the people of India felt in their hearts" and that the spectacles of imperial unity on display in London and Delhi had too long served to conceal.[55]

Dutt's classic work argued that the crippling of Indian industries, the overtaxation of agriculture, and the diversion of revenues to England were the primary factors in a process of underdevelopment in India that had begun in the early days of the East India Company and had continued as policy throughout Queen Victoria's rule. For Dutt, the "manufactures approach," which promoted the production of raw material in India for British industries and the consumption of British products in India, had fatally damaged the Indian economy while benefiting the British one. More broadly, Dutt felt that the commercial practices of the British in India, exemplified by a store like Liberty's, had not been de-

termined by the interests of Indians, but by those of British consumers alone. In his analysis Dutt also turned to the urgent "state of poverty and decline of the Indian craftsman," arguing that "every true Indian" hopes for the survival and regeneration of this ancient figure against the assaults of modern capitalism."[56]

The account offered by Dutt and other nationalist historians of the conditions of dependence created by the manufactures approach helped prepare the ground for the *swadeshi* (homemade) campaign in Bengal. The campaign, which reached its apex in 1905, sought to boycott British goods and promote indigenous economic enterprise. Economic *swadeshi*, motivated by a conscious patriotism, was built on the sentiment that indigenous goods, even if more expensive or inferior in quality to their imported counterparts, should be preferred by the Indian consumer. As Lisa Trivedi has shown, the movement's leaders promoted craft products, from cotton to silk to everyday utensils, and reached out to rural communities through such visual discourses as traveling exhibitions, lantern slide shows, and photographic exhibitions.[57] The deployment of these modern visual technologies at the village level built upon a number of preexisting entertainment forms such as traveling storytelling and theater troupes.[58] What distinguished these outreach efforts from earlier practices, however, was the distinctly "national" framework being developed. Historians have thus turned to the importance of visual culture in the rise of these mass movements in India to challenge the emphasis on literacy and print culture in the formation of an "imagined community" that the historiography of nationalism in Europe has presumed.[59]

For our purposes, however, this visual stage, far removed as it was from the imperial metropolis, also helped to inscribe the difference between a nationalist *swadeshi* product and an imperialist colonial manufacture, like the ones being marketed by Liberty's in London. As Trivedi has suggested, the goods produced and promoted during the *swadeshi* campaign were thus neither the products of India's artisanal past, nor the products of the British colonial economy. Rather, the items promoted during the *swadeshi* movement represented "a new, modern political community that was overcoming the limitations of both traditional and colonial India."[60] There is no doubt that *swadeshi* leaders, through spinning and weaving demonstrations, exhibitions, and poster campaigns, created a new prestige for such indigenous symbols as the handloom, the spinning wheel, and the craftsman himself. However, the movement's rejection of British commerce was driven by a patriotic nationalism rather than a larger awareness by its elite leaders of the damaging effects of in-

Figure 9. Sketch of Indian craftsmen, wire
inlayers from Uttar Pradesh, *Indian Art at
Delhi,* 1903. Courtesy of UCLA Libraries.

dustrial society upon India's impoverished classes and castes. In hind-
sight, this motivation was also a key limitation of *swadeshi* ideology.[61]

Nevertheless, by the turn of the century, the figure of the Indian crafts-
man emerged from the metaphorical background of Rudolf Swoboda's
painting *A Peep at the Train* (see figure 2, page 20) and into the foreground
in rather prominent ways. The status of the Indian craftsman was not only
a central theme in the political and economic awakening that characterized
the visual culture of the *swadeshi* movement, but it was also a dominant
trope in the presentation of Indian art by the turn of the century, and a
major concern for Coomaraswamy and Havell, two of the first, and most
prominent, art critics in modern India. The official catalogue for the 1903
exhibition of Indian art in Delhi, for instance, contained numerous images

Figure 10. Sketch of Indian craftsmen, enamellers from Rajputana, *Indian Art at Delhi*, 1903. Courtesy of UCLA Libraries.

of the craftsman at work, all of them sketched with painstaking detail by Percy Brown, then director of the Art School in Lahore (see figures 9 and 10).[62] These images of the laboring bodies of craftsmen were later praised by Coomaraswamy for their depiction of the "traditional methods of instruction" and the "assurance of the craftsman's purpose and value" in his 1909 book titled *The Indian Craftsman*.[63]

The latter text, one of Coomaraswamy's earliest, was thoroughly preoccupied with the corrupting effects upon the Indian craftsman of the modernizing influences of European rule. Coomaraswamy believed that the fully trained craftsman possessed a richness in soul and spirit in addition to the skills of hand and eye. He argued for an "intrinsic religiousness" on the part of the craftsman,[64] not because the crafts necessarily had a religious function in India, but because the craftsman's position in the larger universe gave "expression to ideals of eternal beauty and unchanging laws" in the same manner as the flowers and trees in the natural world.[65] According to Coomaraswamy, the craftsman was the pure product of preindustrial life in India; his standards had been deeply degraded by the modernizing effects of the British in India. Moreover, it was the indispensable nature of his services, and the "security and hereditary character of his position," that made him an organic element in the national life.[66]

The leading critic and art reformer E. B. Havell similarly viewed the

craftsman as India's most valuable asset, "as essential to the progress of humanity as the development of mechanical science," and saw the products of his labor, which he called the "art of the masses," as the foundation of good living and a civilized life.[67] In an essay on the handloom, Havell further distinguished between the domestic craft practices of Indian women who were not dependent on spinning and weaving for subsistence and the impoverished condition of the village weaver, who stood "on a different footing" altogether.[68] For Havell, the latter group—hopeless, ignorant, despairing, and apathetic—were most in need of a plan for rehabilitation following the damaging effects of British rule. Through an injection of capital and educational reform at the national level, Havell believed that the crafts in India could ultimately be revived to sustain the ideals of beauty and love, and to "serve the highest aims of religion and life."[69]

Both Coomaraswamy and Havell thus linked the plight of the craftsman to a larger loss of artistic understanding in India, and connected the project of artisanal rehabilitation to a higher spiritual and ethical realm. For them, the craftsman was central to the problem of the creative and intellectual status of the country; his degraded condition reflected not only Britain's political power and material prosperity, but also the inability of India to attain its moral vision and spiritual destiny. In this sense, both men also saw a reciprocity between the craftsman and the nation-state: it was the artisan, Coomaraswamy wrote, who "most needed the help of our national idealism" and "whom we as a nation most need as members of our body politic."[70] By reviving the craftsman's hereditary skills, one could reduce the damage to his "physique and morale."[71] In this way the actual physical body of the craftsman—ruined, disfigured, and enslaved by colonialism—became a powerful metaphor in the work of these writers for the state of the national body itself.

GANDHI AS CRAFTSMAN

If the first phase of the nationalist "cult of the craftsman" emerged in the *swadeshi* campaign in Bengal and the aesthetic paradigms of Coomaraswamy and Havell, then the second phase—and the point of culmination—came with Gandhi's powerful appropriation of the whole craftsman semiotic. Indeed, the refashioning of one's body into the figure of a craftsman is an experience that Gandhi would seem to have shared with the ill-fated troupe brought by Liberty's to London in the second half of the nineteenth century. For Gandhi, of course, was not an artisan or a craftsman, in spite of photographer Margaret Bourke-

Figure 11. Gandhi and his spinning wheel, *Life* magazine, 1946. Margaret Bourke-White / Time and Life Pictures / Getty Images.

White's famous *Life* magazine photograph *The Weaver* (figure 11), nor was he from an Indian peasant background. Rather, he confessed in his autobiography that "I do not remember to have seen a handloom or a spinning wheel when in 1908 I described it in *Hind Swaraj* as the panacea for the growing pauperism of India. . . . Even in 1915, when I returned to India from South Africa, I had not actually seen a spinning wheel."[72] The problem was, Gandhi continued, "that all of us [at the Satyagraha Ashram] belonged either to the liberal professions or to business; not one of us was an artisan." Learning how to weave and spin, he acknowledged, "brought us a world of experience. It enabled us to know, from direct contact, the conditions of life among the weavers, the extent of their production . . . the way in which they were being made victims of fraud, and, lastly, their ever growing indebtedness."[73]

Historians concerned with Gandhi's *khadi* (homespun cloth) campaign have tended to downplay his unfamiliarity with the loom and emphasize instead his understanding of cloth as part of the "fabric of nationalism" and the freedom movement in India.[74] These scholars recognize the important symbolism of Gandhi's rejection of Western clothing, and the powerful identification with the peasant masses in India that his self-

presentation in *khadi* enabled. Other scholars have turned to the complex religious iconography of the image of Gandhi promoted in political posters and calendar lithographs of the time, suggesting that Gandhi's reliance on Hindu idioms—for example, his portrayal as Siva, the protector of India—was both a strength and a weakness of his politics. On the one hand, it consolidated his popularity among the masses and established his pan-Indian appeal; on the other it contributed to the growing distance between Gandhi and certain Muslim communities of South Asia.[75] Such analyses, however, have not dealt directly with the image of Gandhi *himself* as a craftsman, nor with the nexus of historical ideas about artisanship that gave specific meaning to Gandhi's political practices. By contrast, the historian Shahid Amin has argued—in his study of violence in the town of Chauri Chaura in 1922, events that led Gandhi to call off his all-India noncooperation campaign—that there was no single authoritative version of Gandhi among the Indian peasantry at this time.[76] Instead, the image of "the Mahatama" that registered in the peasant consciousness took form within preexisting patterns of popular Hindu beliefs and ritual behavior that often departed from those of nationalist leaders and the basic tenets of Gandhian philosophies of nonviolence and civil disobedience. In his study, Amin is thus concerned with the "polysemic nature of the Mahatma myth" and the "many-sided responses of the masses" to it, an approach that enables us to situate the image of "Gandhi as craftsman" alongside the image of Gandhi as a saint, deified by the peasant masses in India.[77]

Although the young Gandhi would not have seen the Liberty's exhibition at Battersea Park, which occurred two years before his arrival in London as a barrister student in 1888, he did attend other exhibitions like it, most notably the Paris world's fair of 1889, where he climbed the newly built Eiffel Tower two or three times, recalling in his autobiography the great "magnitude and variety" of the event.[78] That the ideas on display at this exhibition—in particular, the opposition between the modern, industrial West and the ancient, traditional life of the East—had a long-lasting impact on Gandhi is well established; so too is the influence of nineteenth- and twentieth-century thinkers like Maine, Ruskin, Dutt, and Coomaraswamy upon his cultural writings and political thought.[79] Through such authors, Gandhi recognized the qualities associated with the craftsman—the timeless purity of the Indian village, the dignity of artistic labor, the self-sufficient nature of preindustrial production, and the power of the creative act—and their strategic importance in the political field. By the early 1920s, Gandhi had both incor-

porated these qualities into his self-presentation and called upon the cit-
izens of India to aspire to similar ideals. However, if Gandhi's adoption
of the craftsman aesthetic assisted in bridging the gap between the elite
and the masses, an achievement that eluded the bourgeois proponents of
the *swadeshi* campaign as well as the leadership of the nationalist move-
ment in general, it also led to an anti-industrialism at odds with many of
his political peers.

With Gandhi, the figure of the indigenous craftsman, and the weaver
in particular, was transformed from an endangered species requiring
protection and revival into an icon of India's freedom and independence.
Yet Gandhi's reliance on these images and ideas, themselves derived
from the preservationist approach to India's "industrial arts" promoted
by Birdwood and others at the height of imperial rule, reveals more than
a simple historical irony at work. Indian nationalism of the Gandhian
sort rejected foreign domination, but it did so by asserting some of the
most naïve essentialisms of the colonial paradigms that preceded it: the
ancient purity of the Indian village, the timeless dignity of the indige-
nous craftsman, and the "infinite superiority of the Indian artisan," in
Coomaraswamy's terms, "both physically and spiritually" to the En-
glish factory worker in the West.[80] Thus, Indian nationalism, as Partha
Chatterjee has argued so effectively, although premised on an opposi-
tion to colonial rule, remained ultimately contained by the same domi-
nant conceptual frameworks that it repudiated.[81] In other words, in con-
sidering the "success" of Gandhi's mobilization of the craftsman, we
must recognize that the tensions and ambiguities within Gandhian ide-
ology also frame its historical limitations and the basic disjuncture be-
tween Gandhi's utopian ideals and the emerging realities of the new
nation-state.

CONCLUSION: THE CULT OF THE CRAFTSMAN

There is no doubt that the figure of the craftsman, and the forms of prein-
dustrial labor embodied within it, had a profound impact on aesthetic
expression in the modern era—from the influence of weaving on van
Gogh's painting, for example, to the powerful investment in handmade
products undertaken by William Morris and the Arts and Crafts move-
ment in Britain.[82] Artists and aesthetic movements throughout Europe in
the nineteenth century turned to models of preindustrial craftsmanship
in response to the degradation of labor in the factories and the growth
of the working classes in a period of rapid industrialization. In India,

however, the nexus of relationships between modernity and the crafts-man was further affected, indeed overdetermined, by the structures and effects of the colonial economy. The Indian craftsman was not only a powerful symbol of village life and its communities in the subcontinent; he was also a sign of economic underdevelopment and a symptom of capitalist exploitation in the colony. Variously held up as an ancient repository of hereditary skills, the key to an indigenous social and polit-ical economy, the cause of India's economic backwardness, and a sym-bol of the difference of the modern Indian nation, the idealized figure of the craftsman—homogenous, male, and aesthetically pure—emerged at the center of an enduring discourse that helped facilitate a connection be-tween urban society and the peasantry, even as it tended to eclipse other modern forms of social experience and responses to industrialization.

The "cult of the craftsman," and the fascination with preindustrial life that it sustained, was thus a body of convergent aesthetic, commercial, and anthropological ideas about artisanship that began with men as wide-ranging in their orientations as George Birdwood, Arthur Liberty, Karl Marx, and R. C. Dutt, and that acquired new form in the rhetoric of Indian nationalism by the early decades of the twentieth century. A preoccupation with the figure of the craftsman was not yet a feature of the "manufactures" discourse that prevailed in the first half of the nine-teenth century and dominated the displays of the Great Exhibition of 1851. By the 1880s, however, the craftsman had emerged at the center of popular imperial culture as a symbol of the damage to preindustrial society by the forces of modernization in India. This preservationist par-adigm was soon rearticulated within the wider context of nationalism in India, and transformed into an outright rejection of the socioeconomic politics of British rule. In the rhetoric of Gandhian traditionalism, in par-ticular, the cult of the craftsman was raised to new heights: by adopting the image and practices of the craftsman, Gandhi consolidated his com-mercial, political, and spiritual vision for the nation into a simple yet powerful physical form.

The heterogeneous discourses surrounding the craftsman—aesthetic, political, economic, and ethnographic—reconfigured in multiple ways over time, continue to exert a strong hold over the narrative possibilities for Indian crafts within urban societies today. The representation of the craftsman in public arenas still appears to ignite controversy and crises, from the folklife displays at the Festival of India to the living perform-ance of craft traditions at the National Crafts Museum in New Delhi. However, these two spectacles—hosted by Liberty's in 1885 and the

Smithsonian Institution in 1984–85—frame a hundred-year history of concern with Indian crafts. That history also involved decades of economic planning in post-Independent India, including the establishment of the All India Handicrafts Board in the 1950s and the parallel State Handicrafts Boards during the 1960s and '70s, in an attempt to generate a holistic infrastructure for the revival of craft traditions and to raise the quality of life of Indian craftsmen. These state-initiated schemes, concerned primarily with the relationship between consumer and craftsman, have involved the participation of various cooperatives and NGOs, and constitute perhaps another chapter in the story of production, promotion, perception, and display.

The dilemmas and legacies of craft in India were also a major concern in the post-Independence period for the modern artist K. G. Subramanyam, who, influenced as he was by Gandhian nationalism, subjected the relationship between "artist" and "artisan" to systematic interrogation through his writing, teaching, and artistic production.[83] Subramanyam's call for the modern artist to be part of India's "living tradition," to be "individual and innovative, without being an outsider," was partly an attempt to put to rest what he viewed as "the mechanical relay" of colonial stereotypes.[84] Similarly, his turn to the materials and techniques of India's folk art traditions, along with the modernist techniques and languages of Picasso, Dada, Pop, and, later, American abstract expressionism, was an acknowledgment of the continuous interaction between art historical traditions in an internationalist frame. Subramanyam's unwillingness to accept as immutable the idea of a cultural inheritance for the artist, and his vision of tradition as something that demanded revision and reassessment with each generation, offers a powerful counterpoint to the historical determinism of the "cult of the craftsman" framework. My account in the next chapter of forty-two men who were brought for a "living display of native artisans" at the Colonial and Indian Exhibition of 1886 in London will similarly suggest that the powerful ideologies determining the fate of Indian objects were not simply extended to bodies on display.

"To Visit the Queen"

On Display at the Colonial and Indian Exhibition of 1886

I am going to the abode of the gods.

An old man from Assam to his tribal
neighbors when leaving his mountain home
to be modeled for the Colonial and Indian
Exhibition of 1886

Everyone—rulers and ruled—had proper roles to play in the
colonial sociological theater. There were, however, groups
and categories of people whose practices threatened the
prescribed sociological order.

Bernard Cohn, *Colonialism and Its Forms of
Knowledge*, 1996

Pussy cat, pussy cat, where have you been?
I've been to London to visit the Queen.

Mother Goose nursery rhyme

The cover of a special supplement to *The Art Journal* showed what a vis-
itor facing south on the grounds of the Colonial and Indian Exhibition
would have seen during the summer of 1886: the exterior of a building
boasting a colossal colored map of the two hemispheres of the world on
which the possessions of the empire were prominently marked (figure 12).
Beneath the map appeared statistical tables displaying area, population,
and trade information about the colonies. Above the map were four
clocks proclaiming the simultaneous time in the colonial capitals of Cal-
cutta, Ottawa, Sydney, and Cape Town. Above those was a much larger

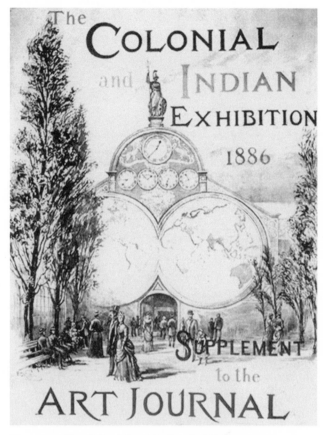

Figure 12. The Colonial and Indian Exhibition, 1886: cover of *The Art Journal*. Courtesy of Vassar College Libraries.

clock announcing the time in Greenwich, England. And above that, topping the whole structure, was a statue of the female figure of Britannia with her trident, extending upward into the treetops and overlooking the entire spectacle.

In contrast to the disorienting refractions produced by the glass and mirrors of the Crystal Palace in 1851, then, this image of 1886 reveals a more powerfully ordered vision of empire, and in particular exposes the way that knowledge was reorganized to underwrite colonial expansionism. For example, the "discovery" of zero longitude and the declaration of Greenwich mean time two years earlier had synchronized the world into a new global chronometry that had at its center the London borough of Greenwich. Developments in cartography and scientific mapping ex-

tended this authority across both time and space, and the rise of statistics would generate what Ian Hacking has called "an avalanche of printed numbers" to quantify and tabulate social phenomena into an irreducible system of coherent social facts.[1]

In relation to India, such expressions of British authority were by no means merely symbolic. The bloody Indian Mutiny of 1857 (known as the Rebellion in Indian historiography) had resulted in the dissolution of the East India Company and the implementation of a more powerful and direct Crown rule. The opening of the Suez Canal in 1869, converting, in Edward Said's terms, a "land barrier into a liquid artery," had dramatically reduced the distance between Britain and India, allowing an easier flow of people and goods.[2] In 1876, with the passage of Disraeli's Royal Titles Act, Queen Victoria had become "Empress of India," redefining both the monarch and the nation in fundamentally imperial terms. Yet, as Britain increased its power over India, so too did resistance to its power strengthen. Significantly, the first meeting of the Indian National Congress in Bombay, marking the beginnings of an organized nationalist movement in India, occurred only six months before the exhibition's opening. For some historians, the history of India as a modern nation-state thus also begins here, in 1886.[3]

In this chapter I turn to a specific historical example—the case of a living ethnological display of native artisans at the Colonial and Indian Exhibition in London—in order to further explicate the production of meaning within these changing historical conditions for cultural display. By reconstructing the journeys of several marginal Indian men inducted into the living display—prison inmates from Agra and a homeless Punjabi peasant in London—I show not only how "natives" were constituted by dominant discourses, but also how the historical subjects of ethnological display refused the terms of their representation. My aim is neither to recover the "lost voice" of the exhibited subject, nor to present a full account from the native's point of view: the very structure of the colonial archive does not allow for such an unmediated act of historical recovery.[4] Instead, I focus on reconstructing the multiple and intersecting contexts, the competing fields of power, and the complex acts of social management that constituted the events of 1886, while taking as a point of departure the subject's "awareness of his own world and his will to change it," however "feeble and tragically ineffective" this awareness may have been, given the particular historical circumstances and conditions of power.[5] In the case of 1886, as I will show, the Indian men on display were both caught within and constituted by a complex interplay between the local needs and institutions of London's inner city, the

administrative interests of the colonial bureaucracy, the class and caste hierarchies of Indian society, and the tensions created by the historical competition between nationalist and imperialist ideologies.

I am also not concerned in this chapter with the truth or falsity of the ethnological exhibit as a representation of Indian artisans. The recruitment of prison inmates and homeless Indian peasants in London by exhibition officials displaces any question of authenticity or purity within this particular cultural performance. Instead, I emphasize the place of travel in this history: I focus on the "journey in" to metropolitan space—the alternate "routes" through modernity—that constituted the conditions for the ethnological display.[6] Ironically, the Colonial and Indian Exhibition helped to define the idea of travel as a bourgeois, cosmopolitan, and worldly experience, even turning Thomas Cook, one of its highly visible official agents, into an icon of the modern travel industry. And yet this dominant narrative about travel did not apply to the men recruited for the living ethnological display. This was not simply because they were Indian subjects, since by the 1880s there were numerous Indian travelers in London—Indian princes, students training for professional lives or careers in the civil service, nationalist leaders, diplomats and statesmen—all generally part of an English-educated Indian elite, itself a product of the dynamics of rule in colonial society. Despite the visibility of elite Indian travelers, who often mingled with Britain's upper classes to become the "darlings of drawing rooms . . . and the heroes of newspapers," as the Viceroy Lord Curzon once complained,[7] the travel of poor Indians to London was, as I will show, a problem for the British and Indian elite alike.

In the final section of the chapter, I turn to the circumstances of a single individual, a Punjabi peasant called Tulsi Ram, who drove municipal and India Office authorities to distraction by his ceaseless demands to "meet the Queen." Traveling to London to seek justice for a local land dispute in Punjab, Tulsi Ram was repeatedly detained in the prisons and workhouses of London's East End before being inducted into the living display. I trace the movements of this Punjabi villager in the metropolis through an extensive trail of official records, including correspondence between officials at the India Office and anxious metropolitan authorities; prison, hospital, and workhouse proceedings; and police memos and court petitions. The movement of this subaltern body in the metropolis, I argue, created a crisis for the organization of space and identities through which the relations of colonizer to colonized were regulated, transforming the spectacle of the living exhibit into a highly contested cultural encounter. Against the dominant official account of the exhibi-

tion in the archive—one that effaces the will of the exhibited subject—I show how bodies on display have their own biographies, strategies, journeys, and petitions that refute their inscription as mere ethnic objects. By offering a detailed examination of this particular case, my aim is to expose the dynamics of objectification and defiance in the constitution of the so-called native, and to help make visible the processes by which "ethnological specimens" were historically produced.

VICTORIAN VIEWS

The Colonial and Indian Exhibition, which ran for six months in 1886, was an elaborate staging of imperial culture that corresponded with the celebration of Queen Victoria's jubilee.[8] The event opened on May 4 to trumpets and a royal procession, led by Queen Victoria and her son, that traveled through the Indian galleries of the South Kensington site past a re-created Indian Palace and an "Old London" street front on the way to the Royal Albert Hall. There, in front of a crowd of fourteen thousand people, the Queen sat for the opening ceremonies on an Indian throne of hammered gold, itself imperial war booty taken from the Maharajah Ranjit Singh during the capture of Lahore. Verses from an imperial ode written by the poet laureate, Alfred Tennyson, were recited, and the national anthem, "God Save the Queen," was sung by a royal choir with two verses in Sanskrit, translated for the occasion by professor Max Muller, the famous scholar of oriental languages at Oxford.[9]

The rise of Indology, the formal study of India, which Muller represented, had itself added to the public stock of images. By the time of the exhibition in 1886, Muller, a German who had arrived at Oxford in 1847 as a young man to lecture on the history of modern languages, had completed his six-volume translation of the *Rig-Veda*. His reputation had been further established with the publication of another massive project, *The Sacred Books of the East*, in which he edited the translations of several Eastern religious scriptures into some twenty-four volumes, an effort that took him almost twenty-five years. Muller's approach to ancient language and literature was in the service of a broader formulation, comparative philology, which sought to trace the evolution of religious and philosophical thought. "A comparative philologist without a knowledge of Sanskrit is like an astronomer without a knowledge of mathematics," he wrote.[10] The exhibition of 1886 certainly helped to popularize Muller's science of comparative philology and the burgeoning field of Sanskrit studies. Muller's Sanskrit version of "God Save the

Queen" was praised by one media account as a "musical novelty" that intrigued members of the choir, who expressed that they were generally charmed by "the linguistic difficulties of the ancient tongue."[11]

The purpose of the exhibition, the Prince of Wales stated in his opening address, was to "stimulate commerce and strengthen the bonds of union now existing in every portion of her Majesty's Empire."[12] To be sure, this ambitious showcase offered a far more complex image of India than that portrayed by the eclectic artifacts and raw materials presented at the Great Exhibition of 1851.[13] The Colonial and Indian Exhibition's multiple buildings, pavilions, courtyards, and gardens, for instance, occupied five times as much space as the exhibits of India at the Crystal Palace in Hyde Park (figures 13 and 14). Moreover, the introduction of electricity meant that artificial lighting could be manipulated to alter the visual effects of display. Outdoor illuminations of gardens and fountains turned the site into a spectacle both day and night, while certain interior spaces were more dimly lit, creating darkened chambers of oriental fantasy.[14] London's new underground subway led to the entrance of the Indian exhibits, and 2.7 million visitors to the exhibition—more than half of the total attendees—were reported to have come through this entrance alone. The novelty of shuttling to the event by underground created the excitement of a journey to India itself—a fact that the travel firm of Thomas Cook and Sons, promoting its first season of tours to India, exploited in their booth on the exhibition site.

By 1886, then, the wide-ranging displays of the Indian exhibits created for the visitor a carefully constructed general *experience* of India, supported by detailed scientific knowledge, the bureaucracies of the imperial state, and changing transportation and visual technologies. What defined this experience for the majority of visitors was an idealized return to a premodern past. "At a single step," according to the newspaper *The Times* in London, "the visitor is carried from the wild, mad whirl of the individual competitive struggle for existence to which civilization has been reduced in the ever changing West, into the stately splendor of that unchanging antique life of the East, the tradition of which has been preserved in pristine purity only in India."[15]

The Colonial and Indian Exhibition thus staged for its visitors an elaborate encounter with a timeless and traditional India from within the "wild, mad whirl" of industrial modernity. At the center of such an image of India—as noted in the previous chapters—was an idealized notion of the village community, itself the product of the developing study of the Indian village represented by the classic anthropology of Sir Henry Maine. Such a conception of a tradition-bound India, whose

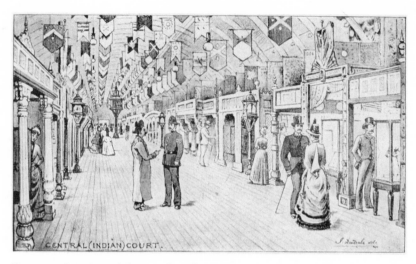

Figure 13. Interior exhibits, Colonial and Indian Exhibition, 1886. Courtesy of Yale Center for British Art.

heartbeat was the village community, also dominated the perception of India by late Victorian art critics, reformers, and entrepreneurs like William Morris, John Ruskin, Arthur Liberty, and George Birdwood. For such men, India provided a nostalgic picture of a precapitalist community characterized by simple craftsmanship that, above all, contrasted sharply with Britain's own industrial realities. Within the climate of disillusionment with industrialization that marked the final quarter of the nineteenth century, India became increasingly important to Victorians as an ideal model for traditional craft skills.

What was on display at the native artisans exhibit at the Colonial Exhibition was thus a reified figure called "the Indian craftsman," a figure that embodied the timelessness of the Indian village and thus captured the essence of India itself. The external features of his body—his dress and adornment, his racial markings, his movements and gestures—were all celebrated as part of an enduring tradition of artisanship that was somehow perfect and historically pure. It was the "serenity and dignity of his life and work," according to George Birdwood in his contribution to the exhibition catalogue, that made him meaningful to Victorian spectators.[16] And yet the disastrous attempt by Liberty's Department Store to re-create an Indian village in Battersea Park had resulted in a telling controversy over the exhibition of humans and foregrounded the idea of failure in the public perception of imperial display. If one thing was clear

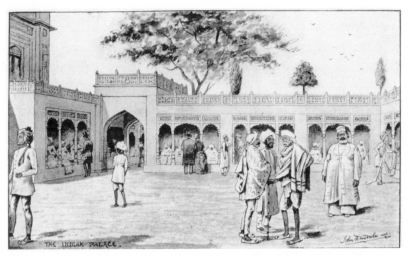

Figure 14. Courtyard of the Indian Palace, Colonial and Indian Exhibition, 1886. Courtesy of Yale Center for British Art.

after the Liberty's debacle, as the *Indian Mirror* observed, it was that "a fresh experiment of an 'Indian Village' in England will heat up few recruits in India."[17]

THE NATIVE ARTISANS DISPLAY

The name of native number sixteen in the Indian artisans display at the Colonial and Indian Exhibition was Tulsi Ram. He was identified as a sweetmeat maker from Agra, age forty-two, and exhibited sitting in the hall of the Indian Palace, where he worked daily throughout the exhibition. With Tulsi Ram there were thirty-three other Indian natives on display. They were all men, identified as weavers, coppersmiths, seal engravers, ivory miniature painters, calico printers, trinket makers, goldsmiths, potters, stone-carvers, wood-carvers, silversmiths, and clay figure makers. The eldest was Bakshiram, the potter, at 102 years old. The youngest were the carpet weavers, Ramphal and Ramlall, both children only nine years old. Two more men, Harji and Dosa, worked as bullock drivers, driving a Durbar carriage around the site outside the Indian Palace. Seven others, identified as "Bombay servants," worked in an outdoor café serving Indian tea as a refreshment to the crowds throughout the summer.

Tulsi Ram's group, the native artisans in the Indian Palace, were cel-

ebrated as "a curiously pretty spectacle of oriental life."[18] Prince Albert, who visited the men with Queen Victoria during the opening ceremonies, declared "how pleased he [was] to see them in England," which was apparently translated to them by Dr. John William Tyler, the superintendent of the Central Jail in Agra, who was personally in charge of the Indian natives. With the exception of Tulsi Ram, most of the craftsmen were inmates from the Agra Jail, and I will turn to this context of selection and recruitment in more detail shortly.

Early in July the Queen invited the men, whom the English press referred to as "her more humble Native subjects," to Windsor Castle for a luncheon with other natives appearing at the exhibition from Ceylon, Hong Kong, Cyprus, British Guiana, Australia, and the Cape of Good Hope.[19] Accompanied by Dr. Tyler, they proceeded in carriages through the high street of Windsor, thronged by "an eager but well-behaved crowd" of those who wished to "shake hands with the dusky visitors from the colonies."[20] In a reception in the Waterloo Gallery, described by the British press in India as both a "strange event" and a "striking spectacle," the "Indians salaam[ed] and present[ed]" the Queen with gifts, which she ceremoniously "touche[d] and return[ed]."[21] Dr. Tyler translated a statement from the group, a "faithful yet humble paraphrase," which began with the sentence, "We are thy children, O mother!" and was later published in English papers as "What the Indians Thought of the Queen."[22] "Living long in the minds of the natives" who met the Empress, "the scene on the green Windsor slopes will never be forgotten," claimed the press. "Illuminated by the rich eastern imagination," the moment will "be described in many an Indian bazaar and many an African village, and the story of that great day will be handed down to all future generations" in the colonies.[23]

One account of this story was in fact handed down by T. N. Mukharji, an English-educated, upper-class Bengali Brahmin, who was one of three Indians hired by the British government to assist in the planning of the Colonial and Indian Exhibition. "As each carriage rolled towards the Castle," wrote Mukharji, and "cheer after cheer was sent forth . . . we Indians as usual got the most hearty reception."[24] After signing the guest book inside the castle, he recounted, we were "presented to her [the Queen] by the Prince of Wales. . . . As the usher called out the name of each guest . . . we made a profound bow and as is usual in such cases each passed on, and was succeeded by another."[25] "Here again," Mukharji wrote, "I noticed the same specially kind look with which Her Majesty always viewed her Indian subjects." The Queen's

preference for Indians was "very noticeable" and was but one of "many other instances" that Mukharji recorded in his book, *A Visit to Europe*, that demonstrated the special character of "her Majesty's affection for her Indian children."[26] *This isn't an adoption agency.*

Tulsi Ram, on the other hand, had not been invited to Windsor Castle on that "great day." In the ten months preceding the Colonial and Indian Exhibition, Tulsi Ram, a humble peasant from Punjab, had been arrested well over a dozen times for vagrancy outside the Queen's residence at Windsor. Traveling to London in 1885 to seek justice for a local land dispute in his village, Tulsi Ram was repeatedly detained in the prisons and workhouses of London's East End. For anxious bureaucrats at the India Office in Whitehall, Tulsi Ram symbolized the "problem of destitute Indians in London," a problem they saw as both a financial liability and as an embarrassing comment on their governance. By the summer of 1886 the man known to exasperated East End officials as "the old Hindoo who wishes to see the Queen" was recreated, for the benefit of Western audiences, into native sixteen, a sweetmeat maker from Agra.

[margin note: arrest]

REMAPPING URBAN AND IMPERIAL SPACE

If the West End of the city, the site of national monuments and government offices, was a logical location for the Colonial and Indian Exhibition, then a very different kind of imperial spectacle was being staged simultaneously in London's East End.[27] The East End in the 1880s was the notorious neighborhood of the urban poor. Its dilapidated landscape of docks, railway terminals, jails, missions, and workhouses was the scene of severe overcrowding and an acute housing crisis. The East India Company Docks, constructed in the early years of the nineteenth century and through which Indian goods and passengers arrived in London, had themselves contributed to the widespread homelessness that characterized this part of the city. Increasingly, the alternating pessimism and hysteria that had characterized middle-class attitudes toward the poor during the 1860s and 1870s became a far-reaching set of social anxieties; as one historian has suggested, by the 1880s the predominant reaction to poverty "was not so much guilt as fear."[28] The East End was increasingly conceived by middle- and upper-class Londoners as a world apart. In the eyes of Victorian social investigators and analysts, it was a distinct landscape home to a largely unintelligible subculture that required interpretation: its inhabitants were a separate "race."

London in the 1880s was thus mapped in profoundly imperial terms, with the West End symbolizing the triumph of empire while the East End became its foreign, dark, and forbidding other. In fact, the language of colonial expansion and exploration became *the* terminology through which urban social divisions were conceived.[29] In his study of 1861, *London Labour and the London Poor,* Henry Mayhew was one of the first to observe that entering the city's East End was like traveling "in the undiscovered country of the poor."[30] For George Sims, writing in 1883, the locus of the urban poor was a racialized "region which lies at our own doors" like "a dark continent that is within easy walking distance of the General Post Office."[31] Similarly, Charles Booth, who published the first volume to his massive study *Life and Labor of the People of London* in 1889 (it would be expanded to seventeen volumes by 1903), concluded that the life of the East End poor was "the life of savages."[32] The inhabitants of London's East End were like a wretched separate race, "a colony of heathens and savages in the heart of our capital," according to William Booth, the founder of the Salvation Army.[33] For Booth, the best model for understanding the poor was Henry Stanley's *In Darkest Africa* (1890), as even the title of Booth's book of the same year, *In Darkest England and the Way Out* (1890), suggests.

Such a discourse functioned to foreground colonial experience in the metropolis by mapping the city's social divisions within the terms of imperial geography. But the language of geographic and social distance in the metropole did not simply replicate the experience of racial and cultural segregation in the colonies. While strategies of separation in colonial spaces reflected deep-seated racial and sexual anxieties and a constant fear of the danger of "mixing,"[34] the fears that characterized metropolitan space were more fundamentally bound up with the stability of the nation. London's urban social ills, epitomized by its East End geography, were seen as a threat to the national body itself. For Charles Masterman, writing in 1901, the phenomenon of urban degeneration meant a "lowering of the vitality of the Imperial Race."[35] The poor, especially foreigners, were feared as the bearers of contagion and pollution. Because Jews escaping Eastern Europe during the early 1880s had provided the latest influx of foreign poor to the East End, anti-Semitic hostility was particularly strong. Destitute Jews, or "foreigners with dark complexions" more generally, were seen as a menace to the national community, preventing the Darwinian rise of British society to an ever-greater level of fitness and health.

The local crises of urban London in the 1880s thus both reflected and

intersected with a growing anxiety about the stability of empire. In India, as already noted, the rise of organized nationalism, symbolized by the first meeting of the Indian National Congress in 1885, had created a degree of uncertainty about the future of the country's rule, an uncertainty that was at its highest since the Indian Rebellion in 1857. Moreover, Indians themselves were increasingly divided by their own conflicting self-interests within the hierarchies and structures of colonial society.[36] Many members of the English-educated middle classes, such as T. N. Mukharji, who was hired to assist with the Colonial and Indian Exhibition, feared that the end of empire might also mean the end of the social advantages they held from their proximity to the British. If distancing oneself from the lower rungs of the colonial hierarchy was an important strategy in India, it became both more urgent and more complicated within the racism and antialien sentiment that pervaded Victorian London. A letter to the British newspaper *The Times* by a self-identified Indian gentleman in London encapsulated a typical response: he was surprised upon arriving from India to see "several Indian beggars" in the streets of London. They were, he wrote, "a great annoyance to the public, but moreso to the Indian gentlemen who visit England."[37] Arguably, given the racism of the imperial city, members of the Indian upper classes who visited London had more at stake in separating themselves from their lower-class countrymen than they did at home in the colonial society of India.

SELECTION AND RECRUITMENT: THE AGRA JAIL

Because of the botched Liberty's department store exhibit, the issue of recruiting natives was a delicate matter for organizers of the Colonial and Indian Exhibition as they planned the native artisans display for Queen Victoria's jubilee celebration later that summer. In spite of the negative publicity generated by Liberty's, the Royal Commission maintained an "earnest desire to have a number of Indian artisans carrying on their various trades and callings" inside the Indian Palace. Their strategy was to hire a private shipping company, Messrs. Henry S. King and Company, to bring thirty-one "skilled workmen" from India for the event. As official agents to the Royal Commission, the company was to be responsible for selecting the men, for making their travel arrangements, and for covering the cost of "transport, pay, and maintenance" for the group. One general difficulty, they noted, lay in how to "reproduce under an English sky" the features of life in an Indian city. "In selecting the men,"

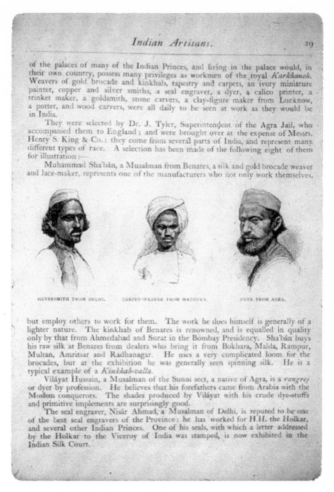

Indian Artisans. 29

of the palaces of many of the Indian Princes, and living in the palace would, in their own country, possess many privileges as workmen of the royal *Karkhaneh.* Weavers of gold brocade and kinkhab, tapestry and carpets, an ivory miniature painter, copper and silver smiths, a seal engraver, a dyer, a calico printer, a trinket maker, a goldsmith, stone carvers, a clay-figure maker from Lucknow, a potter, and wood carvers, were all daily to be seen at work as they would be in India.

They were selected by Dr. J. Tyler, Superintendent of the Agra Jail, who accompanied them to England; and were brought over at the expense of Messrs. Henry S. King & Co.; they come from several parts of India, and represent many different types of race. A selection has been made of the following eight of them for illustration:—

Muhammad Sha'bán, a Musalman from Benares, a silk and gold brocade weaver and lace-maker, represents one of the manufacturers who not only work themselves,

SILVERSMITH FROM DELHI. CARPET-WEAVER FROM MATHURA. DYER FROM AGRA.

but employ others to work for them. The work he does himself is generally of a lighter nature. The kinkhab of Benares is renowned, and is equalled in quality only by that from Ahmedabad and Surat in the Bombay Presidency. Sha'bán buys his raw silk at Benares from dealers who bring it from Bokhara, Malda, Rampur, Multan, Amritsar and Radhanagar. He uses a very complicated loom for the brocades, but at the exhibition he was generally seen spinning silk. He is a typical example of a *Kinkhab-walla.*

Vilâyat Hussain, a Musalman of the Sunai sect, a native of Agra, is a *rangrej* or dyer by profession. He believes that his forefathers came from Arabia with the Moslem conquerors. The shades produced by Vilâyat with his crude dye-stuffs and primitive implements are surprisingly good.

The seal engraver, Nisâr Ahmad, a Musalman of Delhi, is reputed to be one of the best seal engravers of the Province: he has worked for H.H. the Holkar, and several other Indian Princes. One of his seals, with which a letter addressed by the Holkar to the Viceroy of India was stamped, is now exhibited in the Indian Silk Court.

Figure 15. "Indian Artisans," from exhibition guide, 1886. Courtesy of Vassar College Libraries.

the firm reported, "our first consideration was to include not only as many trades as possible, but such as were most picturesque, and most likely therefore to prove interesting to the public."[38]

In fact, the thirty-one skilled workmen (see figure 15) the firm selected, for reasons that I will elaborate further, were all inmates at the Central Jail in Agra. The shipping company had actually subcontracted the task of recruitment to Dr. John William Tyler, the superintendent of the Agra Jail. The plan was that all of the Indians, accompanied by Dr.

Tyler, would travel together from Bombay. They would receive a wage, half paid to them in advance and half left with the district magistrates until their return.[39] It had been carefully stipulated that they "should not be absent more than six months," but the Royal Commission would later "urgently request" a one-month extension to the six-month agreement. Henry S. King and Company reported that this was arranged with the men, "though with considerable difficulty, as they were extremely anxious to return to their families."[40]

The Indians arrived in London with Dr. Tyler on April 20, two weeks prior to the opening of the exhibition. They were "at once installed in the quarters provided for them," in an area near the exhibition site known as the Compound, which housed all the other natives imported from the colonies. The Compound was a space that contained and segregated the natives from the rest of urban society, although it was celebrated in the media as a place in which the "great diversity" of her Majesty's foreign subjects could be seen. "On no previous occasion," wrote one observer, "have so many different representatives been gathered together . . . Hindus, Muhammedans, Buddhists, Red Indians from British Guiana, Cypriots, Malays, Kafirs and Bushmen from the Cape."[41] Henry S. King and Company would bill the Colonial and Indian Exhibition about eleven hundred pounds sterling for the total cost of the Indians' maintenance, which included "food, fire, washing, and medical attendance" for the entire duration of their stay.[42] The Royal Commission for the exhibition reported that no serious case of illness or misbehavior occurred. It praised the Indians for their good health and behavior, in spite of the "somewhat trying circumstances."[43]

Tyler received enormous publicity for his connection to the Indians. Trained as a doctor at the Medical College in Calcutta, Tyler had joined the Indian Medical Department in 1863, but the bulk of his career in India had involved work with prisons—with the policing and punishment of colonial subjects—which secured the confidence of the exhibition organizers. As a result of the exhibition he would meet Queen Victoria on more than one occasion, and he enjoyed the media's depiction of him as "the distinguished Dr. Tyler." He was also promoted to inspector-general of prisons in Oudh and the North-West Provinces, a post he served from 1890 until his retirement. Eventually he was knighted, changing his title from "Doctor" to the more prestigious "Sir" John William Tyler. Such a knighthood, as historians have noted, was often bestowed upon British officials in India in recognition of the highest levels of achievement in their administrative careers.[44]

Exhibition officials praised the collaboration between the firm of Henry S. King and Company and the superintendent of the Agra Jail, which had brought the Indians to London. Although the firm was responsible for the men's travel and maintenance expenses, Dr. Tyler was in charge of their "comfort and well-being," of accompanying them from Agra to London, and of supervising them while they were in the metropolis. The media represented the superintendent's involvement as an act of humanity rather than one of power; he became an escort, a translator, and even a friend to the Indians, despite the realities of their warden-inmate relationship. At the same time, Dr. Tyler's professional training reassured the public that proper discipline would be exercised in the event of any misbehavior. He became something of a hero during the course of the exhibition, and the group would become known as "Dr. Tyler's artisans." To Dr. Tyler, *The Art Journal* stated, "the public are indebted" for the success of the living display.[45]

While the decision to use inmates for the exhibit allowed for stiff social control of the group while in London, it also reflected several assumptions about criminality in India and the reform practices of prisons in the colonial context. For instance, the reforming of India's "criminal castes and tribes," that is, entire populations whom the British believed to be predisposed to crime, required transforming the totality of the group's character, behavior, dress, and personal grooming. Training so-called "criminal populations" in skills like pottery, weaving, carpet making, and so on became a common method of instilling in them the moral value of hard work, while reconstituting formerly "unruly groups" into disciplined and law-abiding bodies.[46] As part of the reform process, inmates were often inducted under supervision into factories, workshops, and industrial schools. External markets were also established for the sale of the leatherwork, silk products, carpets, and other commodities produced by such criminal reform programs. As inmates, then, the men recruited for the display would possess certain skills of craft production, although those skills, ironically, were likely to have been learned through the industrializing processes of prison reform rather than through the ancient, timeless practices of the village. Moreover, under Dr. Tyler's "supervision," they could be forced to cooperate and to perform a repetitive task day after day. Further, as men already marginalized in colonial society, they were unlikely to generate the kind of nationalist public attention that occurred with the earlier troupe of performers for Liberty's.

ON DISPLAY: THE VIEW FROM ABOVE—
T. N. MUKHARJI'S EXHIBITION ACCOUNT

The native artisans display at the exhibition was as successful and seemingly authentic as the Liberty's exhibit was not. "The other day I paid my first visit to the Colonial and Indian Exhibition and . . . walked up the long gallery containing the life-size models of the different Indian nationalities," wrote an Indian traveler in London whose account was published in *The Indian Mirror*. In the Indian Palace, he commented, "I watched the two Punjabi carpenters hammering away, heedless of the crowd of people looking at their work. Squatting on small rugs barefooted, they are making a fancy door panel. . . . I go next to the Benares man, robed in a glittering 'chapkan,' with the gorgeous kinkhabs and other rich dress materials spread before him. . . . On hearing his native speech from me, his swarthy face brightens up with a recognizing smile. We salaam each other and remain for a little time in conversation."[47] Threading his way through "the masses of curious people who besiege this Indian Court to another workshop," the observer stated that "it reminds one of the bazaars of India; in fact the whole Indian Court gives a living representation of the daily working life of Indian artisans."[48]

To the throngs of spectators who came to view the display, the native artisans exhibit was by far the most compelling and "curiously pretty spectacle" featured at the Colonial and Indian Exhibition. According to the Indian visitor quoted above, the Indians sat "brave and dignified and motionless as statues." Bakshiram, the 102-year-old potter, "[did] not look about at all" nor talk to anyone, but remained focused solely on his clay. On "the table before him [were] models" he had produced "of a yogi, a Brahman, a Bania and others," all "exact copies of their originals." Another man could be seen hammering sheet copper into a variety of vessels. Most viewers, the Indian visitor noted, "do not see their work, but only look at them and their movements," while others, he observed with concern, "seem to look upon them as animals."[49]

For the educated, upper-caste Bengali T. N. Mukharji, being associated with the craftsmen in the display was a source of profound discomfort. As noted earlier, Mukharji's nine-month stay in London was the subject of his travelogue, *A Visit to Europe* (1889). There Mukharji reveals that despite his role at the exhibition (described as "planning and other public duties"), he was not housed with the group of natives in the Compound. Instead, he stayed at the Museum Hotel in Bloomsbury, "not exceptionally good," in his estimation, since it was meant for

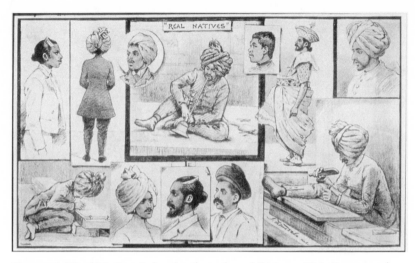

Figure 16. "Real Natives," sketches from the exhibition, 1886. Courtesy of
Yale Center for British Art.

"traders and middle-class country people."[50] This allowed him, how-
ever, to experience the city, "to seek education and enlightenment at the
very fountain-head of modern civilization."[51] London, he wrote, is "the
center of the earth, the heart which supplies the life-blood to the com-
merce of the world."[52] And he was grateful to his British friends, espe-
cially George Birdwood, Max Muller, and Mr. Fitzgerald at the India
Office, for the kindness they showed to him while visiting their country.

In his book Mukharji reveals himself as a loyal supporter of empire
who believed in "the mutual benefits between India and Britain" and op-
posed the campaign for Irish home rule. He also states that he was not
prepared for the spectacle created by his presence at the exhibition; al-
though Mukharji was not part of the native display, he found he was
equally subjected to the gaze of its viewers. "We simply wondered why
there should be any excitement at all over such a small matter [our pres-
ence]. We gradually came to know better."[53] "A dense crowd," he ex-
plained, "always stood there looking at our men as they wove the gold
brocade, sang the patterns of the carpet and printed the calico with the
hand. . . . We were very interesting beings no doubt, so were the Zulus
before us, and so is the Sioux chief at the present time. . . . We were
pierced through and through by stares from eyes of all colors—green,
gray, blue and black—and every movement and act of ours, walking, sit-
ting, eating, reading, received its full share of 'O, I never!' "[54]

Mukharji shifts from describing the display of "our men" to using the collective "we" in his account. This shift communicates his discomfort at being subjected to the same "piercing stares" as the men who performed in the living display. What he called the gap "between our estimate of ourselves and the estimate which others form of us" was, at times, a philosophical problem "applicable to all nations." At other times, however, he found it "more refreshing than a glass of port wine."[55] Once, Mukharji tells us, he was reading a newspaper at a restaurant at the exhibition when he became "suddenly aware that he was being looked at." A man and his daughter were whispering about him and eventually approached his table. "The young lady talked with a vivacity which I did not expect," he wrote. "She was delighted with everything I said, expressed her astonishment at my knowledge of English, and complimented me for the performance of the band brought from my country," actually a West Indian band composed of "Negroes and Mulattos."[56] The misplaced compliment, he said, "made me wince a little, but nevertheless I went on chattering for a quarter of an hour" and furnished her with sufficient means to "brag about seeing and talking to a genuine Blackie."[57] In other instances Mukharji was more critical of the racism of the exhibition visitors, a cruelty, he wrote, that only a European is capable of. "Would they discuss us so freely," he asked bitterly, "if they knew that we understood their language?"[58]

Mukharji's account reflects the class anxieties of the elite colonial traveler in London, who felt uncomfortable sharing the category "native" or "blackie" with the indigenous lower classes. But it also reveals a unique strategy that enabled his escape from the objectifying processes of the "piercing stares": he transformed the exhibition into a space where "Europe," too, could be observed. "Of considerable interest in the Indian Bazaar," he wrote, were the "*natives of England* . . . [the] men, women and children [who] flocked from all parts of the Kingdom."[59] Each day thousands of viewers looked upon the Indian men with "anxious inquisitive scrutiny," and the peculiar contortion of Mukharji's own position was dramatized by his preferred location at the display: to stand, for hours, "behind these people to hear the remarks that fell from their lips."[60]

TO VISIT THE QUEEN: THE CASE OF TULSI RAM

In contrast to Mukharji's firsthand account is the perspective on the living exhibit provided by the trail of correspondence between urban officials in London's East End and the Home Office of the Indian Govern-

ment regarding the "problem" of Tulsi Ram. On February 25, 1886, the India Office headquarters in Whitehall received an anxious letter from Fred E. Hillary at the Union Workhouse in Leytonstone, indicating that a native of India named Tulsi Ram had been admitted to the workhouse. "The man," he wrote, "is a great anxiety to the Workhouse Officials as his habits are extremely eccentric." The staff, he explained, did not know what to do; they had tried to persuade him to return to India, "but he still declines." Because the man reiterated continually that he had been "badly treated," they were now desperately seeking the advice of the India Office.[61] A few days later the India Office replied: the man, Tulsi Ram, "to whom you refer has been several times in different workhouses in London and in jail as a vagrant." They "cannot interfere, nor can they advise" in this case. It was beyond the control of the India Office.[62]

Less than a month later, a similar letter arrived from the Whitechapel Infirmary in the heart of London's East End. The Whitechapel neighborhood was especially notorious for its degraded and "immoral" landscape, and would two years later provide the sensational setting for five of the six brutal murders of prostitutes by Jack the Ripper.[63] Tulsi Ram had been admitted to the infirmary there because of his possible mental disturbance. The letter, dated March 15, 1886, was from a sympathetic male nurse "who was able to speak to the poor man in Hindoostani."[64] According to him, Tulsi Ram showed "no symptoms whatever of unsoundness of mind," but was "under the strong conviction" that he had been cheated. He repeatedly referred to a grievance in India, a story "consistently adhered to throughout." He also refused to return to India until his grievances had been redressed. Within five days the India Office responded: "The case of Tulsi Ram is a judicial one, and has already been before the court of appeal. . . . it is impossible for the Secretary of State or the Executive Government in India to interfere in the matter."[65]

Within three weeks another letter arrived at the India Office requesting instructions about "the case of the Hindoo, Tulsi Ram." This time it was from the Commissioner of Police at Whitehall, Charles Warren, who had charged Tulsi Ram with vagrancy for "once again visiting Windsor to see Her Majesty." "He is an elderly man," he wrote, "by caste a Khetis Brahman, a native of village Lusara, district Jullundhar, Punjab. He complains that some *Zamindar* cheated him of his land, that he applied to the courts, but that all the judges decided his case against him. . . . He came to England eleven months ago to get redress and see the Queen. He is well known in every Police Court in the metropolis, as he has been frequently in custody for causing obstruction."[66]

By early April 1886, officials at the India Office began to mark such memos regarding Tulsi Ram "Immediate." They recognized that "the movements in this country of the native in question . . . render it quite [an] exceptional" case.[67] They conceded that if Tulsi Ram could be "induced by the Police" to consent to return to India, then the Home Office would arrange for the payment. A week earlier, they had sent a telegram to the administration in Allahabad to enquire into his alleged grievances. The telegram read, "Native calling himself Tulsi Ram, Lusara village, Jullundhar District, asserts property forcibly taken by Raja Ram four years ago; appeal, Chief Court Lahore, dismissed. Believed here story fabrication, and that he is escaped convict. Please inquire, and telegraph anything known about him."[68]

The reply from India was quickly received. The lieutenant governor of Punjab had established that Tulsi Ram's story was true. In a return telegram, it was confirmed that Tulsi Ram did file a suit against another man in his village, Raja Ram, approximately five years earlier. The case, the telegram reiterated, was appealed in Lahore and "given against him." "He is now said to be in London," came the reply, "doubtless in hopes of getting reversal of the order. No reason to suspect him to be an escaped convict."[69]

With the authentication of Tulsi Ram's story, the Home Office of the Indian Government determined that it had a "problem" on its hands. More generally, Tulsi Ram's case revived a longstanding unresolved issue for the imperial administration: the problem of pauper foreigners or destitute Indians in London. "The question is rather a delicate one," according to an India Office memo.[70] "Great hardship is really entailed on an Indian pauper who has to remain indefinitely in the workhouses, where his language is not understood . . . where the food is unsuitable to his caste prejudices. On the other hand the presence of such paupers in workhouses interferes with the due enforcement of discipline and is a source of annoyance and inconvenience to the authorities."[71] More importantly, urban officials have always "resented and resisted . . . this class, and have attempted to throw the burden on India." The subject of "such people," the administration concluded, "is growing in importance as the numbers are increasing and will probably increase still more rapidly every year."[72]

By the 1880s the vexed question of "such people," or, more precisely, the awkward presence of subaltern colonial figures among London's urban poor, already carried with it substantial historical baggage. The question of responsibility for homeless Indians in London was first raised in relation to *lascars,* Indian sailors hired by the East India Com-

pany to work on its ships as cheap labor, and again with *ayahs,* female domestic servants. Although the system of indentured labor that provided Indian bodies as workers to various parts of the British Empire like Ceylon, Burma, South Africa, Fiji, and Trinidad did not extend to Britain itself, by the 1840s there were about three thousand *lascars* arriving in London on East India Company ships each year.[73] Commonly mistreated and generally despised, many *lascars* were housed in places unfit for humans; others were robbed, abandoned, or abused; and others still became ill lying in hospitals or workhouses. Hundreds of servants or *ayahs,* either in flight from their masters or abandoned, similarly ended up in the workhouses, prisons, and hospitals of London's East End. By the middle of the century, Christian concern for the "wretchedness" of their lives led to the establishment of the Strangers' Home for Asiatics, Africans, South Sea Islanders and Others Residing in the Metropolis, and later, in the 1880s, a female shelter called the Ayah's Home. The former, a home for sailors, was opened in the East End in 1857 and run by the missionary Joseph Salter.

In his two books on the subject, *The Asiatic in England* (1873) and *The East in the West* (1894), Joseph Salter reflected on his career as a missionary among foreign "heathens in our great Christian metropolis."[74] It was necessary to establish the Strangers' Home, he recalled, because "the habits of strangers are so different from those of our own countrymen."[75] His work had been more difficult, he claimed, than that of the missionary in India. "There," he reasoned, a missionary was "sent to tell of eternal life and of heaven." But in London, Indians were "left in their heathenism, unsought after, uncared for—forming plague spots of Oriental vice."[76]

In spite of the fundamentalist zeal that defined Salter's urban missionary career, he was committed to helping colonial subjects in the city, largely because the Indian government was not.[77] The East India Company had not wanted to use their profits to provide relief for abused or abandoned Indian sailors or servants, and this ambivalence was basically extended into official government policy after the Mutiny in 1857. According to a revised emigration act in 1869, "England is not a place to which emigration from British India is lawful."[78] While it was "a punishable offense" to assist any "Native of India" in emigrating to England—the word "emigrate" here defined as "departure from India for the purpose of laboring for hire"—an exception was clearly made for sailors and menial servants. As a result, during the 1860s and '70s, according to one official, "upwards of sixteen hundred destitute natives of

the East—nine-tenths of whom were natives of India," were sheltered in various London institutions.[79] The only strategy that attempted to address their plight was the institution of a security deposit: any European bringing an Indian to England was required to leave a deposit in India for the return passage of the Indian subject. The European employer would receive their deposit back when the "body of the native" returned to India. The amount began at one hundred pounds sterling, but was reduced to fifty pounds in 1840. However, the deposit system lapsed over the years, and the last deposit was recorded in 1844.[80]

By the 1880s reports about *ayahs* and *lascars* were joined by accounts of impoverished performers, such as the group brought by Liberty's for the Indian Village at Battersea Park discussed in the previous chapter or the case of a group of five Punjabis and their performing bear. Joseph Salter himself wrote to the India Office regarding the latter: "Sir, there are five Punjabees in London in very distressed circumstances. They came here with a performing bear with which they hoped to realize a fair income, but for want of the English language and other obstacles they have failed altogether and are now huddled together in an empty house. . . . Is it possible that the council for India will . . . help these men out of their perilous position?"[81]

The India Office, as usual, declined all responsibility. "The five Punjabees are trying to sell their bear and if they succeed they will try to regain admittance to our home," wrote a staff member to Joseph Salter in early December.[82] Will the India Office then "pay their food and lodging if we take them in?" the staff member requested. The government's response was unchanging. A memo issued on Christmas Eve replied, "Dear Sir, I am afraid that I cannot be of any assistance to you in the matter referred to in your letter. . . . this Department will not be responsible for any expense incurred."[83]

THE PROBLEM OF THE PETITIONER CLASS

If the majority of destitute Indians in London were employees—*ayahs, lascars,* servants, and performers—the administration believed that a new class of natives, "not seamen," had compounded the problem after the Queen became Empress in 1877. This category they dubbed "the petitioner class," and Tulsi Ram was its exemplary figure. The petitioner class, according to Sir Gerald Fitzgerald, the political aide de camp, was composed of "natives of India, mostly from Punjab, who have been unsuccessful litigants in the Indian Courts." They come to London, he ex-

plained in a memo, with the hope of gaining a reversal from Her Majesty, "in ignorance of the fact that no appeal lies in this country against the decisions of Indian Courts."[84] Fitzgerald, who was initially appointed to act as *mehmendar* (host) to the Indian princes in London and later inherited the issue of destitutes, considered the petitioner class to be his "main problem" and declared that "the sooner they return to India the better." They were "simple villagers" who flocked to England to take advantage of the Queen's role as Empress of India; they glorified her as the "fountain of justice," and this created, in his view, an evil that demanded "legislative remedy."[85] "These cases are always extremely difficult to deal with," explained another India Office memo marked "private." "In the first place the Secretary of State has no funds . . . nor does he acknowledge any liability to assist. . . . In the second place we have found from experience . . . [that these men] generally and often at the last moment refuse to go."[86]

Another official, Sir Charles Bernard, agreed with Fitzgerald about the urgency of the question of the petitioner class. "But I would go further," he stated. "These men, so far as I have seen them, are respectable landholders who have been litigating their claims for years. . . . it is very hard on them to be sent to jail, or to the workhouse, because it is from ignorance that they have come." Bernard found it odd that there was "more darkness and ignorance on the matter in the Punjab than in any other province." At the same time he complained that "it is a scandal that such men should be haunting the gates of the India Office and howling for redress."[87]

The problem of the petitioner class was not the financial burden they supposedly represented. Their numbers, contrary to what Fitzgerald believed, were not "rapidly increasing" and making an already difficult matter "daily moreso." Nor was their "evil" a threat to the Queen, since characters like Tulsi Ram standing outside Windsor Castle did not constitute any real threat to her safety. The main problem in the eyes of officials was the ignorance of the peasant villager who sought justice from the physical body of the Queen rather than from the abstract processes of colonial law. And the visibility of such ignorance in the civilized capital was an embarrassing imposition on urban life. The real problem for colonial officials, in other words, was the manner in which these men brought their petitions to the very foundations of the imperial system.

Tulsi Ram, on the other hand, had a very different definition of the so-called problem of the petitioner class. In his effort to petition for justice—an effort that followed the traditional model of seeking justice

from the Emperor, which originated in the Mughal period—Tulsi Ram had endured the oppression of the state judicial system, the cruelty of petty officials, and the chill of urban poverty in London. Above all else, he felt deeply cheated. Enclosed in the correspondence between frustrated metropolitan officials and the stubborn bureaucracy in the India Office are two translated statements made by Tulsi Ram himself. In one of them Tulsi Ram explains, "About four years ago I lived in the village of Lusara, in the District of the Deputy Commissioner of Jullhundar. I had twenty houses there valued at five thousand rupees. These were taken from me unjustly and by force by Rajaram."[88]

Tulsi Ram had petitioned desperately against the action, but his petition was rejected by the chief court in Lahore. He then sent two petitions to the viceroy in Simla, and "when the Viceroy moved to Calcutta," he explained, "I went down and sent two more petitions, but with a like result." Despondent and in financial despair, he then took a ship to Rangoon with the encouragement of an Amritsar merchant, Sher Singh, who upon their arrival robbed him. "He knew I had two hundred rupees and my papers in a bag round my neck, and when I was asleep he cut it off." Tulsi Ram then worked for another merchant in Rangoon for the next twelve months and saved enough money to come to England. "For ten months," he concluded, "I have been going about trying to see the Queen, but a lot of people always collected near me and caused me to be locked up. I have been in about twenty courts and been locked up. At one of the Courts one elderly gentleman offered me two hundred rupees to pay my passage back to India, but I told him I did not want money, I wanted justice and until I get that I will die sooner than return to my own country."[89]

Unfortunately, the administration's method for dealing with the petitioner class, to "tackle the problem at its source," was of little use in Tulsi Ram's case. By 1890, the local provinces in India were instructed to issue notices in the vernacular languages warning Indian claimants that appeals did not rest in England. No petitioners, they were advised, will "obtain any hearing in England from Her Majesty."[90] Prospective petitioners were informed of the risk of "becoming destitute" in London. And the provinces were warned that if "any men of this class should be repatriated" by the Home Office, the expenses would be billed "to the Provinces to which they may belong."[91] But such measures were taken well after Tulsi Ram's arrival in the capital city. For over ten months, the man had exasperated both metropolitan and colonial officials. His claim to "die sooner than return to my own country" was seen as unreason-

able and irrational. If anything, the man had grown more persistent, not less, as a result of his encounters with urban authorities. On top of everything, the sight of Tulsi Ram outside Windsor Castle was not the kind of imperial spectacle envisioned by officials for the Queen's jubilee. In their eyes, his situation required immediate action.

There is an odd silence in the historical record at this point. But on May 4, 1886, Tulsi Ram appears as native sixteen at the Colonial and Indian Exhibition in South Kensington. Forcibly? Willingly? There is no account of how this decision was made, or by whom. For the crowds of spectators, Tulsi Ram, seated on the floor of the Indian Palace, was reinvented under the title "Sweetmeat Maker from Agra." Perhaps he produced sweetmeats that were sold as refreshments to visitors. The experience, however, proved to be his defeat, for Tulsi Ram did not endure it for very long. Within three weeks, on May 24, he was arrested for vagrancy once more, but this time the letter from the West Ham Police Court expressed a startling change: "He now states he is willing to return to India if sent there. . . . I have no doubt you know the case. He is the old Hindoo who wishes to see the Queen."[92]

Thankful that Tulsi Ram had consented to leave London, the India Office agreed instantly to pay the cost of his return. The arrangements were made for June 24. On June 25, Mr. Phillips of the West Ham Police wrote that "after some little trouble," Tulsi Ram was "induced to return." "I went down to the Albert Dock yesterday afternoon to see him off on board the British India S.S. Goorkha," he wrote. "I saw the captain of the boat who promised to deal kindly with the old man . . . enclosed I send the bill [of eighteen pounds] for his passage."[93] At the Home Office an exception was made, and a memo recommended that they reimburse Mr. Phillips for Tulsi Ram's fare: "I think a short draft should be prepared thanking Mr. Phillips," it suggested. "The departure of this native is a great relief."[94]

Incredibly, Tulsi Ram wrote another petition before leaving London that ensures him the final word in my narrative, and preserves his resistance in the historical record. His petition, which remains on file in the records of the India Office Library, states:

> The petition of your humble servant Tulsi Ram . . . is that your worships obedient servant is neither a rogue, a vagabond or a criminal of any sort, nor is he a monomaniac of any description whatever. That ever since your worship's servant has set his foot in this city he has been treated like a common criminal . . . for what crime he knows not. This cruel injustice has not only added to his sufferings but has defiled him in a religious sense. . . . I

prayeth that your worships humble servant may no longer be treated as a criminal or a madman but that he may be protected as a poor stranger in this strange land.

Your Worships Most Humble and Obedient Servant, Tulsi Ram Morn.[95]

EPILOGUE: NATIVE JOURNEYS, COSMOPOLITAN TALES

Tulsi Ram's journey to London is a rich and polyphonic account that is simultaneously many things. It is a tale of persistence by a subaltern figure against the authority of urban and imperial officials; it is an expression of claims by a colonial subject to a citizenship that he is uniformly denied; it is a narrative of power and modern urban space; it is the story of a "poor stranger in this strange land." At the center of the problem presented by the petitioner class, or of "destitutes in London" more generally, was the undesirable visibility of particular bodies (colonized, racialized, and poor) within the urban space of the imperial city. In this way, Tulsi Ram's transgressions threatened the boundaries of public space, both the geographic distance between "home" and "colony" that was painstakingly maintained by the British in power, and the socially divided space of urban London with its starkly mapped inequalities and separations. The exaggerated notion of the petitioner class, conceived of as a *collective* of Indians who at any time might rush the grounds of Windsor Castle with their petitions, reveals the anxieties of colonial officials whose careers were given to the maintenance of such boundaries.

The Colonial and Indian Exhibition was an elaborate fiction that staged itself through yet another fiction: the fiction that nation and colony were brought into a maternalized union by Queen Victoria's jubilee. According to this narrative, the monarch symbolized the top of a social order that brought all British and colonial subjects into a single hierarchy. Victoria was cast as the matriarch of the nation, the mother of empire, and an emblem for the superiority of the British race. And yet, while the image of the monarch became more popular and grand, as historians have noted, her actual participation in political life declined. Tulsi Ram rejected the terms of this fiction and demanded in fact that her symbolism be realized. Tulsi Ram was a desperate man who had gone from being a property owner to a landless villager, driven by the impossible mission of regaining the status he had lost. That the British judicial structure had not helped him but rather had repeatedly endorsed the verdict against him was not altogether surprising, given that its rulings commonly reflected the interests of the dominant landowning class.[96] But

Tulsi Ram sought justice from the personal body of the Queen rather than from the anonymous body of colonial law. And this, according to British authorities, was not an appropriate public image of Queen Victoria during her jubilee year.

Tulsi Ram thus was not granted a space in the spectacle of empire at Windsor Castle even while Mukharji and the inmates from the Agra Jail were all assimilated into this extended performance. The manner in which these different parties participated in the pageantry reflected their different relationships to the imperial nation. The upper-class, upper-caste Bengali, Mukharji, saw his stake in Victoria's "specially kind look" for the indigenous elite who pledged their allegiance to her presence and power. The prisoners, on the other hand, were by definition denied such a status as colonial subjects. For all of the men, however, the living display would rigidly inscribe their participation in public life, transforming them into ethnic commodities and rendering their bodies available for European consumption. For Tulsi Ram, determined "to die rather than return to [his] country," being placed on view in such a way proved to be a more powerful form of containment and punishment than anything experienced in London's East End and resulted in his return to India. Yet Mukharji's tactic of reversing the gaze onto the "natives of Europe," and Bakshiram's refusal "to look about him at all," suggest that the physical gestures, complaints, and petitions of the native leave the processes of objectification at best incomplete.

Art historians and anthropologists have much to gain from focusing on these incomplete processes of cultural representation, for they can instruct us in our attempts to rethink the disciplinary relationships to our objects of study. First, to focus on the incomplete processes of objectification is to acknowledge the structures of defiance and the forms of conscious intervention on the part of historical actors that exist in relation to dominant strategies of representation and that operate at the level of everyday life. In other words, the living display reminds us that the subjects of ethnological and aesthetic representation are also living beings whose movements, desires, motives, and tactics in highly charged ideological landscapes have never been adequately contained by history's authoritative representational forms. Second, to identify forms of visual knowledge in the colonial period as fundamentally incomplete is to recognize the polysemic nature of visual imagery, and the multidimensionality of meanings and contexts that can serve to upend a dominant image from the history of power in which it is rooted. Finally, to focus on the incomplete processes of objectification is to confront, from yet another

perspective, the conditions of possibility for the persistence of tropes like "native," "villager," or "indigenous artisan," which continue to mark authenticity and difference in spite of the challenges to their authority by critical actors.

Tulsi Ram, the unfortunate villager who became visible in the show-case of the imperial city, at the very least traveled a great deal, even if he was denied the social distinctions of travel, challenging the assumption that natives lack cosmopolitan histories or that indigenous mobilities are exclusively local. In fact, the experiences of the men and women in the living ethnological exhibits expose the uneven nature of the history of modern travel and the nation-states through which such journeys are defined. They represent the cosmopolitan tales that have remained invisible in our histories and ethnographies. They are innovative routes through imperial topographies of power. And together they map the complex entanglement of modernity's urban, national, and imperial domains.

The Discrepant Portraiture of Empire

Oil Painting in a Global Field

By putting Indian fine art on a lower intellectual plane than
that of Europe you lower the whole intellectual vitality of
India, for nothing is more intellectually depressing than the
feeling of a constitutional inferiority.

> E. B. Havell, *The Basis for Artistic and Industrial
> Revival in India,* 1912

Are there ways we can reconceive the imperial experience
in other than compartmentalized terms, so as to transform
our understanding of both the past and the present and our
attitude towards the future?

> Edward Said, *Culture and Imperialism,* 1993

There is a long hallway at Osborne House—Queen Victoria's summer
residence on the Isle of Wight—where a row of Indian "heads" have
been hanging for more than a hundred years. These portraits of the
Queen's Indian subjects were painted for her by a little-known Austrian
artist, Rudolf Swoboda (1859–1914), during the 1880s and 1890s, at the
height of British rule in India. The painter selected his subjects from a
large cross-section of Indian society: he painted men, women, children,
Muslims, Sikhs, Hindus, tribals, military officers, villagers, princes, and
several of the Queen's Indian servants in England. Swoboda presented
these "heads" in a variety of ways, using frontal or three-quarter profile
views for some, as in the image of Chutter Bhuj Kula, a revenue officer
from Jodhpur; side profiles for others, as in the portrait of eighteen-year-

old Khodir Bakhsh; and occasionally tighter close-up views, as in the intimate painting of Sunder Singh (figure 17). He also manipulated the backgrounds in his portraits to add to their aesthetic qualities: the image of a fair Parsi girl, for instance, is depicted against a background of light pinkish tones (figure 18). Other compositions, like his painting of Addu, display a more complex interplay of light, shadow, and color, often resulting in striking effects (figure 19). His oldest subject was Bakshiram, the potter from Agra at the Colonial and Indian Exhibition reported to be 102 years old (figure 20), and the youngest was Miran, the four-year-old girl from Srinigar with the large innocent eyes (figure 21).

The pictures immediately recall another colonial collection, *The People of India,* the eight-volume catalogue published between 1868 and 1875 containing some five hundred photographs of India's "ethnic types." In this work, which served the interests of the colonial administration, human beings are presented as scientific specimens as neatly "as butterflies impaled on pins," as David MacDougall has noted.[1] *The People of India* is thus a classic enactment of the kinds of modalities identified by Allan Sekula in his influential account of photography's interpellation into nineteenth-century hierarchical society: its "archival mode," its "instrumental realism," its repressive logic of "optical encyclopedism"—all of these make this catalogue of mug shots a "powerful, artless, and wholly denotative" form of visual empiricism.[2] And yet, Sekula's account of the photographic portrait as a socially repressive instrument is not easily extended to the specificities of painting and its unique historical trajectories in the subcontinent. For Sekula, the paintings housed in the National Gallery, erected in London's Trafalgar Square in 1831, represent the opposite pole of portrait practice, embodying an honorific, rather than repressive, logic. Indeed, Sekula's argument is that the new medium of photography did not simply "democratize" the honorific functions of bourgeois portraiture, as one version of the history of photography has claimed, but that every "proper portrait" housed in the National Gallery has its "lurking, objectifying inverse in the files of the police."[3]

Although Sekula's intervention has been a valuable one for thinking about the forms of objectification at stake within photographic portraiture, his account, which constructs an opposition between painting and photography, does not seem to help us navigate the recent arrival of Swoboda's oil paintings at the National Gallery on Trafalgar Square, where they were the subject of an exhibition called "An Indian Encounter: Portraits for Queen Victoria" (2002–03).[4] These "proper por-

traits" do not generally follow the logic of colonial photographic collections such as *The People of India*, with their powerful claims to scientific objectivity and truth. Nor have they been acknowledged by historians of anthropology concerned with a critical account of colonial ethnology and its disciplinary practices of representation. Indeed, Swoboda's paintings have been curiously neglected by anthropologists, art historians, curators, and artists alike.[5] Why then, we must ask, have these portraits of Indians—embodying the imperial section of the royal collection—been so long overlooked? And how should we read this hall of "colonial heads" from the vexed perspectives of our postcolonial era?

To respond to the latter, I turn in this chapter to the historical specificities of painting in the colony, in part to extend Edward Said's account of "contrapuntal" understanding to the narratives of art history and the visual archive. As we will see, Rudolf Swoboda's Indian career during the last two decades of the nineteenth century converged with the dramatic emergence of new kinds of artists and aesthetic forms in India, and a major shift in the practices of painting, exemplified by the ascendancy of oil. Drawing from Said's imperative that we articulate discrepant experiences "together, as an ensemble,"[6] I revisit Swoboda's forgotten collection as an occasion to make visible the "politics of the palette"[7] in imperial culture, and to explore the transmigrations of oil painting itself during the latter part of the nineteenth century.

Oil painting in India has had an unusual genealogy: it was introduced by Europeans in the eighteenth century, promoted by the British in the nineteenth century through the institutional structure of their colonial art schools, and then renounced by nationalists in the early twentieth century, who rejected it as a foreign medium. My account is thus concerned not only with the imperial practices of Swoboda's commission for the Queen, but with the wider structure of British art education in India, and the discrepancies in stature and professional success between Indian and European oil painters this structure produced. Finally, by contrasting Rudolf Swoboda with his contemporary, Raja Ravi Varma, whose distinctly modern expression of "Indianness" in art made him a national hero at the time of his death in 1905, but who was later rejected by the nationalists of the Bengal School for his hybridity and debased Western style, I show how the emergence of the "gentleman artist" in India, predominantly the oil painter, was constituted as separate from the social category of the "native craftsman" visited in the previous chapters. By bringing into focus this larger picture of transformation to the practices of oil painting during empire, I narrate a story of intertwined histories—

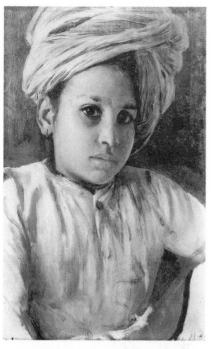

Figure 17. *Sunder Singh*,
1886–88 (oil on canvas, 29.8 ×
19.1 cm). The Royal Collection ©
HM Queen Elizabeth II.

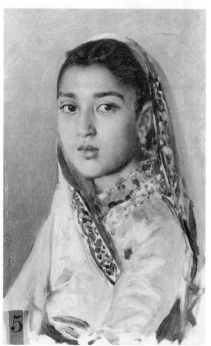

Figure 18. *Sirinbai Ardeshir*,
1886–88 (oil on canvas, 26 ×
15.9 cm). The Royal Collection ©
HM Queen Elizabeth II.

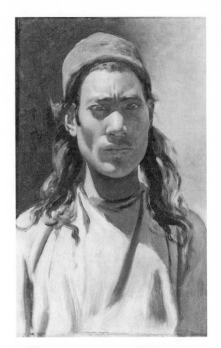

Figure 19. *Addu,* 1886–88 (oil on canvas, 29.8 × 19.1 cm). The Royal Collection © HM Queen Elizabeth II.

Figure 20. *Bakshiram,* 1886–88 (oil on canvas, 26 × 15.9 cm). The Royal Collection © HM Queen Elizabeth II.

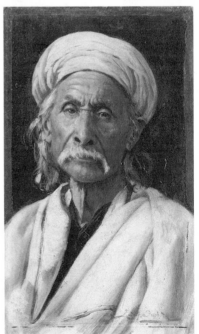

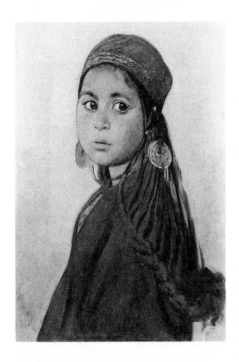

Figure 21. *Miran,* 1886–88 (oil on canvas, 29.8 × 19.1 cm). The Royal Collection © HM Queen Elizabeth II.

in Said's terms—through which a more expansive account of European portraiture, with its powerful role in the self-other relation, can begin to emerge.

The "occidental orientations"[8] that characterize this period of aesthetic production in the Indian subcontinent have been a major concern of the "new art history" of India, driven by the work of historians of South Asian art who have begun to critically interrogate the knowledge practices of their fields.[9] The art of India during the colonial period, for example, for too long has been considered derivative or unimportant, or overshadowed by other epochs such as the classical age of ancient India or the great period of Mughal painting from the sixteenth to the eighteenth centuries. Only recently have scholars begun to revise this view by exposing the colonial bases of such constructions themselves and revealing the significance of the nineteenth century in the emergence of dominant and enduring art historical narratives about India.[10] Such a shift in approach also reflects the move away from a purely stylistic inquiry into Indian art, and toward a more broadly interdisciplinary project that seeks to investigate how the social and political contexts of colonialism, and the production of knowledge about cultural difference,

continue to shape the way we view the art and architectural forms of the subcontinent today. Far from being a dark, imitative, or insignificant period in the history of Indian art, the nineteenth century is now seen as an era of profound and complex transformation to the visual arts, in part because of the enormously radical nature of Britain's colonial encounter with India.

This spirit of revisionism has led to a reexamination of several fascinating areas of inquiry in nineteenth-century Indian art. There has been a fresh interest, for example, in the drawings, watercolors, and paintings of the early nineteenth century attributed to the Company School, the name for the Indian artists who were employees of the East India Company and received a training in Western aesthetic techniques.[11] Although the essential impulse of the Company School was assimilative, its results were quite the opposite: what emerged was a unique genre in its own right, characterized by a plethora of hybrid styles, and a blending of visual vocabularies unlike anything seen before. A similar interest has been extended to the Kalighat pictures of the late nineteenth century, an urban, vernacular form in which the village scroll painting traditions of Bengal met with the new technologies of mechanical reproduction that were transforming Calcutta's street life at the time.[12] Significantly, the anonymous producers of Kalighat images often took as their subject matter the rapid erosion of Bengali social values under the impact of Westernization. And yet, the reassessment of these arenas of cultural activity has not entirely put to rest the problem of what I call painting's "mimetic imperative" in the colonial case, and its powerful role in determining meaning and identity in relation to the individual artist. As we shall see, the expectations and impositions placed upon oil painting with regard to originality, creativity, priority, and copying have resulted in a particular, enduring burden for Indian artists, whose fate was sealed at the outset by the structure of colonial art education and its emphasis on emulating the privileged traditions of the West. To track the history of these dislocations and discrepancies, however, it is necessary first to return to London and our European painter, Rudolf Swoboda, whose particular journey will take us through a number of social contexts in England and India relevant to this larger story.

SWOBODA IN ENGLAND

Although Rudolf Swoboda's paintings have had a marginal status in the art historical canon, he was not a marginal figure in the art world of his

time. On the contrary, Swoboda was from a well-established family of artists and intellectuals in Vienna. His father, Eduard, was a painter and lithographer; his brother, Heinrich, was an archaeologist; and his sister, Josephine, who joined him in London, was also a painter, even though she—like many women artists—did not receive the professional recognition accorded to her brothers. It was, however, Swoboda's famous uncle, Leopold Carl Müller—the leading Viennese orientalist painter of the period, known for his extensive body of work in Egypt—that most influenced the artist. In 1879 Swoboda traveled to Egypt for the first time with Müller, a trip that marked the beginnings of his career. Egypt thus became an important source of inspiration and patrons for Rudolf Swoboda, and he returned six times during the 1880s.

In 1885 Swoboda followed his uncle to England, where he was introduced to Queen Victoria by the influential Austrian artist Heinrich von Angeli. "Saw a young Austrian artist recommended by Angeli," the Queen wrote in her journal after their meeting. "He is only twenty-six, of the name of Swoboda, and is full of talent."[13] Swoboda's timing was particularly good: in London, the preparations had begun for the Colonial and Indian Exhibition. In conjunction with this high-profile event, exhibition organizers brought a group of thirty-four men from India—identified as weavers, potters, coppersmiths, carvers, silversmiths, and so on—for a living display of "native artisans" on the grounds of the South Kensington exhibition site (see chapter 2). The men—who performed their crafts daily throughout the summer in a re-created Indian Palace at the exhibition—were said to constitute a picturesque scene of village life in India. Early in July the Queen invited these men, whom the English press referred to as "her more humble Native subjects," to Windsor Castle for a luncheon with other natives appearing at the exhibition from Ceylon, Hong Kong, Cyprus, British Guiana, Australia, and the Cape of Good Hope. Needless to say, Tulsi Ram, the homeless Punjabi villager in London arrested for vagrancy on numerous occasions outside the Queen's residence at Windsor, was not invited to the ceremonies that day.

As part of this imperial spectacle, Swoboda was requested to paint five portraits of the Indians and three others, a Cypriot weaver, a Malay dressmaker, and a diamond washer from the Cape. These paintings—the artist's first commissions for the Queen—included the image of the stonemason Radha Bullabh; the portrait of Bakshiram, the aged potter, who was reported to "sit brave and dignified and motionless" as a statue at the exhibition (see figure 20, earlier in this chapter); and the melancholy picture of Ramlal, a child carpet weaver who was the youngest of

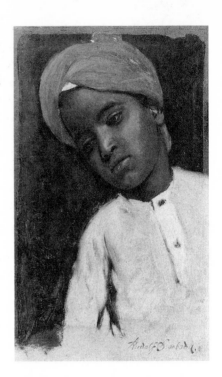

Figure 22. *Ramlal,* 1886–88 (oil
on canvas, 26 × 15.9 cm). The
Royal Collection © HM Queen
Elizabeth II.

the group at only nine years old (figure 22).[14] The latter, in particular,
tends to reveal some of the extraordinary circumstances surrounding the
group: as I described in the previous chapter, the "native artisans" on
display were selected and recruited from the Central Jail in Agra, where
the men were also incarcerated at the time. The decision to bring inmates
for the exhibition was linked to the reform practices of prisons in the
colonial context, whereby India's so-called "criminal castes and tribes"
were trained in skills like pottery, weaving, and carpet making as a way
to instill in them the moral value of hard work and to create disciplined
and law-abiding subjects. The "native artisans" exhibit thus exposed the
colonial fiction of a timeless, authentic image of India, displaying instead
how such an image was contingent upon (and contorted by) the modern
realities of industrialization and the perversities of prison reform in
nineteenth-century imperial culture.

Swoboda's paintings play a part in concealing such contradictions
even as they expose some of the mood surrounding this ideological
drama: the portrait of Ramlal, for instance, seems almost stamped with
sadness. But the pictures also help to consolidate—and elevate to "offi-

cial" status—an idealized image of the village craftsman, a figure that embodied the timelessness of the Indian village and thus captured the essence of India itself. This social category, the "native artisan," would stand in stark contrast to another Indian artist—the European-style professional painter trained in the techniques of oil and easel—taking shape in the subcontinent at the same time. The parallel emergence of *this* Indian artist, who aspired to the same status as the European painter and the professional prestige of portrait commissions, will be traced by following Rudolf Swoboda to India on the next leg of his professional journey.

SWOBODA IN INDIA: A KIPLING TALE

Victoria's enthusiasm for Swoboda's exhibition paintings resulted in another exciting commission for the artist. In the fall of 1886, he was sent to India at the Queen's expense with instructions to produce additional sketches of the different nationalities and "ethnic types" of the Indian subcontinent. Her specific wishes were conveyed to the artist in a letter dated October 1886: "The sketches Her Majesty wishes to have are of the various types of the different nationalities. They should consist of heads of the same size as those already done for The Queen, and also small full lengths, as well as sketches of landscapes, buildings, and other scenes. Her Majesty does not want any large pictures done at first, but thinks that perhaps you could bring away material for making them should they eventually be wished for."[15]

When Swoboda arrived in India in 1886, he joined a long line of European portrait painters in the subcontinent depicting Indian subjects, a line that began in the late eighteenth century with artists such as Thomas Hickey, Charles Smith, Francesco Renaldi, and George Chinnery.[16] Some hundred and twenty years before Swoboda arrived, for instance, the British painter Tilly Kettle, a pioneer of large-scale portraits in India, had gained prestige through his paintings of confident naval officers, merchants, and East India Company servants, including the first governor-general, Warren Hastings. Like many foreign painters in India, Kettle soon supplemented his portraits with "native scenes" of South Indian temple dancers, *nautch* girls, and picturesque scenes of *sati*. For these painters, India was—in the words of one artist—"an inexhaustible field for artistic energy. It is unlike anything else ever painted. It outdoes in originality . . . and presents not only the most original combinations of color and form at every turn, but abounds in romantic tradition."[17]

Others, such as the German-born John Zoffany and the Scottish artist George Willison, significantly profited from their images of native princes: the latter's canvas of Muhammad Ali, the Nawab of Arcot, was hung at the East India Company headquarters on Leadenhall Street and became one of the first images of Indian royalty to be seen by the British public.[18]

Unlike several of his predecessors—Thomas and William Daniell and Edward Lear, for example—and contrary to the Queen's request, Swoboda did not sketch landscapes and buildings, and thus did not leave us a visual record of his itinerary in the subcontinent.[19] Nor did he publish a journal or travel diary documenting his impressions while traveling in India, as did the British artist Val Prinsep ten years earlier when he received another prestigious royal commission to paint the Imperial Assemblage of 1877.[20] Swoboda apparently arrived in Bombay in October, visited Agra, Rawalpindi, and Peshawar late in that year, and spent the summer of 1887 in Punjab with Lockwood Kipling, the director of the Mayo School of Art in Lahore and Rudyard Kipling's father.[21] He was received and hosted as a matter of routine by the inner circles of the British administration, including the viceroy, the Duke and Duchess of Connaught, Dr. Tyler from the Agra Jail, and the Kipling family in Lahore. In November 1887, after approximately a year in India, Swoboda wrote to the Queen's secretary stating his intention to "remain out here longer as I have seen only a few towns in the Punjab and part of Kashmir—altogether a very small part of Her Majesty's immense Empire." He continued:

> At the end of this month I am going back to Lahore to finish three larger pictures I began there and which will show plainly the most marked features of dress. As the costume in this part of India, especially in Kashmir, is not a picturesque one, I have not made any full length sketches of people, but I hope to get down [south] in India some very interesting looking subjects. On my arrival in Lahore I will send a part of my collection of heads and would be greatly obliged by your informing me which of them are approved by Her Majesty.[22]

The young Rudyard Kipling—only twenty-two years old—may well have encountered Swoboda in Lahore in the summer of 1887. At that time the writer was employed as a reporter at the *Civil and Military Gazette,* having recently returned to the subcontinent after his long and unhappy education in England. Lahore had only a few hundred British residents living in the Civil Lines at the time, and Rudyard's offices were a short walk from the museum and art school where his father worked.

This setting was later immortalized by Rudyard in the opening chapter of his novel *Kim*. Indeed, it is widely acknowledged that the younger Kipling's account of "the old Ajaib-Gher—the Wonder House, as the natives call the Lahore Museum," and the kindly learned curator who worked there with his "mound of books, French and German, with photographs and reproductions," was an affectionate tribute to his father's life in Lahore.[23]

Significantly, it was here that Kipling produced some of the writing that would make him famous, including his volume of forty-two short stories, *Plain Tales from the Hills* (1887). Like Swoboda's commissioned project, this collection consisted of small sketches of life in India composed in 1886–87. Thus Kipling and Swoboda both created a whole imaginative world out of what they saw in this relatively short period of time in India. However, while Kipling viewed India as a broad canvas teeming with hybrid compositions that culminated in the adventures of his outcast, multilingual, mixed-race Kim,[24] Swoboda, by contrast, was firmly focused on a coherent, if colorful, selection of characters that would provide an "authentic" portrait of India for the Queen. These differences appear to be confirmed in a letter written by Kipling to a friend in the winter of 1889. The correspondence presents a striking caricature of two Austrian artists who visited his father's home in Lahore, one described as "a red bearded tornado with a cracked voice," and the other "a dried up walnut looking sort 'o man who couldn't speak English." Kipling wrote mercilessly:

> *Gott in himmel!* An incursion of Austrian maniacs has just swept through the house, gutted the studio and fled, carrying the Pater with 'em to the Museum. There were two of 'em—one a Count something or other—simply wild about India and all that is therein. . . . They wanted to see Graeco-Bhuddist sculptures—they wanted to encamp on the Attock; they wanted to embrace the whole blazing East and they wriggled with impatience as they explained their needs. . . . They tore through the Pater's portfolios; they seemed ready to tear down the pictures from the walls and the big one, backing the Pater into a corner, stood over him while he shouted: "Tell me now about Alexandare. I am in him mooch interest. Did he now come to this place, and where is Taxila." . . . The other man had got hold of T's photo-studies of men and animals taken to help the Pater's drawings and between gasps of Austrian admiration was wildly appealing to me for duplicates. "I am artist you know" was his explanation and he spoke as who should say: "I am the Almighty."[25]

Was Kipling referring to Rudolf Swoboda? Perhaps. The archives, although sketchy, do suggest that the painter returned to India in 1889 for

a second visit by way of Egypt. In any event, Kipling's impatience with "almighty artists" who seek to "embrace the whole blazing East" is a familiar objection to the touristic presence of European painters in the non-Western world who constructed a timeless and exotic Orient that contrasted sharply with their own societies.[26] Kipling's comments make visible the tentative boundary between artistic inspiration and acts of aesthetic appropriation while also highlighting the insatiable thirst for imagery and knowledge that would have driven a foreign artist like Swoboda in India. They also reveal some of the processes—at times, violent impositions—through which the painter acquired his visual language for the subcontinent. According to Kipling, the method was close to madness: these "Austrian maniacs" swept through his father's house; they gutted the studio, tore through his portfolios, appealed wildly for duplicates, and "wriggled with impatience as they explained their needs."

DISCREPANT EXPERIENCES: COLONIAL ART EDUCATION
AND THE RISE OF THE INDIAN ARTIST

The setting of Lahore, however, is not merely of interest as the site where Swoboda and Kipling may have crossed paths. It is also one location through which a broader historical picture of the evolution of painting in the subcontinent begins to emerge. For the Mayo School of Art, directed by Rudyard's father, Lockwood Kipling, was one of the four major art schools established by the British by the middle of the nineteenth century as part of their wider program for cultural "improvement" in the colony, to be achieved primarily through Western education. The official goal of the administration, following Thomas Macaulay's famous 1835 "Minute on Education," was to convert the intelligentsia by inculcating a training in English through literature and the arts of civilized life, "to form a class who may be interpreters between us and the millions whom we govern; a class of persons, Indian in blood and color, but English in taste, in opinions, in morals, and in intellect."[27]

And yet, the art schools—which opened in Madras in 1850, Calcutta in 1854, Bombay in 1856, and Lahore in 1878—were also influenced by the model of South Kensington, and sought to respond to the "degeneration" problem within the sphere of Indian crafts with a second goal of rejuvenating India's craft traditions.[28] The result was a somewhat confused approach to art education, one that was driven by a set of muddled imperatives. The approach nevertheless served to institutionalize a distinction between the "industrial arts" or "decorative arts" on one hand,

defined as the domain of the Indian craftsman, and the "fine arts" on the other, defined as the product of Western training in painting or sculpture.[29] The schools in Madras and Lahore were thus dedicated to fostering the former (crafts), while those in Calcutta and Bombay were oriented toward the latter (fine arts). Lockwood Kipling, significantly, was at the center of these emergent formations, having arrived from South Kensington in 1865 to take charge of the sculpture department in Bombay before joining the Mayo School in Lahore in 1880, where he founded the *Journal of Indian Art and Industry*, a publication that has had a significant role in the production of art historical knowledge of India.[30]

The colonial art schools would have far-reaching consequences for the fate of the visual arts in India. Their priorities and activities led to the emergence of art societies in many urban centers, an expanding exhibition circuit, profound changes to the structure of patronage, and a new desire for the Western-style "high" arts being promoted by the British. They brought, in other words, the "entire ideological underpinnings of the nineteenth-century salon" in Europe to the task of inculcating good taste in the Indian bourgeoisie.[31] But they also exposed a new generation of Indian students to European techniques and media—in particular, to the conventions of academic realism and oil painting—which led to a corresponding shift in the self-image of the artist. Indian painters increasingly sought to gain prestige by showing their work at exhibitions and by securing portrait commissions from the English-educated Indian elite. The identity of *this* artist, molded from a Western model and belonging to the professional and intellectual classes, clearly differed from that of the "native artisan," the social category on display in the spectacle of empire back in London. And yet, the accomplishments of Indian oil painters who began to compete with their European counterparts in the largely Anglo exhibition scene in India remained inscribed by such judgments as "excellent of their class," or segregated by labels like "native work in a particular medium." In these social circles, as Partha Mitter has noted, the Indian artist was still perceived as essentially inferior to the European artist, a hierarchy that was by no means unique to the arts, but that expressed the broader racial segregation of imperial society at the end of the nineteenth century.[32]

The discrepancies inherent in the history of oil painting in the colony, what I referred to at the outset as the "politics of the palette," are expressed—indeed allegorized—in unique ways by the emphasis on *copying* in the colonial art curriculum. In the words of amateur painter Richard Temple, a leading figure in Indian art education, a central goal

of the curriculum was "to teach them one thing, which through all the preceding ages they have never learnt, namely drawing objects correctly, whether figures, landscape or architecture."[33] For Temple and others, "to draw correctly" meant to copy old masters as closely as possible, to sketch endlessly from books and nature, and to imitate reality with exactness and precision. If the Indian artist was not seen to be lacking in his knowledge of ornament and design, he was perceived as deficient in these "scientific" skills, reflective of the prevailing ideologies of academic realism at the time. However, the emphasis on slavish copying, perhaps best embodied by John Griffiths's twelve-year Ajanta Project—in which Griffiths, the principal of the J. J. School of Art in Bombay, employed his students to make complete copies of the ancient murals in the Ajanta Caves between 1872 and 1885—also represented for the artist a stifling of creativity and a suspension of originality.[34] For this reason, several of Griffiths's students refused to participate in the project, and Pestonji Bomanji, who went on to become one of India's leading oil painters of the period, denied later in life that he worked at Ajanta.[35]

The literary theorist Homi Bhabha has done much to further our understanding of the enunciative possibilities inherent in such mimetic relations. His attention to the space between "mimicry and mockery," and its role in exposing "colonial ambivalence," has been highly influential in interdisciplinary discussions of cultural representation, and has become part of the dominant vocabulary of postcolonial criticism.[36] However, the mimetic relationships at stake in the history of painting, in which the judgment of "derivative" or "imitative" haunts the colonial artist adopting for the first time the colonizer's medium of oil, have been difficult to conceptualize exclusively within these terms. Significantly, such tensions regarding originality, indigenousness, borrowing, and authenticity would be a central strand in the unfolding of modern art in post-Independence India, and continue to shape the concerns and practices of many artists working in the subcontinent today. It is, in other words, the enduring impact of the colonial past on the present, and the implications of this for the modern and contemporary art history of South Asia, that remains undertheorized still.

In spite of the parameters of imperial hegemony within which the Indian oil painter made his debut, there were a number of artists trained in the art schools that gained national distinction by the end of the century: the Parsi artist Pestonji Bomanji, for example, became one of the leading portraitists in Bombay. Others included the Calcutta-based J. P. Gangooly, a highly distinguished landscape painter related to the Tagore

family; A. X. Trinidade from Goa, who was nicknamed the "Rembrandt of the East"; and M. F. Pithawalla, another of Griffiths's students, who became the first Indian painter to receive an exhibition in London in 1911.[37] These painters and others had established themselves as rising stars by the time Rudolf Swoboda arrived in India, and they were no doubt a source of interest and suspicion for European artists working in the subcontinent. A decade earlier Val Prinsep, the official painter of the Delhi Durbar in 1877, admitted that a commission from the Queen would "naturally fill the mind of an artist with anxiety," and spoke contemptuously of the "monstrous native portraits" being produced by Indians painting in oil.[38] However, the greatest competition for the European painter undoubtedly came from Raja Ravi Varma, the legendary "father of modern Indian art," who surpassed all the others in popularity and professional success. Significantly, Varma did not emerge from the British art schools, but was instead self-taught from books and pictures in his home state of Kerala. If Swoboda did not encounter this artist directly during his short time in the subcontinent, he would certainly have been aware of his competitive hold over portraiture commissions for the ruling elite. Or perhaps he had seen the two paintings by Ravi Varma that had won prizes back in London at the Colonial and Indian Exhibition of 1886.[39] Nevertheless, Varma's national reputation was well established by the late 1880s, and the artist—along with his dutiful brother, Raja Raja Varma, a painter with whom he worked all his life— was *the* force to contend with in the Indian art scene. Therefore, it will be necessary to return to examine the phenomenon of Varma shortly, as a counterpoint to the story of Swoboda.

"BEAUTIFUL THINGS"

Rudolf Swoboda was not a painter entirely lacking in skill. Even Kipling, critical as he was, conceded that the artist in question "could draw more than a little."[40] The forty-three studies that resulted from his first Indian trip (1886–88) were likely executed very swiftly, but they also display a mindful consistency and a certain care and attention to detail. In keeping with the Queen's wishes, they were primarily "heads of the same size," in frontal or three-quarter profile views, representing a broad spectrum of Indian subjects across ages, genders, and "social types." A number of his sitters were no doubt selected because of their convenience: Sunder Singh, the ten-year-old son of a silversmith (see figure 17, earlier in this chapter), and Ghulam Hassan, the thirteen-year-old Muslim boy

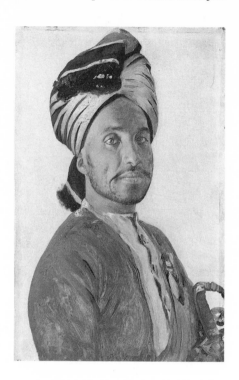

Figure 23. *Gulam Muhammad Khan*, 1886–88 (oil on canvas, 29.8 × 19.1 cm). The Royal Collection © HM Queen Elizabeth II.

from Lahore, were both students in residence at Lockwood Kipling's art school, where Swoboda worked while in Lahore. Some of his models, like Kibira Khylan—whose bare shoulder is exposed through his torn clothing—were probably painted outdoors, as the green leafy background and bright sunlight in this image suggest. Another painting—of Gulam Muhammad Khan, the twenty-seven-year-old military officer with the large gentle eyes (figure 23)—was sketched at Mian Mir, the military cantonment in Lahore not far from the art school and museum where the officer was stationed that year. The latter portrait reflects Swoboda's particular preoccupation with "military types," which he depicted as a broad spectrum of uniforms, regiments, and ethnicities, presumably in accordance with the wishes of the Queen. Three striking examples of these paintings include the humble portrait of Bulbir Gurung, the Nepalese sepoy in the Gurkha Army whose chin strap is worn high on his face (figure 24); the regal image of Bal Singh, a Sikh member of the Bengal Cavalry; and the picture of a man named only Paime, of unknown tribal origins and a member of the tribal regiment in the Queen's Indian army, the Maywar Bhil Corps.

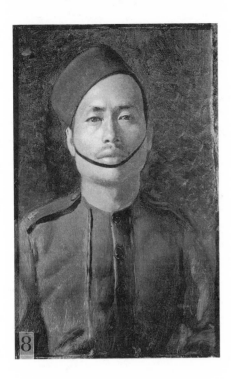

Figure 24. *Bulbir Gurung,*
1886–88 (oil on canvas, 29.8 ×
18.7 cm). The Royal Collection
© HM Queen Elizabeth II.

Notably, almost all of Swoboda's Indian figures are presented in colorful turbans or headdresses, which appear in a range of textures and fabrics, variously knotted or twisted or loosely draped. Swoboda seemed taken by the aesthetic qualities of these textiles and their ability to express a personality when offset by a particular profile or pose. In the picture of Warseli, for instance, a red turban twists eccentrically down the left side of the young man's face. In another striking image—of Makkan Singh—a thick turban is combined with rapid brushstrokes to create a memorable, if slightly crazed, beard. Elsewhere, in the unfinished portrait of Gulzar—an eleven-year-old dancing girl from Lahore—the loose sweep of a dark head scarf gives the appearance of long hair (figure 25). At other times, the headdress clearly functions to represent a military or ethnic type, as in the green *topi* of Bulbir Gurung, the Nepali sepoy in figure 24, or the humble headdress of sixteen-year-old Munni, who was intended by the artist to represent her underprivileged sweeper caste. The emphasis on the headdress was likely a way for Swoboda to communicate the variety and richness of Indian clothing without presenting full-length portraits. At the same time, the headdresses serve to underline the

Figure 25. *Gulzar,* 1886–88 (oil
on canvas, 29.8 × 19.1 cm). The
Royal Collection © HM Queen
Elizabeth II.

basic "otherness" of his subjects. What Swoboda's portraits do not rep-
resent, for example, is the emergent socioeconomic class of the era—the
English-educated Indian elite—who are widely represented elsewhere in
front of the camera, in *cartes de visites,* or in commissioned paintings, in
the model of their European counterparts. But Swoboda's eye does not
focus on these hybrid Indian subjects prevalent by the 1880s, often wear-
ing top hats, wristwatches, and Bond Street suits. Instead, he maintains
an unwavering gaze on an authentic form of Indianness, defined in the
end by its fundamental difference from a modern, European, and thus
civilized self.

Paradoxically, these paintings emphasize the unique attributes of
their Indian sitters while simultaneously undermining their autonomy as
individuals—for they were conceived, after all, *as a collection.* Their
small, precious size (7 × 11 inches on average), their three-quarter front
or side-view profiles, and the consistency of their solid frames all con-
tribute to a striking uniformity and reveal a desire for unity in their very
production. Indeed, the Queen was delighted by their decorative effect
and praised Swoboda for "such lovely heads," referring to them as

"beautiful things" while noting in particular that she was pleased by their "quantities."[41] Accordingly, Swoboda was compensated for all forty-three pictures together, receiving the same rate he was given two years earlier for his work at the Colonial and Indian Exhibition—ten guineas per painting.

"INDIAN THINGS"

In 1890–91, Queen Victoria commissioned a design from Lockwood Kipling and his most talented student, the Punjabi craftsman Ram Singh, for a new banquet hall at Osborne House to be built and decorated in an "Indian style."[42] The result—completed in 1892—was an exotic fantasy of interior design known as the Durbar Room, which any visitor to the Isle of Wight can view at Osborne House today. The plaster walls and ceilings of this opulent space were molded from hand carvings by Ram Singh, and then enriched with teak framing and a boggling range of decorative motifs, including the Hindu elephant god, Ganesh, and an enormous peacock fireplace. Swoboda's portraits were initially hung at the Queen's residence in Windsor, and later, in 1894, transferred to this new wing of Osborne House. In 1891 Victoria's eldest daughter, the Empress Frederick, wrote to the Queen expressing her delight at the progress of the Durbar Room: "You have so many lovely Indian things to put into it, and Swoboda's heads and studies would look very pretty there too."[43] When the work was finally completed in 1892, Swoboda also painted Ram Singh, who succeeded Lockwood Kipling as head of the Mayo School in 1893.[44] This portrait joined the other forty-three heads after their transfer to Osborne House, clearly a significant new showcase for the Queen's "Indian things."

Ram Singh's portrait is distinguished by its heavy gilt frame, which has a gold leaf pattern and proudly bears the inscription "Ram Singh. Who Designed the Decoration of the Durbar Room, Osborne House, 1893." It is one of several larger and more finished compositions—all of which are elaborately framed—produced by Swoboda during the 1890s after the Osborne House Indian wing was completed. These paintings depict the Queen's Indian servants in England, including Abdul Karim, the *munshi* or tutor who was famously favored by Victoria. Swoboda portrayed him with a book in his hands, a symbol of his literacy and slightly elevated status. Ghulam Mustafa—one of the Queen's Indian cooks whom Swoboda painted on two occasions—is depicted here in a striped turban and a bright red tunic boasting the Queen's Empress crest

Figure 26. *Ghulam Mustafa,*
1888–97 (oil on canvas, 30.5 ×
18.7 cm). The Royal Collection ©
HM Queen Elizabeth II.

in gold (figure 26). Similarly, the image of Sir Pratap Singh, a rare full-
length portrait, shows the Indian prince in formal attire, wearing nu-
merous exotic jewels, including the Star of India and the Jubilee Medal,
both symbols of his loyalty to the Queen.[45] The confidence of this Indian
maharajah, shown seated on an elaborate gold throne, contrasts sharply
with the shy cautiousness, perhaps even fear, evident in the expressions
of some of Swoboda's other subjects. Much like the military portraits al-
ready discussed, these pictures of the Queen's favorite Indian princes and
servants served to mark and maintain the social status of their sitters as
well as the colony's loyalty to Britain. They record, in this sense, a hier-
archy of Indian proximity to the Queen, and make visible the privileges
that this hierarchy sustained.

AN INDIAN ENCOUNTER

Perhaps the most significant Indian painting by Swoboda in the Queen's
collection is *A Peep at the Train,* which was exhibited at the Royal Acad-
emy in 1892 and is unusual for him in both style and content (see figure

2 in the introduction, page 20). As others have noted, this distinctive scene addresses the relationship between traditional Indian society and the modern presence of the British in India in unique and compelling ways.[46] The composition shows an old man and a group of children positioned around a wooden fence: behind them is an Indian village, populated by a scattering of its inhabitants, including several craftsmen performing their daily activities. In the lower left corner—easy to miss upon first glance—is a small fragment of a railway track cutting through the bottom edge of the frame. The entire scene is drenched in midday sunlight; the shadows in front both sharpen this sense of temporality and intensify the feeling of heat and dust. In spite of its ethnographic realism, there is strong evidence to suggest that the picture was completed in England: two of its characters, the old man and the young boy seated upon the fence, are in fact models from Swoboda's earlier work. The old man is Khazan Singh, the aging headman of a village in Punjab (figure 27); the young boy seated on the fence is probably Sunder Singh (figure 17, earlier in this chapter), Lockwood Kipling's student in Lahore; and the prototype for two of the young girls appears to be Gulzar (figure 25, also earlier).

Although the work is titled *A Peep at the Train,* a more appropriate title might be "A Peep *from* the Train," because the viewer is positioned as if he or she were on a train, looking out from a railway carriage at a passing scene. The presence of the train track within the picture space is a powerful symbol of British technological progress in the colony. Elsewhere the train was also seen as a "mechanical horse" or a "fire-snorting animal" that increasingly dominated the landscape, creating a new visual relationship to the world—one that was fleeting, momentary, or snapshot-like, at best. "It matters not whether you have eyes or are asleep or blind, intelligent or dull," wrote John Ruskin, notorious for his dislike of the railways. "All that you can know, at best, of the country you pass is its geological structure and general clothing."[47] In this way, while the painting records the lives of the villagers that it depicts, it also reflects the anxieties about these new social encounters as they were experienced by European viewers. The picture captures, in other words, the modern subjectivity of the colonial traveler, and the consciousness on the part of the European artist of a rapidly changing social order.

It is interesting to learn that Rudolf Swoboda inscribed yet another title for this image on the back of the frame. The alternative title he offered was *Waiting for the Train . . . Madras.* The reference to Madras is puzzling indeed given that a number of visual clues—the young girl's red

Figure 27. *Khazan Singh,*
1886–88 (oil on canvas, 29.8 ×
19.1 cm). The Royal Collection
© HM Queen Elizabeth II.

salwar chamise, the old man's Rajasthani or Punjabi footwear, the
hookah near the village artisan on the right—seem to firmly locate the
village in the north of India rather than in Madras in the south. The ar-
bitrariness in this act of naming further highlights the mythic and fun-
damentally imagined nature of the geography being depicted. If "wait-
ing" is a comment on the passage of time, then this title also reveals the
picture's central preoccupation with temporality itself, or, more accu-
rately, with the unspecified meeting between two different temporalities:
the timeless rhythms of traditional India on one hand, and the rapid
heartbeat of the modern industrial West on the other. Here, the "denial
of coevalness," that persistent and systematic tendency to place the
Other in a time outside the present, has found iconic visual expression.[48]
How should we read Swoboda's rendering of this temporally loaded cul-
tural encounter? Did the artist see India as a picturesque landscape under
threat from the destructive forces of Western technology? Or was he af-
firming and celebrating the integration of the railway into the existing
landscape of India? Or perhaps he was simply offering for contemplation
the new encounters that the railway had created and made accessible to

the European traveler? In the end, I suggest that one way to respond to such questions is to seek out a different perspective altogether, namely that of the Indian painter Ravi Varma. The contrast between Swoboda's work for Queen Victoria and the portraiture generated by Ravi Varma brings two worlds into sharp relief at the point of their intersection.

INTERTWINED HISTORIES:
RAVI VARMA AND THE ETHNOGRAPHIC BIND

Much scholarly effort in recent years has been directed toward interpreting the story of Ravi Varma and, in particular, toward deconstructing the heroic biographies of the artist enshrined by earlier nationalist accounts.[49] For our purposes, however, the phenomenon of Varma best dramatizes the massive transformation to the arts in India as a result of the colonial encounter, especially the shifting relationships between painting and print production that were reshaping the new bourgeois sphere. Varma, the self-taught oil painter from Kerala, not only proved his mastery of oil and the dominant style of academic realism through his "excellent likenesses" in the field of portraiture and his large neo-classical renderings of Hindu mythological themes, but he also toward the end of his life opened a printing press with his brother and shifted his focus from the realm of "high art" to the domain of mass production. Significantly, he would be rejected by Abanindranath Tagore and the Bengal School when their nationalist project of a "new Indian art" was inaugurated in 1905 in response to the perceived hold over creativity by the British art schools.[50] For the proponents of the latter, it was Ravi Varma's capitulation to the Western techniques of oil and easel, as well as to the market-based forces of mass production, that made him unsuitable to the task of a national art form.

It is precisely because of these paradoxes and contradictions that we now see Varma as the "indisputable father figure of modern Indian art"—not because he was the prodigy "who stole the fire for his own people," but because he represents the ironic fact that "the modern never properly belongs to us as Indians, or we to it," as Geeta Kapur has poignantly observed.[51] Many of his pictures stand as "masterpieces of liminality," positioned as they are between different audiences, both Indian nationalists and the British elite, and between secular ideals and Hindu thematics.[52] His success was that he melded academic painting, elite patronage, and popular production together in a uniquely successful national sensibility.[53] By the early 1870s he had broken away from the regional artistic conventions

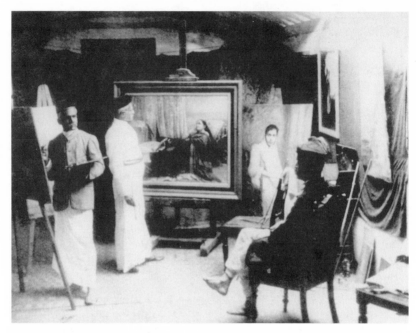

Figure 28. Ravi Varma and his brother, Raja Varma, painting in their Bombay studio, 1894. Courtesy of Erwin and Christine Schelberger.

of his home in Tanjore, most notably its tradition of painting on glass, and he produced his first commissioned portrait in oil at the age of twenty-two. Soon after, he earned full recognition as a portraitist with his commissioned picture of the Madras governor, the Duke of Buckingham. By the end of the decade he had become well known for his skill in depicting the "European-like" grace of his Indian subjects, and for his respectable images of Indian women with their neoclassical features and ivory skin. In the 1880s and 1890s he traveled all over the subcontinent gaining visibility and prestige, securing commissions, exhibiting his work, and winning awards. Unlike Swoboda, he proved equally adept at capturing the likenesses of both Europeans and Indians.

Ravi Varma can thus be seen as a challenge to the monopoly of European painters in the late Victorian representational project. And yet, there is a lack of consensus regarding the range of visual alternatives presented by Varma to the dominant modalities we have seen thus far. Accordingly, some scholars have directed their attention to interpreting his theatrical, large-scale history paintings, such as his *tableaux vivants* of Hindu and Sanskritic mythology, while others turn to his kitsch, col-

orful oleographs and the ubiquitous printed output of the Varma Lithographic Press. Still others highlight Varma's complex position within a nexus of visual regimes such as painting, print, theater, and film, and acknowledge that his early transgressions were pictorial precedents for some of the vibrant visual forms operating in the subcontinent today. More relevant for our purposes, however, are his activities as an Indian portraitist rivaling the likes of Rudolf Swoboda in his attempt to showcase the people of India on the national and international stage. In 1892, for example, Varma submitted a consignment of ten pictures titled "The Life of Native Peoples" to the World's Columbian Exposition in Chicago as a self-consciously constructed corrective to the ill-informed image of the "white man's burden" on display at the international exhibitions. According to one biography, Varma felt it was his duty as India's premier artist "to bring to the notice of the West the charm and sophistication of the Indian people."[54] The paintings he chose were all of women—from different castes, ethnicities, and regions, and dressed in traditional attire. They included one titled *Malabar Beauty,* depicting an elegant woman with her hair done up in a traditional Keralan style playing the *veena,* a string instrument. Another, *Begum at the Bath,* showing three female servants preparing an aristocratic Muslim woman for her bath, recalls the sensuous treatment of this theme by European painters like Ingres and Gérôme. Others, such as *Hope* and *The Disappointing News,* offer small vignettes of human emotion, from joy to misery, with a relentless eye on the physical beauty of his idealized female subjects. An accompanying pamphlet that described the theme of each painting for the American audience confirmed this process of idealization. One entry describing, for example, "a Muslim woman dressed in Hindu style," stated that "she can be seen anywhere in India."[55]

Ravi Varma received two gold medals for these entries, and his success on the international stage further cemented his popularity in India. His awards, of little consequence to American audiences, made headline news in the Indian press. The *Malayala Manorama,* the major daily of his home state, proclaimed that the news of Varma's first prize in Chicago was cause "for great jubilation to not only the Keralites but to all the Indian people."[56] The diploma he was granted, however, reveals several truths at odds with the reception he was given at home. Praising Varma's "well-executed paintings" for being "true to nature in form and color," the judges also stated that they demonstrated British progress in the area of "instruction in Art," and they congratulated the imperial ad-

ministration for their accomplishments, a great irony, since Varma was of course not institutionally trained. More significantly, Varma's paintings did not make it to the venerable fine arts pavilion at the Chicago World's Fair. Instead, his pictures, along with those of the Indian photographer Deen Dayal, were relegated to the ethnographic section, admired not as works of fine art, but rather commended by the judges for their "ethnological value" and held up as evidence for the continued success of the civilizing mission.[57]

On the surface, Ravi Varma's portraits for the Chicago World's Fair may appear to inhabit the same kind of space as Rudolf Swoboda's royal commissions for the Queen. Both painters displayed, for instance, the need to capture a cross-section of Indian society, the commitment to a colorful composite account, and the determined pursuit of "beautiful things," all crafted for highly visible international arenas. Moreover, it appears that Varma, like his European counterpart, painted his series of ten pictures for Chicago rather quickly: five in December 1892 and the rest in April of the following year.[58] However, I am suggesting, to the contrary, that their parallel careers should expose—not collapse—the profound asymmetries of their professional trajectories within the power relations of imperial rule. The contrast between the two painters in the end reveals a number of imbalances that have plagued the history of painting in the colony, and returns us to a previous theme, namely, the powerful parameters of representation witnessed in the spectacle of empire at the metropolitan exhibitions. As Kapur has suggested, Varma's containment in the domain of ethnography on the international platform of the Chicago World's Fair put him in the difficult bind of "representing the race to the alien gaze."[59] For Kapur, this raises an "endemic problem" for the non-Western artist seeking to appropriate and devise an identity for his people, namely, the problem of accepting the "terms of the other's fantasies."[60] If Varma's experience in Chicago shows the signs of this lapse, it does not in the end prevent him from reshaping the fantasy into a visual iconography for the emerging nation, one that is autonomous and oriented toward "unity in diversity," a paradigm that is expressed most powerfully in his 1889 painting A Galaxy of Musicians (figure 29). In this painting of a "closely packed, richly bedecked band of female musicians"[61] representing the different regions of the subcontinent, we see Varma rework the prevailing orientalism, and not least of all portraiture itself, to serve the interests of a national reality that is fundamentally at odds with the one that Rudolf Swoboda once served.

To return, then, to the question with which I opened this chapter: how

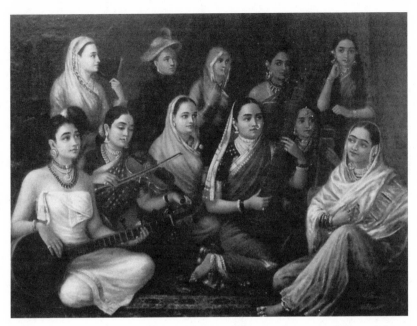

Figure 29. Ravi Varma, *A Galaxy of Musicians,* circa 1889 (oil on canvas).

should we read Swoboda's hall of "colonial heads," recently unveiled at London's National Gallery, from the vexed perspectives of our post-colonial era? This overlooked archive of "high empire" paintings, com-missioned by a British queen, created by an Austrian, and featuring an all-Indian cast, should be viewed, at the very least, as a transnational col-laboration in which a number of histories have come to converge. Today these paintings embody and expose the intertwined nature of these his-tories; they recall not merely the visit made by a European artist to India, but also the journey of oil painting to the colony, and the subsequent tra-jectories of Indian painters, often back into the "exhibitionary complex" of the Western metropolis and its structures of classification and con-tainment. Against the tendency of connoisseurs of the Royal Collection to valorize their formal attributes, their contribution to a national past, and their supposed attention to ethnographic detail, I have suggested that Swoboda's pictures of the Queen's Indian subjects should be read in-stead as a window onto the larger asymmetries that remain hidden within the history of portraiture itself. The British role in art education in India, the emphasis on copying in the colonial curriculum, the adop-tion of the culture of the European salon by Indians, the rise of a new

identity for the Indian artist: all of these have been crucial to the "politics of the palette" and the discrepancies between Europeans and Indians that have permanently imprinted the course of art in the twentieth century. Several of the tendencies in Swoboda's painting, such as the construction of a vast temporal distance between Europe and India, the fascination with a traditional Indian subject, and the preoccupation with the village and its leitmotif, the craftsman, are legacies that continue to exert their pressure on the practices of representation today. Similarly, the problem of "borrowing" from the art history of the West, and the struggle to arrive at an Indian expression through techniques and styles derived from Europe and America, continue to persist as ambivalences and paradoxes for contemporary artists in the Indian subcontinent. Swoboda's "peep" at the Queen's Indian subjects, read through a comparative or contrapuntal frame, offers an aperture on these multiple legacies *together*, and poses dilemmas for representation on a global scale.

Collecting Colonial Postcards

Gender and the Visual Archive

In most souvenirs of the exotic . . . it is the possessor, not the souvenir, which is ultimately the curiosity.

Susan Stewart, *On Longing,* 1993

With individuals as with societies, the need to accumulate is one of the signs of approaching death. . . .

Walter Benjamin, *The Arcades Project,* Convolute H

The date of the postcard album of Miss Josephine Eppes, preserved in the Oriental and India Office Collections in London, is approximately 1900. Bound in a decorative red cloth cover with the words "Postcard Album" embossed on the front, it contains private photos, loose newspaper clippings, and other forms of personal memorabilia, as well as seventy-two different postcard views of people and places in Burma, Simla, Darjeeling, Calcutta, Lahore, Delhi, Bombay, and Agra. The *preciousness* of Josephine's postcard album reminds us of the Queen's collection of portraits by Rudolf Swoboda, which she similarly viewed as an array of "beautiful things." But Josephine's postcard album never received the aesthetic praise given to this nineteenth-century royal collection, nor did it achieve the privileged status of colonial photography, with its powerful claims to truth and objectivity. Instead, the postcard has remained decidedly unscientific, lacking the seriousness, skill, or physical beauty accorded to painting and photography.

Josephine's album thus generates several observations that serve as the point of departure for this chapter. The first is that the emergence of the

picture postcard in Europe in the last decade of the nineteenth century occurred at the height of British political rule in India and European expansionism in other colonies. The extraordinary popularity of the postcard from roughly 1890 to World War I, a period in which postcards were produced, consumed, collected and circulated with an energy that remains historically unmatched, must be understood within this context of "high" empire. In other words, the golden age of the picture postcard corresponded roughly with "the heyday of invented tradition," the period in British history during which national and imperial ideologies were reinvented in such a way that the dominant symbols of the British nation became inseparable from imperial ones.[1] The colonial postcard thus represents a distinctively modern visual genre—one that emerged largely as a souvenir of public and imperial exhibitions, but that also became the subject of its own peculiar collecting phenomenon throughout Europe at the turn of the century.

My second observation is that the phenomenon of the picture postcard is not reducible to the history of photography, with which it has too often been conflated. As a representational form, the postcard perhaps has the most in common with the *carte de visite,* a form of photographic portraiture developed by Disderi in 1854 that became a bourgeois fashion during the 1860s. As Deborah Poole has demonstrated, these miniature portraits mounted on "firm cardboard backings" were collected, received, and distributed by an international bourgeois class in the second half of the nineteenth century.[2] Like the *carte de visite,* the postcard reached the status of a commodity that could be collected, arranged, and exchanged. Yet not all postcards from the golden age were photographic representations: some of the most popular, in fact, were colorful illustrations. And unlike the *carte de visite,* whose precise depictions of human beings provided useful evidence for nineteenth-century racial theorists, the postcard provided views of distant lands and peoples that were far less susceptible to appropriation by science. The postcard, in general, is not reducible to the logic that determined nineteenth-century photography. What distinguish the postcard as a visual genre are its complex circuits of production, consumption, collection, and travel. Indeed, I suggest that the ephemerality, collectibility, and availability of the postcard are themselves important elements in the way it functions as a form.

My final observation is related to this: the colonial postcard is inseparable from the thematic of gender, for the postcard, as others have noted, reveals a complicated sexual and political economy.[3] Postcards were not only preoccupied with images of exotic women from distant

lands, but they also implicated European women, such as Josephine Eppes, as consumers and collectors of their non-Western counterparts. Malek Alloula, author of *The Colonial Harem*, ignores this latter fact in his book about images of Algerian women on French picture postcards from the period between 1900 and 1930. Alloula describes this archive as a "pornographic one"—"the equivalent of an anthology of breasts"— an archive that history has swept "with broad strokes out of its way."[4] Claiming that these cards depict the harem as "a brothel," and that the Algerian women in them have been "raided, possessed" by the European photographer, Alloula undertakes a twofold operation: "first, to uncover the nature and the meaning of the colonialist gaze; then, to subvert the stereotype that is so tenaciously attached to the bodies of women."[5] Alloula presents his contestatory project as an attempt, "lagging far behind History, to return this immense postcard to its sender."[6]

As one feminist critic has observed, Alloula's book thus reproduces a voyeurism "even as it attempts to label that gaze as hegemonic," both through its oversized format (most of the images of nude women are blown up larger than the postcards themselves) and in its highly sexualized model of colonial relationships that posits the Western male photographer as spectator/violator and the non-Western woman as the object of his gaze/penetration.[7] And indeed, Alloula conceptualizes the encounter between the European photographer and his Algerian models as a narrative of heterosexual copulation involving frustration, impotence, and eventual violation. He argues that the veil disables the photographer's ability to penetrate the woman with his lens. Further, the woman's eyes, like "tiny orifices," filter through the veil back at the photographer, making him feel photographed. The photographer's response is thus a "double violation," one that Alloula confesses he cannot bear to watch: in the privacy of his studio, the photographer unveils the veiled and represents the forbidden. Alloula's attempt to "return this massive postcard to its sender" is thus ultimately a project of retaliation, and echoes an all too familiar historical competition between nationalist and colonialist patriarchies. That competition leaves no space for the female subject (her silence, in fact, is predetermined by it), but instead plays itself out upon her body.[8] *His* women's bodies, Alloula implies, have been violated by the colonist's gaze.

A feminist reformulation of the colonial postcard must reject Alloula's nationalist account and the paradigm of "visual violation" that it proposes. I argue in this chapter that postcards of India reveal much more about the structure of gender relations than the heterosexualized drama

Alloula projects. To understand the gendered economy of the postcard, I reflect on the form in several different ways: I focus on its origin as an epistolary object, on its production, circulation, and collection practices, and on the tragically "low" status and historical legacy of this genre. I then examine how colonial postcards functioned in relation to India by analyzing some of their social representations, especially those cards depicting native human types defined by caste, occupation, and gender-based categories. The empirical site for my study is postcards of India from the heyday period, found in both private and public collections in Britain and the United States. The images of women that appear on these cards not only show Indian women as sexual objects, but they also depict European women in the colonies, as well as the meeting *between* women in colonial society. What these postcards of India thus make visible are differing and hierarchical constructions of womanhood that are defined in part in relation to each other and through women's different relationships to the colonial public sphere. Furthermore, the role of European women as consumers of these images makes the legacy of colonial history itself visible within the context of transnational feminist relationships today.

THE EMERGENCE OF A MODERN GENRE

It is telling that, in the era of the invention of photography, the postcard originated as an epistolary innovation rather than a visual one. An Austrian post office official, Dr. Emanuel Herrmann, was the first to successfully argue for the introduction of a card, "thin and buff coloured" and uniform in size, that could help relieve the financial burden of postal correspondence on the state.[9] Austria thus became the first country to introduce the postcard, in 1869. By the early 1870s the use of these postal mailing cards—cards without pictures—had been adopted by most countries in Europe. Shortly thereafter their production was privatized. In Britain, for example, by 1875 any company could print a postcard, as long as it obeyed a strict set of rules issued by the British Post Office: the words "Post Card" and "The address only to be written on this side" must be printed on the front of the cards. The cards must be white, and not tinted; they "must not be folded nor cut in any way"; and they must conform to the same size and thickness as the official post office cards. Finally, in the early 1870s no cards were to be sent out of the country.[10]

 The early history of the postcard was thus a history of regulating the form—of determining the rules that would restrict its functions and sep-

arate the card from other kinds of communication. "The infringement of any of these Rules," the postal authorities warned, "will render the cards liable to higher postage," or, worse, will result in confiscation.[11] While Britain's prohibitions related to the postcard's size, destination, and the format of its message, other countries such as Austria and France also censured the content of its message. The Austrian government warned, for example, that a postcard would not be delivered if "obscenities or libelous remarks" were found on the card.[12] French authorities issued a more ambiguous instruction: post office employees were both forbidden to read postcards *and* not allowed to deliver any postcard with a "written insult or abusive expression."[13]

The idea that postcards could improperly exhibit their private messages to the general public led some members of the bourgeois classes to express their opposition to the new epistolary form. In particular, the postcard's lack of privacy was perceived as a threat to the structures of class: "Would not the servants read the messages?" asked members of the upper strata.[14] Others saw it as too cheap a form to have any social value, arguing that the use of a halfpenny postcard was an insult to its recipient. "If a penny was not paid for a message," they believed, "then it was hardly worth sending at all."[15] Yet the expediency of the postcard—its ability to convey a short, quick message—would eventually outweigh the perceived disadvantages of the form. The postcard was efficient and, as one commentator noted, "in this busy and whirling world in which we live, it is just this aspect that makes it dear to people."[16] "The picture postcard is a sign of the times," summarized another turn-of-the-century writer. "It belongs to a period . . . with express trains, telegrams and telephones."[17] If long, leisurely letters belonged to the time of the stagecoach, then the postcard with its two- or three-line sentiments, was the perfect form, temporally speaking, for the modern world.

The idea of printing a picture or view on the postcard, which emerged in the 1880s, made the postcard an even more efficient form by further reducing the need for written communication. Pictures compensated for the paucity of content in the message, serving as a substitute for any substantial correspondence. Because illustrations had been incorporated on writing paper and envelopes for many years, it seemed logical to extend them to the postcard. At the same time, the reduction of exposure times in photography and the arrival of George Eastman's Kodak in 1888 had enabled high-quality photographic images to be mass-produced and sold cheaply, widening the market for visual images and reshaping the processes by which images were produced and consumed.[18] The tech-

nology of lithographic reproduction had been also transformed by the
new collotype process, a German invention in color printing, resulting in
brightly colored and aesthetically pleasing pictures on postcards. In
1902, when the divided-back format, which separated the space allotted
to the message from the space intended for the address, was introduced
in Britain, it became possible for publishers to use one entire side of the
card for a picture, formerly shared by both the inscription and the image.
The picture eventually came to dominate the postcard, reshaping it by
the end of the century into a distinctively modern and fundamentally vi-
sual genre.

THE HEYDAY OF THE PICTURE POSTCARD

The result of these changes to the form of the picture postcard was a
frenzy of postcard activity in the period between approximately 1890
and 1918. Postcard publishers in Europe and America scrambled to meet
the demands of consumers who claimed to be swept away, in the words
of one contemporary enthusiast, by the enormous "attraction of these
persuasive little agents."[19] In France, for example, picture postcard pro-
duction was recorded at an estimated 8 million cards in 1899, jumping
to 60 million by 1902 and 123 million in 1910.[20] In Britain during 1908,
more than 860 million cards were reported to have passed through the
British post, a figure that some claim is unmatched in history.[21] And in
Germany, one of the leaders in postcard production, some 786 million
cards were sent in 1900, meaning that every member of the German pop-
ulation would have sent an average of fifteen postcards that year.[22]

As such figures suggest, postcard collecting became one of the most
fashionable hobbies in Europe and North America. Membership in
mail-in clubs such as the Globe Postcard Exchange Club based in Min-
neapolis became a popular way for individuals to circulate, exchange,
and acquire new cards. Moreover, dozens of collectors' newsletters and
magazines, such as *The Postcard Connoisseur* (1904) and *The Picture
Postcard and Collector's Chronicle* (1903), appeared around the turn of
the century. "The craze has had a curious effect," observed one writer in
the summer of 1900. "Wherever you go the picture postcards stare you
in the face. They are sold at cigar-shops, libraries, chemists', and fruit-
stalls." People no longer speak to each other, he added with some con-
cern. Instead, they seat themselves in public spaces with "little piles of
picture postcards" upon which they monotonously write.[23]

Who actually produced these cards? The story of postcard production

is today barely legible; it is elusive, sketchy, and historically scattered. Naomi Schor, in her study of early twentieth-century postcards of Paris, writes of "the enigma of those initials," referring to the initials on the back of a card that, if they appear at all, provide the only trace of a publisher's identity.[24] The initials may result in a certain uniformity in the look and quality of the image, but they do not operate as the signature of an author. Even more confusing is the fact that the publisher of the postcard was usually different from the printer. Most postcards prior to World War I were printed anonymously in Germany or Austria, countries that were leaders in the technology of lithographic reproduction. The British publisher Raphael Tuck and Sons, for example, used unidentified German printers for many of their cards. The same was true for Indian publishers such as the Phototype Company in Bombay and H. A. Mizra and Sons in Delhi, whose postcards were printed in Germany and Luxembourg. Like many of the publishers that profited from the boom, Raphael Tuck and Sons were already known as "art publishers to the Queen," with an established reputation in the printing of greeting cards prior to the arrival of postcards. Unfortunately, the Raphael Tuck postcard factory, and several others like it in Europe, were destroyed during World War II.[25]

This lack of information itself reveals a great deal: postcards were mass-produced across multiple sites, transnational in nature, and anonymously executed. Postcard production around the turn of the century was an international business, encompassing many large national firms and an even larger number of tiny, local operations. If, as Alloula has suggested, "travel is the essence of the postcard, and expedition is its mode,"[26] then the dispersed circuits of postcard production extend the idea of its travel far beyond any simple journey between colonial sender and metropolitan receiver. Even the means of travel itself could become a site for production, as in the ship postcards printed by shipping companies and issued free to their passengers.[27] For the colonial postcard, the circuits of travel were even more staggering: a photograph might be shot in India, produced as an image by a publisher in Britain, sent to Germany to be printed as a postcard, sold to a colonial officer or traveler back in India, returned to Europe as a souvenir or greeting, only to find its place on display in a private collection in a European home. The postcard, in short, was always everywhere. Mass-produced, dispersed, and always in motion, it was the quintessential traveler of the modern age. The postcard is therefore both a cosmopolitan form and a constant reminder of the imperial conditions that establish the basis for modern cosmopolitanism.

NATIVE VIEWS

Although these qualities have led one author to describe the postcard as
having "little regard for nation-state politics," the themes depicted on
colonial postcards in fact suggest that the phenomenon was inseparable
from the imperial nation. Images from the golden age of the postcard are
by no means exclusively concerned with the colonies; on the contrary,
they encompass every subject imaginable, from technology, sports, ar-
chitecture, and politics to more specialized topics such as accidents, mil-
itary history, favorite dogs, or special events. However, images that be-
came known as "native views" were especially desirable in Europe and
America. A native view postcard relied on a preexisting repertoire of aes-
thetic themes and conventions in its depiction of colonial spaces. It
brought the romanticized landscape of picturesque painting, the ethno-
graphic portrait enabled by advances in photography, and the humorous
caricature of a *Punch* illustration simultaneously into its aesthetic frame.
In the case of India, native views depicted Indian buildings or landscapes
along with images of colonial bodies defined by caste, occupational sta-
tus, gender, and religion. By definition, a native view postcard displayed
the entire human and physical geography of India.

Native views of India would often celebrate Britain's architectural
achievements in the colony through photographs of sites such as a statue
of Queen Victoria in Rawalpindi, a post office in Lucknow, or a railway
station in Calcutta. These images of British architecture—of buildings,
bridges, gateways, and arches—functioned as symbols of Britain's in-
dustrial strength in the colony and underscored ideologies of Western
progress in India.[28] Other native views displayed precolonial architec-
ture, especially buildings from the Mughal period, such as Wazir Khan's
mosque in Lahore, the fortresses of Delhi erected by Akbar, and, of
course, the Taj Mahal. While imperial architecture was often represented
through the authoritative aesthetic of full-size sepia-toned photographs,
precolonial architecture in India was more often depicted in a drawing
or painting, sometimes framed by a smoky or fuzzy border, evoking a
sense of nostalgia (figure 30). Still other native views depicted interior
spaces, such as the hall of a palace in Delhi, or picturesque landscapes
from a particular perspective, such as "View from the Mall, Simla." The
aesthetic conventions of these images—the medium in which they were
executed and the manner in which they were framed—served to separate
the past from the present. They suggest a "before" and "after" portrait
of India, that is, before and after the British arrived. These images

Figure 30. "Delhi Gate, Agra Fort" (postcard).

convey a sense of the distance between the modern, civilizing presence of the British in India and the ancient purity of its traditional culture. They express the triumph of empire in colonial space, the *work* of civilization.

Such native views rendered India (and indeed the whole non-Western world) in miniature, creating another world of tiny cards that could be collected, arranged, and exchanged. For its European owner, the three-by-five-inch native view established a visual connection to a particular place and transformed that relation into an act of possession. Native views of India thus functioned in the formation of imperial identities by affirming the capacity of the Western recipient or collector to possess, admire, or discard "the rest." In the totalizing words of one early British collector, "Nothing in print is more universal than the postcard"; no native view, "however unimportant, can escape its delineation."[29]

The status of the postcard as a souvenir object is evidenced by the fact that the best native views, those perceived to have the highest value, were those received or purchased from the locations they depicted. A native view card sent from Agra, for instance, would be more valuable than a postcard of Agra purchased in London. The Asian Exchange Club, a European postcard club based in Poona, was established precisely in response to such preferences. For a small annual fee, members received a complete list of addresses of the membership and a subscription to its quarterly newsletter, *The Indian Philocartist,* which featured the latest postcard information. At the back of this newsletter (and most other col-

lectors' magazines) were lists where individuals in search of native views could advertise their postcard preferences. These exchange lists, which operated on the simple rule of "a card for a card," encouraged reciprocity. Ads would typically read, "all countries exchanged, Asiatic views preferred," "send postcards of your district and I will send same number in exchange," or, simply, "Wanted Native Views." Other entries specifically requested that a card be "posted from [the] place depicted," illustrating that the quality of a native view also depended on its postmark or stamp. A native view card bearing a postmark from India, for instance, was more desirable than a postcard of India purchased in London: the postmark became like "the receipt, the ticket stub, that validates the experience of the site."[30]

Publishers participated in this culture of collecting by issuing native views in thematic sets (usually of six or twelve) and by promoting special collecting accessories such as postcard albums, pouches, packets, and boxes. In 1907, for example, Meyers and Company, self-described as "postcard album specialists," advertised their very latest product, a pocket-sized album called The Little Gem, available in silk or padded leatherette. In relation to India, the British firm of Godfrey Phillips published a series called "Our Glorious Empire," which consisted of thirty scenes of India designed primarily for display as a collection. Another popular series, "Beauties of India," boasted "artistic images of the gentler sex of India" and comprised part of a larger collection of women of different Asian nations. The thrill for collectors was in acquiring all the native views in the series, and they would specify in collectors' magazines their wants in these terms (indicating, say, "Looking for native views, especially Godfrey Phillips, Series One to Thirty"). In 1903, Raphael Tuck and Sons, perhaps the largest British producer of postcards at the time, introduced its "Wide-Wide-World Oilette" series, which included thousands of native views of India (including Delhi, Lucknow, and Agra) and other colonies, all numbered, captioned, and labeled for the collector (see figure 31). Another of its series was titled "Historical India," still another "The Rise of Our Empire Beyond the Seas." The images, according to the publisher, were adapted from "real photographs, skillfully colored and worked up by expert artists into a rich facsimile of a real oil painting."

This last series was one of many that featured native views that were not photographic representations. Such postcards were frequently designed as little paintings, often printed with fake wood or gilt borders, which added to their preciousness, and hence their collectibility (see figures 38 and 39, later in this chapter). As mentioned earlier, native view

Figure 31. "Lahore Central Museum" (Raphael Tuck and Sons' "Wide-Wide-World Oilette" postcard).

postcards were heavily influenced by the conventions of painting and portraiture. Each card of Raphael Tuck's oilette series ("rich facsimiles of real oil paintings") was stamped with a trademark symbol of an artist's palette and easel. Significantly, the logo represented the painter's tools, but not a particular painter. In reality, publishers such as Raphael Tuck would employ numerous artists for whom postcard work was a steady source of income. Most used pseudonyms or remained anonymous, since such work was not seen to further an artistic career. By the end of the nineteenth century, illustration was considered an acceptable occupation for women, and many women who were already employed illustrating calendars, children's books, greeting cards, and so on ended up in postcard design.[31] The close relationship between postcards and painting was an important factor in the collectibility of cards, transforming what was cheap and widespread into something perceived as an original product. For only a few pennies it was possible for anyone to create a gallery of their own oilettes.

By the last decade of the nineteenth century such postcards had transformed the fascination with exotic native types that had shaped the photographic collection *The People of India* by making the images available in a portable and more accessible form (figure 32). Yet the portrayal of Indian people on postcards was not just the idealized depiction of a prim-

itive culture, apparent on similar postcards of Africa and other parts of the world.[32] Native views also displayed a preoccupation with the social structure of caste in India, itself increasingly considered by colonial anthropologists as an essential component of Indian society.[33] By the late nineteenth century, an individual's caste position was seen to correspond to his or her occupational status, transforming caste into an observable trait rather than an abstract principle of the Hindu religion.[34] The postcard's form was particularly well suited to portraying caste as a coherent system because it displayed supposedly distinct caste types as collectible cards within a larger series. Native views of India thus offered endless images of human types represented by their religious or occupational status (a tailor, a shoemaker, a Sikh, a Muslim). Although some of these images were printed from photographs, most originated as illustrations and sketches, most likely because of the cumbersome nature of the camera outside the studio. Instead of using photographs, publishers of native views most often depicted Indian caste categories using attractive, multicolored illustrations, in the manner of the postcard called "Hindu Tailor," shown in figure 33. Other postcards used humorous caricatures, such as one in the East and West Series that posed an Indian *mali* (gardener) next to a British farmer under the title "How does your Garden grow?" (figure 34). Still others, such as those in Tuck's oilette series, also carried didactic or ideological messages on the back. For example, the back of a postcard titled "Group of Sikh Native Officers" reads, "The Sikhs are a native race of religious origin inhabiting Punjab. In the middle of the nineteenth century they gave the Indian Government considerable trouble, but since their final subjugation in 1849, the Sikhs have been loyal subjects of England."

Such images presented the natives of India through their occupations or religions, which were in turn associated with caste position. A group of men and women praying under a tree is thus titled "Mohammedans at Prayer, Delhi" (what is important to know is that they are Mohammedans and not perhaps Parsi or Jain). Together these images could be combined to construct a larger portrait of Indian society. A collector could have, say, a potter, a postman, a gardener, and a cook but be missing a tailor and a Muslim in the collection. Native view postcards thus became like the building blocks of caste: collectors could organize and arrange the entire caste system through these three-by-five-inch representations of natives. With the native view postcard, this vision of caste and religious difference in India became available for mass consumption in Europe.

Postcard images also demonstrate how gender difference is produced

through a category such as caste, as many postcards showing Indian women define a woman first by her caste position. Unlike men, however, Indian women were not defined by their occupations, and therefore their bodies were made to perform caste differently. In the example of figure 35, a waist-up portrait titled "Batia Woman," the woman's costume and jewelry serve to signify her Batia status. Most often, Indian women are shown seated or standing in the studio, with a simple prop (a table or a chair), and dressed or adorned in meaningful ways. Unlike the postcard views of Algerian women examined by Alloula, these images depict Indian women fully clothed, and are occasionally framed by imitation wood borders that create the effect of a miniature painting. Other cards, as in figure 36, present a woman in a supposedly spontaneous and always nonphysical activity such as "thinking" or "dreaming." This is not to suggest that these images are without erotic content or are not sexually charged. They are indeed highly sexualized fantasies of Indian otherness, and sometimes a seductive pose or an exposed hand or foot of an otherwise heavily ornamented female body subtly stages an exotic sexuality (figure 37). Yet even the images in the popular series of "Indian Dancing Girls" are subdued: although colorful and highly adorned, the women are seated in respectable poses, and their likenesses are framed like beautiful paintings (figure 38).

In contrast to these exotic portraits of Indian women, other postcards featured the spectacle of white women's presence in the colony. The image in figure 39, for example, of a European woman carried by four bearers titled "Darjeeling: A Dandy," was variously and endlessly reproduced. In some versions, the Victorian woman who is the subject of this picture is carrying an umbrella to protect herself from the sun; in others, a hat fulfills this function. But in all of them, the woman is carried by four native men. The image is a humorous one, the dandy symbolizing excess or folly. The dandy cards become, in effect, a recurring motif for the curious place of white women in the colonies.

Such postcards, although extremely common, were markedly different from native views and thus should be considered a separate category. They are, more precisely, tourist or traveler cards. These tourist postcards represent European women in India as colonial adventurers in exotic locales. Most of them feature photographs taken in public spaces rather than the private space of the studio. If Indian women were portrayed as seductive yet traditional, passive, and inactive, then the opposite was true for their European counterparts. Here, the immobility of the Indian woman (as in the *zenana*, for instance, where she was seen as imprisoned

Figure 32. "A Hindu Family"
(postcard).

Figure 33. "Hindu Taylor"
(postcard).

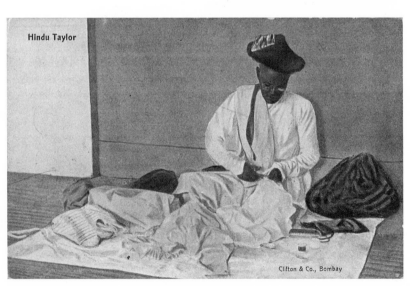

Figure 34. "How does your Garden grow?" (East and West Series postcard).

and secluded by *purdah*) stands in stark contrast to the traveling Western woman with her pioneering spirit and freedom to move around.[35] In many of these cards, however, the European woman appears with her husband. Figure 40, a postcard titled "Around the World with Winfield Blake and Maude Amber," was published by a couple with those names in 1910. The image shows the pair at what is labeled a "Jain Temple, Calcutta," above which appears their logo—a picture of their smiling faces transcribed onto a globe, with a camera, a train, and a steamship in the background.

The printing of such tourist cards—at a time when photography was still a cumbersome way for average bourgeois travelers to collect images of their journeys—preserved the modern experience of mass tourism more than it did the specific details of any given tourist site. The cards are thus souvenirs of bourgeois travel itself, of the ability and mobility to view different spaces. Though they claim to depict particular Indian destinations, their real message is "Look at me!" The representation of European women on these cards, however, conveys multivalent meanings. The modern female traveler in the colony was legitimized by the presence of her European husband; on her own or in relation to native men, she was seen as a "dandy," a symbol of excess or folly. In this way, these cards reveal the anxieties that were generated by the uncertain place of white women in the colonies. The Victorian woman's proximity to "the natives" was a constant threat to a colonial patriarchy intent

Figure 35. "Batia Woman" (postcard).

Figure 36. "Thinking" (postcard).

Figure 37. "A Hindu Lady" (postcard).

Figure 38. "Indian Dancing Girl" (postcard).

Figure 39. "Darjeeling: A Dandy" (postcard).

on protecting her perceived sexual purity. These postcards assured their mass audiences at home that European women were being properly managed within the precarious relations of race and gender that structured the colonial public order.

At the same time, these postcards mark the cultural boundary between European and Indian notions of womanhood, which are defined in part through their relation to each other and through their gendered interaction with the patriarchal public sphere. Postcards portrayed the Western woman as a modern and active presence in colonial public space while representing the Indian woman, bound by caste and tradition, as inactive and confined to domestic space. Yet these understandings were also hierarchical, as is demonstrated by a third and final type of colonial postcard, the missionary card. Postcards were perfectly suited for religious propaganda, and thus were widely printed by missionary societies, which used the cards—in Alloula's terms—as the "fertilizer of their colonial vision." Such postcards were circulated to gain support for overseas missionary projects, to recruit individuals into the church, and to disseminate a positive and exotic picture of missionary work in India. And since women led the Christian reform practices in health and education, missionary work was largely equated with women's work by the turn of the century.[36] The domain of missionary activity is thus a highly feminized one, and the images we see on missionary postcards are the only ones that depict European and Indian women together.

Figure 40. "Around the World with Winfield Blake and Maude Amber" (postcard).

Above all, missionary postcards dramatize the racism that structured the relations between women within the benevolent context of the Christianizing mission. Like native view postcards, they too offer before-and-after imagery—in this case, before and after conversion to Christianity. In figure 41, for example, a postcard titled "People of Darkness among Whom We Work," we see a group of villagers who appear pathetic and impoverished before their encounter with Christianity. In the "after" picture, a postcard titled "Khushi and Her Girls" (figure 42), we see what can happen after conversion and the ministrations of the white woman missionary. Khushi, the Western missionary with an Indian name, is surrounded by a group of smiling Indian girls, the epitome of good health and cleanliness with their crisp white uniforms and musical instruments. The girls have miraculously been brought out of the darkness of their past and placed into a sunny present. Missionary postcards such as this one depict the encounter between European and Indian female subjects as a benevolent transaction. In another card, a white woman missionary is seated cross-legged facing an Indian woman whom she is teaching to read; they stare at each other eye to eye, a profile of a gentle encounter on an even plane. Together the women symbolize the triumph of Christianity, the victory of order and hygiene over the tragedy of chaos and filth. These images thus dramatize the inherent racism of the evangelical

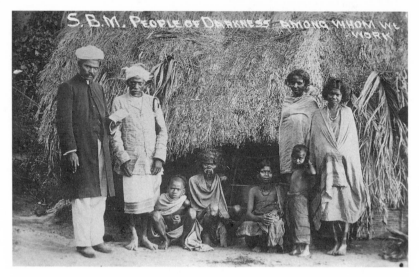

Figure 41. "People of Darkness among Whom We Work" (missionary postcard).

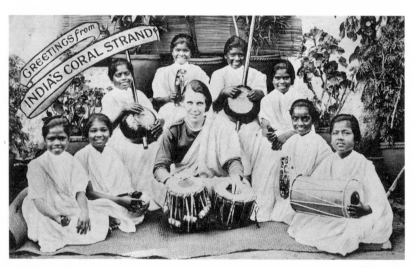

Figure 42. "Greetings from India's Coral Strand: Khushi and Her Girls" (missionary postcard).

mission while staging a portrait of cooperation between women that erases the relations of power between them. What these images *do not* represent are women's political and economic horizons, their conflicted relationships to their communities, their daily activities, their passions, or the dignity of their private lives.

A "LOW" CULTURAL FORM

To read the often hastily scribbled messages on the backs of colonial postcards is to find oneself, as Naomi Schor has suggested, "in the position of the voyeur, or better yet the eavesdropper on everyday life."[37] Such messages are occasionally personal but more often generic, and they are frequently at odds with the visual image in a predictable kind of illogic: "Arrive Marseilles, June 11, 1905" might appear, for example, alongside an image called "Ear-picker," or "Merry Xmas and Happy New Year" might be written next to an image of the Jeypore Girls College in Rajasthan. At other times the message will refer to the image, such as "This is Benares where the brassware comes from, love Jim," or "Here is where Mother lived when she was over here, yours Karen." A large number also comment on the activity of collecting: "Here's another for your album," or (my favorite) "You must let me know when you get tired of these postcards." In the case of native view postcards, the sense of voyeurism is doubly felt: one participates in a colonizing gaze at a highly differentiated racial and cultural other while also peeking at the inscription made by its European sender.

What Schor calls the "two-sided specificity" of the postcard, that is, the fact that both the front and the back of the card operate in its existence as a cultural object, thus takes on new significance in the transaction of colonial relations. Postcard backs are in fact not silent and can challenge the meanings of the dominant front image. No postcard backs are entirely alike: the printed iconography of the word "postcard," for instance, can have as much variation as the picture it displays. It is tempting to view the native view postcard as structured by a tidy binary: the back as bearing an imprint of the modern West (represented by its printing, travel, and postal technologies), in contrast to the traditional otherness depicted visually on the front. But in its unique archive of personal messages, in its compelling transactions between the picture and the "scribble" (that is, between visual and written colonial narratives), the postcard as a form discloses a more complex display of the tensions and negotiations of modernity's raced and gendered relations.

The great paradox of the colonial postcard is that while it evokes the triumph of the imperial gaze, its life is also stamped by sadness. Its existence is cruelly brief. It is devalued, disposable, unimportant, and kitsch. It is frequently indistinguishable from its siblings on the rack. Its producers prefer not to be associated with its production. It is neither a real gift nor a full letter. It is quick, "abundant, systematic and cheap," and it has a marginal standing within the archive.[38] Unlike other printed collectibles such as baseball cards or stamps, postcards are very rarely valued at more than a few dollars.

In short, the postcard is a notoriously *low* cultural form. Early collectors' magazines were committed to the task of trying to raise it out of its degraded status as a product of mass culture. In 1904, the editors of *The Postcard Connoisseur* wrote that the task of their journal was to "disparage carelessness and vulgarity in the art" and to "arouse a more intelligent interest." But the postcard would escape all attempts to create a high culture of connoisseurship around it. And like other products of mass culture such as the romance novel and the television soap opera, it would become unmistakably associated with the feminine.

The feminization of mass culture—that is, the relegation of mass culture to the inferior sphere of women—has its origins in the nineteenth century and is paradigmatic of modernism.[39] Postcards, too, were delineated as low because of their association with women. It was "the feminine love of ornament," according to male writers, that explained the postcard craze.[40] In 1907 another stated, "The postcard has always been a feminine vice. Men do not write postcards to each other. When a woman has time to waste, she writes a letter, when she has no time to waste, she writes a postcard."[41] Such judgments were levied not only against the writing of postcards, but also against the activity of collecting. Even the hobby itself was identified as a woman: it was referred to as the "Cinderella of collecting," and viewed with disdain by her elder sibling, stamp collecting.

Indeed, my survey of postcards in private and public collections confirms that European women were major collectors of postcards during the heyday period. Several museum collections have been constituted largely of donations by American and European women, and women's names appear in large numbers on the exchange lists in journals from the period. Little is known about these female collectors (who bear such names as Miss Ernestine Klastte of the German Rhine, Mrs. Ashleigh Ardern of Cheltenham, and Miss Frieda Guttman from St. Petersburg,

Russia) except that they resided all over the Western world and partici-
pated enthusiastically in postcard collecting.[42] Postcard journals were
also filled with advertisements for products directed at female con-
sumers, such as a Christmas "Lady's Postcard Album" or Bertrand's
Hand Balm for "softer, whiter hands." Although it is difficult to deter-
mine with historical precision, it is probable that women also had a sig-
nificant presence in the anonymous field of postcard illustration. For
Malek Alloula, at least implicitly, European women neither collected nor
produced nor appeared on colonial postcards. But contrary to his as-
sumption, the possession of images of Indian women was not simply an
activity of the colonizing white male. European women figure centrally
in the life of the postcard, from the processes of its production to its col-
lection and display. Even in the tragedy of its lowness the postcard is, in
Schor's terms, "the very example of the feminine collectable."[43] Reading
the colonial postcard through rather than around this lens of gender of-
fers a perspective that restores European women as historical subjects,
consumers, and producers of postcards.

The inclusion of Western women within the sphere of the postcard al-
ters the historical picture considerably. Indeed, it reveals a cultural and his-
torical encounter very different from the "drama of penetration" perceived
by Alloula.[44] Postcards reveal more about the structure of gender relations
in colonial society than the obvious fact that they sometimes depict sexu-
alized images of women's bodies; they show competing and hierarchical
constructions of womanhood that were simultaneously embedded in im-
perial patriarchies. In another sense, these postcards document a female
subject whose presence has been historically eclipsed by the logic of a male-
centered nationalist response to colonialism.

Unlike Alloula's French postcards of Algerian women, the surviving
British colonial postcards of Indian women do not commonly feature nu-
dity. The Victorian morality of late nineteenth-century Britain may par-
tially account for such a difference, but what is relevant here is not
merely the difference between French and British notions of sexuality.
Although these images of Indian women are indeed sexually encoded, to
constitute the archive as *entirely pornographic* would depend on a spe-
cific, that is, masculine and nationalist, relation to history. An alterna-
tive reading situated at the juncture of feminist and postcolonial prob-
lematics reveals a rather different portrait of women across the complex
hierarchies of colonial worlds. These postcard images stage salvation,
benevolence, cooperation, and contempt, and are stamped with women's

desire, fascination, racism, and revulsion—relations that require histori-
cizing as part of the vexed colonial history in which the problematic fem-
inist project of global sisterhood was formed. Bringing *this* history into
visibility may have more important political implications for women
than any misguided attempt to, in Alloula's words, "return this immense
postcard to its sender."

A Parable of Postcolonial Return

Museums and the Discourse of Restitution

The treasures captured outside Europe by undisguised looting, enslavement, and murder, floated back to the mother-country and were there turned into capital.

Karl Marx, *Capital*, vol. 1, 1867

As we have seen, the histories of European collecting and display of the non-European world, and the institutional practices of the Euro-Western museum in particular, have been inextricably bound up in the relationships of power that have structured imperialism in the modern era. Today, the complexities of issues regarding museum representation often lead us back to the crudeness of early conditions of acquisition, and the unsanctioned collecting of colonial officers, researchers, and travelers, frequently amounting to outright plunder. In the case of India, the unashamed pillaging that characterized the early phases of British rule in the subcontinent gradually took the shape of legalized large-scale, systematic collecting driven in part by the rapid emergence and development of museums and museology in the metropolis. It seems sadly ironic, as Jawaharlal Nehru once pointed out, that the Hindi word "loot" was interpolated into the English language at about this time, as it accurately describes some of the attitudes and actions of British collectors during this era.[1] In spite of the political and cultural processes of decolonization led by figures like Nehru in the twentieth century, European and American museums have generally refused to give up the "loot" acquired under conditions of colonial rule. The very notion of cultural property, which extends assumptions regarding the sanctity of property linked to the rise of the bourgeoisie in Europe to the realm

of culture, has emerged since World War II as part of a vocabulary of social justice and international diplomacy concerning museums and these acts of possession. While museums have responded in a variety of ways to the difficulty of these institutional dilemmas, it is fair to say that the demand for the repatriation of objects, complicated by rival claims between parties and competing definitions of ownership, is one of the thorniest and most troublesome issues facing museums in the postcolonial era.

This chapter seeks to shine a critical light on the "retention versus return" debate that has become part of the framework of museums and cultural property, in order to displace some of the polemical terms in which the argument has been played out, and to historicize moments of the prevailing discourses of museological restitution in relation to colonial and postcolonial societies and their histories. I undertake this by recounting a thirty-year struggle, beginning in the 1920s and ending in the 1950s, for the return of two Buddhist relics excavated in India in the late nineteenth century and relocated to the Indian section of the Victoria and Albert Museum in London. Unlike Tipu's Tiger, the wooden musical toy depicting a tiger devouring an Englishman, or the Koh-i-noor diamond, the literal embodiment of the "jewel in the crown"—the two most famous Indian objects under dispute—these ashes and bone fragments said by tradition to belong to the Buddha's disciples were not seen by the museum to have any particular visual or aesthetic importance.

In the pages that follow, I trace the history of competing claims to possession placed upon these relics through a number of official and unofficial discourses across different historical moments: from concerned museum officials in London, to members of a local British Buddhist society lobby, to a wider network of Buddhist groups in India, Burma, and Ceylon organized in the postcolonial era. The story of this extended custody battle makes visible the clash between different notions of value and meaning associated with objects: in this case, the notion of aesthetic value propagated by the metropolitan museum, the conception of ritual or sacred value offered by neo-Buddhist groups, and the claims to historical-national value made by the newly independent postcolonial state. Further complicating the matter, as I will show, these notions of value are not coherently deployed against each other from opposite sides of the custody dispute; at times all three are at play simultaneously, in contradictory ways, by multiple groups. I argue that, against repeated claims to the intrinsic, "essential" historical significance of the relics, their value has been produced and sustained through the formal and in-

formal social exchanges between museum officials and their diverse constituencies, and that these social processes have also served to conceal the acts of evaluation involved.

The historical and political contingencies of "value" in relation to the material culture of modern India has been an important theme in recent scholarship by Richard Davis and Tapati Guha-Thakurta, the former a scholar of South Asian religion, and the latter well known for her influential contributions to an interdisciplinary art history of the Indian subcontinent. As Guha-Thakurta has shown in her study of the Didarganj *Yakshi,* the famous life-size sculpture of a female form attributed to the third century B.C., heralded as one of the great masterpieces of Indian art (and whose enigmatic half-smile has made it a sort of Indian "Mona Lisa"), the values and meanings accorded to antiquities reflect the changing colonial, national, and international contexts of reception over time. When in 1917 the Didarganj *Yakshi* was first unearthed by local residents on the banks of the Ganges River, for example, it was for a short time set up under a bamboo canopy and turned into an object of worship, before being seized by local officials and relocated to the Patna Museum. In this brief confrontation on the banks of the Ganges, as Davis has asserted, "two worlds collided," and with them two different systems of belief about the meaning and value of cultural objects.[2] For Davis, the goal is to "exhume and examine" the past lives of Indian religious images, "whose identities are not fixed once and for all at the moment of fabrication, but are repeatedly made and remade through interactions with humans."[3] Guha-Thakurta's concern, by contrast, is to "track the institutional practices as well as the mounting discourses of the artistic and the sexual that determined the modern destiny of objects such as this."[4] The latter thus seeks to expose the value of an object, while also considering how valuation itself has contributed to the exclusions, inclusions, and particular priorities of the emerging disciplinary practices of art history in India.

Drawing from these insights, and the strategic use of "biographical" methodologies, I offer in the pages that follow a compelling parable of postcolonial return, one that renders the very idea of a return to a pure point of origin impossible.[5] The term "repatriation" assumes that artifacts have a "patria," Latin for "fatherland," and this etymology is significant in a number of ways.[6] It reveals the inability of this conceptual paradigm to account for the instability of "origins" within shifting historical and political relations, as well as the centrality of concepts of property to the political identities of patriarchal society. As Jordanna

Bailkin has noted in her study of cultural property in Britain, repatria-
tion in a number of historical instances "has been one way of keeping
things very much the same."[7] By framing the historical and political con-
ditions under which assessments about meaning are made in statements
by the museum, the state, and neo-Buddhist lobby groups, I will show
how the imperatives governing visuality and the dynamics of identifica-
tion and consumption become reconfigured at key moments in the tran-
sition from colonial to postcolonial historical conditions. The notion of
return underlying restitution must therefore be considered through these
contexts of reinscription and reconfiguration. I suggest, in other words,
that the particularities of postcolonial history present some distinctive
challenges to the practices of the museum that extend well beyond the
more conventional concerns of representation, exhibition, and curator-
ial display.

RETENTION VERSUS RETURN

Two of the most significant paradigms for the return of cultural prop-
erty today have emerged out of the radically different historical condi-
tions involving the dispossession of indigenous peoples, particularly in
North America, and the Nazi invasion of Europe in the Second World
War. It is therefore necessary to briefly examine these contexts before
turning to the circumstances of our own custody dispute. In the case of
the latter, the massive looting operations undertaken by specially trained
forces in Hitler's army generated vast collections of cultural treasures
that were transported back to Germany from countries across Europe
and North Africa. When Soviet troops arrived in postwar Germany,
Stalin's so-called trophy brigades undertook similar pillaging operations,
shipping large collections of art by train back to museums and secret
repositories in the Soviet Union, some of which became known as re-
cently as 1991.[8] The earlier complicity of museums and the European art
market, which benefited from transactions in stolen art, has gradually
turned into a tide of repentance and a global consensus that such cultural
property should be returned to survivors of the Holocaust and their fam-
ilies. And yet, as new cases of Nazi-era loot continue to emerge, they
have generated ever more heated controversies among European nations,
often resistant to part with prestigious works of art, regarding issues of
ownership, justice, culpability, and ethics, symbolically making the art
from this era, as one advocate of restitution has stated, one of the "last
prisoners of war."[9]

The question of repatriation of Native American cultural property, though derived from a very different set of historical circumstances, similarly implicates cultural property as a form of restitution to past victims of historical injustice. In the United States, the passing in 1990 of the Native American Graves Protection and Repatriation Act (NAGPRA)—the federal legislation requiring all museums and government agencies in the country to return human remains and sacred objects to the Native American tribes that claim them—introduced a new set of standards to the long history of European plunder, desecration, and possession of the cultural materials of indigenous peoples. On one hand, this has been an important mechanism in enabling the return of items in museum collections to those who claim a preexisting history to them. On the other hand, the persistence of a preservationist paradigm, in which museums justify their right to ownership through their role in the preservation of artifacts—a paradigm that itself has its roots in the hierarchical impulses of the nineteenth century to salvage the earlier, "disappearing" stages of human evolution—has tended to thwart a number of post-NAGPRA efforts at restitution.[10] The recent controversy over Kennewick Man, the human skeleton found in Washington State that for the physical anthropologists involved represents important "evidence" about the origins of humanity, is perhaps the best example of a custody battle in which the rationale of science is pitted against the symbolic meanings of the bones to native groups, who perceive them to be the human remains of their ancestors.[11] Significantly, what characterizes this dispute, and others like it, is the incommensurability of the views at stake, and the unequal distribution of power that shapes the polarizing tone and structure of the debate.

In both of these historical precedents—the Nazi invasion of Europe and the dispossession of indigenous peoples in the Americas—restitution has become a mechanism to help mediate the histories between perpetrators and victims. As such, the discourse is imbued with a sense of morality and justice, and a political understanding that groups, especially minority groups, have rights similar to those traditionally extended to individuals. The argument for museological restitution recognizes the symbolic value of objects under dispute, and its proponents typically support the unconditional return of all objects acquired by museums through theft, looting, or unauthorized consent from the place of origin.[12] While acknowledging that terms like "authorization" and "consent" do not always apply in the context of colonial power relations, those in favor of restitution argue that museums continuing to hold

ects have a moral duty to return them in order to ac-
rical injustices of the past. They point to the power-
ial culture to affirm collective identity, the rights of
and control their own cultural heritage, and the
ing cultural patrimony for the processes of decol-
,, ... pro-restitution camp argues that historical op-
pression cannot be redressed without the physical return of objects, be-
cause the removal or obliteration of one's material culture was, and
continues to be, a form of subjugation itself.

The other side—in favor of retention—including, predictably, some of
the largest museums in the Euro-Western world, rejects any position that
might jeopardize the integrity of their vast collections of cultural objects.
In 2002, the directors of eighteen major museums in Europe and Amer-
ica, including the British Museum in London, the Louvre in Paris, and
the Metropolitan Museum in New York, issued a controversial joint
statement defending their right to retain all objects in their collections ac-
quired under historical conditions different from the present. These di-
rectors argued that their institutions are "universal museums," that is,
cultural accomplishments in their own right that transcend national
boundaries by bringing the common heritage of mankind together under
a single roof. They pointed to the importance of the research and study
of objects in their collections, the significance of greater access to them,
and the benefits of advanced technologies for the care and preservation
of historical artifacts. Finally, they argued, paradoxically, that over time
objects in museums become part of the heritage of the nations that house
them, but that these institutions have a universal commitment because
they serve in the end the peoples of all nations, and that this overrides all
other considerations.[13] As they assert their rights to both "national" and
"universal" heritage simultaneously, such museums have increasingly
found themselves in an awkward position vis-à-vis the public, display-
ing a self-consciousness about the emergent multiculturalism of their
urban environments while fudging over their imperial histories and con-
cerns about the neoimperial implications of their self-defined roles.

The British Museum, which has famously refused the long-standing
Greek demand for the return or even temporary loan of the so-called
Elgin Marbles, a name that itself reflects the paradigm of ownership
under dispute, is no doubt an exemplary form of the "universal mu-
seum."[14] The Greek claim, which gained new international sympathy in
light of Greek lobbying to have the marbles returned to Athens for the
summer Olympics of 2004, is perhaps the most famous among the un-

resolved restitution cases, which also include the bid by Turkey for the return of the Pergamon Altar housed at the Pergamon Museum in Berlin, and the Nigerian appeal for the return of the Benin bronzes looted during the nineteenth century and now part of the collections of the British Museum and the Royal Academy of Arts in Britain.[15] With respect to India, the two objects already noted, Tipu's Tiger and the Koh-i-noor diamond, have acquired their legendary status in part because they are themselves powerful signifiers of British imperial conquest over India. The former, Tipu's Tiger, was seized from its owner, Tipu Sultan, the ruler of Mysore, during his defeat by British forces in the Battle of Seringapatam of 1799, and remains today on contentious display at the Victoria and Albert Museum in London.[16] The latter, the Koh-i-noor diamond, has a more complicated history, involving successive Mughal, Afghani, and Sikh possession from the time it was first mentioned in the historical manuscripts of the *Baburnama* until its seizure by British troops and presentation to Queen Victoria in 1849.[17] Today, the diamond remains part of the British crown jewels on display in the Tower of London, and has been subjected to numerous repatriation claims in the postwar period by India, Pakistan, and Afghanistan, dramatizing some of the problems in defining possession and return through the territorial claims of postcolonial nation-states. I explore these problems in a little more detail at the end of this chapter in my discussion of cultural patrimony in relation to the 1947 partition of the Indian subcontinent. For now, it seems important to note how such prominent disputes—in all their political, legal, ethical, and emotional complexity—have come to represent the central role played by material culture in the ongoing contest over the construction of history, and the encounter between unequal yet entangled national identities. At times, however, these disputes have also had the effect of replaying the history of power relations between West and non-West, and positioning the museum as a neoimperial institution.

SCENE I: THE ACQUISITION

The larger narrative framing our story dates back as early as the third century B.C., when devout Buddhists in South Asia built a celebrated religious complex on a hilltop at Sanchi, located some forty-six kilometers from Bhopal in what is today known as Madhya Pradesh (figure 43). By the thirteenth century the ancient site, consisting of magnificent stupas (memorial mounds), monasteries, temples, sculptures, and pillars, ap-

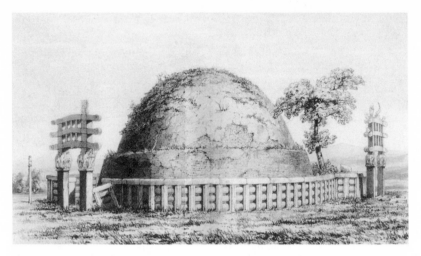

Figure 43. Sanchi, the Great Stupa. Courtesy of UCLA Libraries.

parently was deserted, as the influence of Buddhism in the subcontinent declined. The site subsequently descended into relative oblivion, but in 1818 it was "rediscovered" by the British when General Taylor of the Bengal Cavalry famously stumbled upon the overgrown ruins one day while encamped nearby. During the next few decades chaotic pillaging of the Sanchi complex by foreign treasure hunters, local villagers, and amateur archaeologists caused substantial damage to its ancient architecture. Growing British concern with the preservation and documentation of the monuments at Sanchi and similar ancient Buddhist sites became the basis for the entire paradigm of colonial archaeology in India, which was fully institutionalized by 1861 with the formation of the Archaeological Survey of India.[18]

Ten years before the founding of the Archaeological Survey, in 1851, General Alexander Cunningham and his colleague, Lieutenant-Colonel F. C. Maisey, undertook a major excavation at Sanchi, which included opening up the great domed stupas to search for the Buddhist relics that were typically housed within. Cunningham, the first archaeological surveyor for the British government in India, was also responsible for the "museumization" of other Buddhist sites in India, namely the monuments at Amarvati and Barhut, which—unlike Sanchi—were almost entirely removed and relocated to museums in India and Britain in the interest of "safe custody."[19] In their respective books on the Sanchi excavations, Maisey and Cunningham provide painstakingly detailed

drawings of the site and offer individual accounts of their find. "I arrived at Sanchi on the 23rd of January, 1851," wrote Cunningham in his preface to Maisey's volume, *Sanchi and Its Remains* (1892), "and the same morning, after only a few hours work, we found the relics of Sariputta and Moggallana, the two chief disciples of the Buddha in the ruins of No. 3 stupa."[20] The No. 3 stupa, measuring about forty feet in diameter, was smaller than the more famous No. 1, or "Great Stupa," at Sanchi and resembled "a mere mass of ruins" or "a heap of fallen stones" when Maisey and Cunningham entered it that day by sinking a large shaft down the center of the tope (figure 44).[21] In Maisey's words, they then hit a "rectangular cavity covered by a stone slab six feet by three feet. . . . Under this, embedded in the floor of the cell, were two massive stone chests," inscribed in Pali with the labels "of Sariputta" and "of the great Moggallana."[22] Inside each chest they found what they described as "an elegant steatite casket" covered with black glazed earthenware about eight inches wide "of very delicate manufacture" (figure 45).[23] In the southernmost miniature casket, linked to Sariputta, Maisey and Cunningham found "a small fragment of bone and seven jewels, evidently once strung as a necklace," which included a piece of pearl, a small amethyst, a ruby, a lapis star, and crystal beads—representing, they concluded, the "seven precious things which it was customary to bury with the ashes of holy persons."[24] In the other casket, belonging to Moggallana, they found two more small fragments of bone. Next to the caskets lay "bits of sandalwood," likely used in the cremation of these holy men. The northern and southern positions of the caskets, they concluded, symbolized the relative status of Sariputta and Moggallana, who were the two most significant disciples of the Buddha, considered second only to the Buddha himself in the sacred hierarchy of Buddhist veneration.

However, these were not the only precious things found by Maisey and Cunningham that winter. Similar excavations of surrounding stupas—at Sonari and Satdhara, both located roughly six miles from the Sanchi complex, and then at Bhojpur and Andher, also within a dozen miles of Sanchi—yielded numerous other miniature caskets with small fragments of burnt human bone said to belong to other Buddhist disciples, as well as additional relics of Sariputta and Moggallana (figures 46 and 47). In fact, the massive scale of their seizure would later be sharply criticized by John Marshall, another director general of archaeology in India, who undertook extensive restoration of Sanchi between 1912 and 1919. In his 1940 book *The Monuments of Sanchi*, Marshall called Cunningham and Maisey "blundering excavators" who had "con-

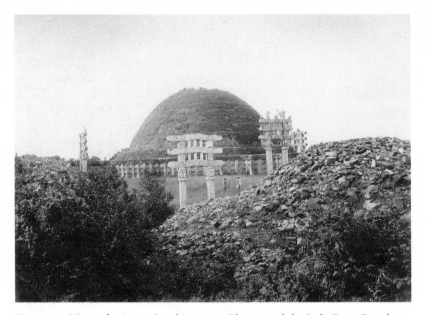

Figure 44. View of ruins at Sanchi, 1880s. Photograph by Lala Deen Dayal.
The Alkazi Collection of Photography.

tributed to the general spoliation of the site by hasty excavations in sev-
eral of the monuments."[25] "Though they succeeded in recovering a most
valuable series of relic-caskets from the 2nd and 3rd stupas," Marshall
complained, "their discoveries hardly compensated for the damage en-
tailed in their operations."[26] "The idea of repairing and preserving these
incomparable structures for the sake of future generations seems never
to have entered anyone's head," Marshall stated with astonishment.[27]
The task was unfortunately left for him, and Marshall spent the next
seven years undertaking a massive restoration of the site, including com-
pletely rebuilding the dome of stupa No. 3, which had been reduced to
pure rubble after Maisey and Cunningham's recovery of the relics, and
erecting a small museum at the foot of the hill "to protect the numerous
movable antiquities which lay scattered about the site."[28]

 To be fair, Maisey and Cunningham had not entirely ignored the
question of preservation during their excavation of Sanchi in 1851: after
dividing their stupa finds between them, they had sent almost all of the
reliquaries back to England. Cunningham delivered his collection to the
British Museum at the end of his service in India, taking the precaution
of sending the property on two different ships. One of them—the
steamer *Indus*—sank off the coast of Jaffna, and some of the relics from

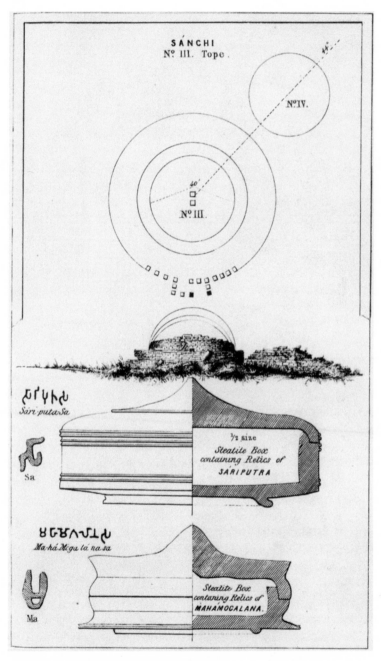

Figure 45. Maisey and Cunningham's drawings of caskets containing the relics of Sariputta and Moggallana. Courtesy of UCLA Libraries.

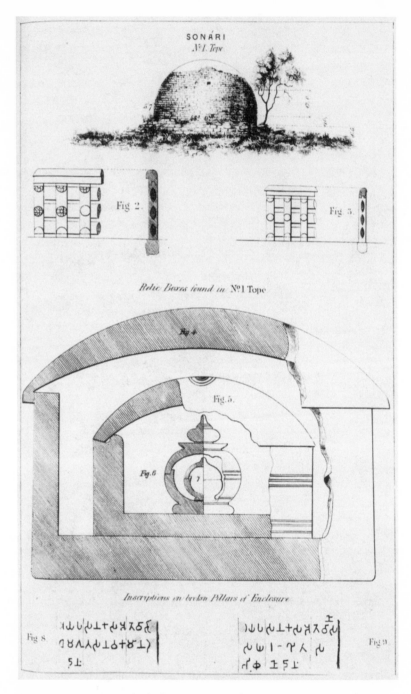

Figure 46. Drawings of relic boxes excavated at Sonari. Courtesy of UCLA Libraries.

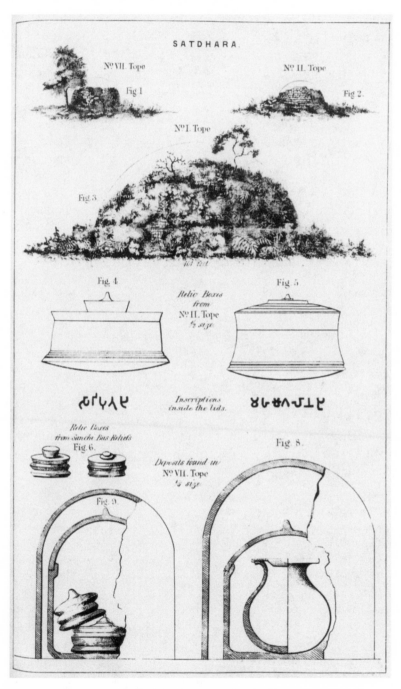

Figure 47. Drawings of relic boxes excavated at Satdhara. Courtesy of UCLA Libraries.

Sanchi and Sonari appear to have gone down with the ship, while the rest were received by the British Museum in 1887.[29] Maisey's share of the findings, sent separately to England, were loaned to the India Museum, an institution without a permanent home at the time, in the winter of 1866.[30] At the time Cunningham had also recommended that the gateways of the Sanchi tope should be installed in the British Museum to frame a new "Hall of Indian Antiquities."[31] Although his vision for the British Museum would not be realized, casts of the East Gateway were undertaken by Henry Hardy Cole—son of Henry Cole, champion of the Great Exhibition and superintendent of the South Kensington Museum—and presented in 1869 to museums in several major European cities, including London, Edinburgh, Dublin, Paris, and Berlin.[32]

Cunningham and Maisey clearly understood the historical and archaeological value of the objects that they had uncovered, although differences emerged between them regarding the objects' origin and date. Cunningham believed that the relic caskets were from the age of Asoka, dating them to the third century B.C., whereas Maisey felt they belonged to a later period and had been brought to the Sanchi site by pilgrims later than that. Cunningham let it be known in the preface to his colleague's book that he disagreed with Maisey on this point, announcing that he believed Maisey's views "may have been biased by the pious wish to prove that Christianity was prior to Buddhism."[33] In any case, the difference in opinion was substantial enough that Maisey and Cunningham never worked together again. Some forty years after their excavation at Sanchi, Cunningham noted with a degree of detachment that he had not stayed in touch with Lieutenant-Colonel Maisey, and had seen him only once since their partnership at Sanchi.[34]

SCENE II: THE APPEAL

Scene two of this narrative opens eighty years later at the Victoria and Albert Museum in London, an institution whose historical and epistemic shifts have provided a rich field of study for contemporary scholars.[35] On April 17, 1932, the museum received a letter from the London mission of the Maha Bodhi Society, an international Buddhist organization located across the city in Regents Park, with other locations, according to their stationery, in Colombo, Calcutta, Benares, Madras, Dharamsala, and New York City. The letter stated that the Buddhist relics on exhibit at the Victoria and Albert Museum and the British Museum had been a source of concern to the society for some time.[36] A new *vihara*, or temple, had

recently been opened at Sarnath, the letter explained, "and we feel that could the Government be induced to hand the ashes of the Buddha's most famous disciples to the *vihara* authorities, it would not only be doing an act of grace to the Buddhist community throughout the world, but would ensure their safe custody in a Buddhist Shrine on the actual soil from whence Buddhism sprang." The gesture of returning the relics, the letter concluded, "would be an act for which Buddhists would be profoundly grateful."[37]

The letter was referring to eight of the reliquaries from Maisey's collection, which had been on loan to the India Museum since 1866 and had been officially purchased from Maisey's granddaughter for two hundred pounds in 1921, by which time the institution had been renamed the Victoria and Albert Museum. Immediately after receiving the letter, Eric Maclagan, director of the Victoria and Albert Museum since 1924, sent a note across town to the British Museum—reminiscent of the call for help in the joint statement on universal museums referred to at the beginning of the chapter—to inquire whether they too had been approached about the relics, noting that such a request "would obviously provide a precedent for many awkward demands upon them. But it is clearly a case in which the two Museums should take approximately the same ground."[38] A British Museum authority responded immediately to Maclagan's request: they had also been approached by the Buddhist Mission with an appeal to hand over the relics of disciples in their museum. "I remember a similar appeal emanating from an Indian source some three or four years ago, which you also received," the British Museum official recalled, noting that he intended to prepare a reply to the society stating "very simply that the Trustees are precluded from giving up objects in their trust, and that these relics are kept with great care."[39] There seems no reason "to enter into an argument in the matter," he added. Nevertheless, he would be interested in knowing "what line you will take in answering the appeal" as well.[40]

Maclagan responded within the week by thanking his colleague at the British Museum for "just the lead that I required. . . . I think I can arrange to reply in a very similar strain."[41] He proceeded to write a memo to his board of trustees explaining the situation and the British Museum's response. While the actual ashes themselves were not really "of any special importance to the Museum," he confessed, "I think we must be careful about this case and about the phraseology we use in reply. . . . Obviously all leading museums contain all sorts of articles which are of great religious, sentimental or historical interest to the coun-

tries of their origin, and any general acceptance of the view that it would be reasonable to return such articles from whence they came would raise fundamental issues."[42] At the same time, he admitted that political circumstances—pressure from the British government in India—might make such a return difficult to resist.

The political circumstances to which Maclagan referred were no doubt a significant consideration for the museum. By the late 1920s the swirling currents of Indian nationalism had irrevocably transformed the imperial relationship between Britain and India. The Indian nationalist movement's strategies of noncooperation and civil disobedience to attain their vision of "complete independence" had increasingly defined the political atmosphere. In the spring of 1930, Gandhi's famous Salt March— in which several thousand followers trekked across the country in a highly publicized act of protest against the unjust British monopoly on salt—had contributed to the prevailing mood of agitation in the subcontinent. Meanwhile, the first two Roundtable Conferences to begin official negotiations on India's constitutional future had been convened in London in 1930 and 1931. In fact, Gandhi had been in London to attend the latter for several months just prior to Maclagan's exchange with the British Museum. The media had followed his every move, and the Mahatma's presence in the city during the fall of 1931 was itself a kind of spectacle that had attracted European viewers.

In this same period the Indian collections of the Victoria and Albert Museum—at the time housed across the street from the museum in a vast rented gallery almost ten times as large as the space the collection currently occupies—were also at a crossroads.[43] A subsequent keeper of the Indian collections, Kenneth de Burgh Codrington, later stated that there had never been "a time when India and Indian affairs have been so much discussed" in Britain as the thirties and forties.[44] But the political tenor of the time made it no longer fashionable, as it had been in the Victorian era, to boast of the expansive holdings of the museum's imperial collections. And the tiny pieces of charred human bone retrieved from Sanchi, unlike the more famous Indian objects housed in London's institutions such as Tipu's Tiger or the Koh-i-noor diamond, both exotic symbols of imperial conquest, were not seen by the museum to be aesthetically significant.[45] Nonetheless, by the early twentieth century, a particular framework of historical meanings had come to surround such Buddhist relics, a framework that had increased their value for the museum. Ancient Buddhist art and architecture had come to be projected by colonialist and nationalist scholars alike as the pinnacle of aesthetic achieve-

ment in an overarching classificatory scheme of the "great ages" of Indian art, an evolutionary framework or broad chronological periodization that was consolidated in the space of the museum through a series of successive galleries through which the visitor was intended to pass.[46]

The museum's reluctance to part with the bone fragments despite seeing them as lacking any special importance was no doubt related to its commitment to this larger framework as much as it was an expression of anxiety about official museum policies and precedents. The entire vocation of the museum was, after all, defined by the *collection*, not the return, of cultural objects, and to establish such a precedent was a potential threat to the very identity of the institution. In the end, Maclagan, clearly eager to resolve the situation, sent a perfunctory reply to the Maha Bodhi Society stating that the museum was "unable to authorize" the society's request that the ashes in the Indian Section of the museum be handed over to the *vihara* authorities at Sarnath. "At the same time," the director continued, "I would like to assure you that these relics are kept in the Museum with every possible precaution and you may be assured that they will not be treated with any disrespect."[47]

The situation, however, would not be resolved as simply as Maclagan had hoped. After months with no apparent communication between the parties, in the fall of 1932 the Buddhist Mission wrote again, this time to the head of the museum's Indian Section, A. D. Campbell, with a fresh explanation about the significance of the relics as religious objects. The two saints in question, explained the secretary of the Buddhist Mission, "occupy a position only second to that of the Buddha in the hearts of many millions of Buddhists today."[48] Because "the value of these relics as objects of worship is inestimable," the London society was now requesting to "pay our homage to these relics." The 2,476th anniversary of the passing of Sariputta was to be honored during the next full moon in November, he continued, and "we therefore beg you to be kind enough to send these relics under the protection of someone of your staff to our headquarters of the Buddhist Mission for a few hours on the day mentioned above."[49]

The new request was clearly more manageable than the previous: the society was now seeking a temporary loan—merely a few hours—in order to pay their respects to these objects considered sacred to Buddhists. Campbell sent the new request to Maclagan, his superior, noting that he was inclined to comply, "especially since the relics are to remain in this country," and he offered to personally take the casket to the society headquarters in Regents Park and "bring it back to the Museum the same

day."[50] But Eric Maclagan denied his request, firing a memo to the board of directors. "I have told Campbell that this is definitely against our regulations," he informed them, noting that the museum had refused requests "with much better reasons behind them."[51] In response to this refusal, however, "Campbell now asks whether I would allow him to bring the reliquaries into his office in the Indian section on Sunday afternoon so that a few representatives of the Buddhist Mission might come and venerate them there."[52] Reluctantly Maclagan conceded to this arrangement, saying that he would not object if only a few people, no more than twenty, attended the proceedings, and the event was entirely private, with no press coverage and "no audible chanting." "I do not myself see that it could have any awkward consequences," he told the board, and it might help mollify the feelings of the members of the Buddhist Mission, who "evidently feel rather sore" about what he saw as "our accidental possession of the relics."[53] If a group of Roman Catholics wished to visit and venerate one of the museum's Christian relics, he reasoned, then "I imagine we should allow them to do so, just as we should allow a body of Art students to have one of our Museum objects taken into an office and to study it there or to have it described to them."[54]

As a result, the Maha Bodhi Society members in London were successful in paying their respects to the relics on the anniversary of Sariputta's death during the fall of 1932. Maclagan, balancing issues of acquisition with the public and pedagogic role of the museum and the Euro-Christian roots of its institutional identity, finally granted permission to show the relics to no more than twenty people at a time between 3 and 5 P.M. on the anniversary. The sympathetic Campbell described the event in a memo to the museum staff: "About thirty members of the Maha Bodhi Society . . . came to the India Museum on the afternoon of Sunday, Nov 13 and did reverence to the bone relics," he wrote.[55] One of the principal members of the mission gave a "short discourse upon the life of Sariputta, and a large bunch of chrysanthemums were placed before the relics." The relic casket, enclosed "under a glass-shade hung at the back with black velvet," was placed upon a square plinth with a lower plinth in front, presumably for praying.[56] According to Campbell, the Buddhists had draped the entire "mise-en-scène," which included a Tibetan Tanka of the Buddha with Sariputta and Moggallana and a large brass tray for the offerings of flowers, with a canopy of yellow fabric.

The sacred contexts of such objects are not the stories that curators tell, as former curator and art historian Craig Clunas has observed.[57] Clunas was referring to his personal experience when, as a young boy

newly arrived from China, he had bowed in front of the emperor's throne upon seeing it for the first time in the Chinese collections at the Victoria and Albert Museum. Clunas recounted the humiliation he felt as the embarrassed guard looked the other way, and the painful lesson he learned that day: that, in largely subtle ways, museums permit certain relationships to objects while disallowing others. Like Clunas, the members of the Maha Bodhi Society, through bodily practices unusual in a museum setting (praying, chanting, offering flowers, paying reverence), had subverted the museum's dominant script, if only for a few short hours. As we shall see, this symbolic victory, however seemingly inconsequential, would set the stage for an escalation of Buddhist activity against the museum that takes our narrative through the historical changes accompanying World War II and Indian independence.

SCENE III: THE ESCALATION

Scene three opens in 1938, shortly before the devastating effects of World War II in Europe, and after the Indian collections at the Victoria and Albert Museum had been radically reorganized by a new keeper of the Indian section, Kenneth de Burgh Codrington. Significantly, Codrington, unlike his predecessors, had come from a family with several generations of personal experience in the subcontinent. His father, grandfather, and great-grandfather had all served in the Indian army, and Codrington himself was born in India, where he had spent his childhood before coming to England as a young man to study Indian archaeology at Cambridge and Oxford.[58] Codrington's affection and respect for Indian culture had led him to a strong belief in a mid-century ideal of a universal humanity, itself partly a response to the crises of metropolitan humanism brought on by the vast social questioning of the legitimacy of colonial rule, and he saw the museum as a pedagogic tool that could help address—and ultimately repair—the eroding imperial relationship between Britain and India. "There are other things to talk about in India than politics," he insisted in an exhibition catalogue titled *The Study of Indian Art*. "India is not merely a problem. . . . Her history, her literature, her art, her manifold ways of life, exist as accomplishments. Whatever happens in the future . . . no man who boasts himself a humanist can afford to neglect them."[59]

Soon after his appointment in 1935 Codrington abandoned the decorative arts approach to the Indian collections that had prevailed since the nineteenth century, and he reorganized the vast rooms of the museum's

rented space into a series of largely thematic clusters. Under Codrington's new scheme, a visitor to the main galleries of the museum's Indian collection could still walk through an ancient Indian sculpture gallery, proceed to a Mughal-era room, and arrive at a room dedicated to the history of India during the period of the East India Company—a chronological arrangement that not only reflected the dominant evolutionary approach to Indian art, but also, as Kavita Singh has noted, consciously or not offered "a Malinowskian charter myth for the colonial project."[60] But there were also additional galleries devoted to Indian arms and armor, music, theater, crafts, and dance, and two rooms intended to explain the principles of Hinduism and Buddhism in the subcontinent. It was in the latter— the Buddhist room—that Codrington had displayed the small Buddhist reliquaries, along with stories and images from the life of the Buddha, and paintings and relief sculptures—mostly plaster casts—from Buddhist monuments in India. Additional rooms on Tibet, Nepal, and Burma served to round out the story of Buddhism in the subcontinent by showing its variations to the north and east.[61]

 In the summer of 1938, Codrington received a letter from a self-described English Buddhist concerned about the relics from Sanchi, Frank Mellor, who requested that a seat be placed in front of this exhibit "so that any Buddhists who wish to do so may sit there and meditate."[62] When the museum rejected his request, noting that such a seat would greatly inconvenience the general public, Mellor persisted. The proper place for the ashes of holy men, he wrote back, is in a religious building. "They should not be exhibited in a museum . . . these relics should either be returned to India, to be replaced in the stupa from which they were stolen," or kept in a private place until a Buddhist temple is built in London.[63] Responding on behalf of the museum, the director Eric Maclagan—his patience apparently wearing thin on this issue—objected to the implication that the museum had "stolen" the relics. "The caskets in question were purchased in this country," he stated, thereby dissociating himself from their original removal by Maisey and Cunningham in the previous century. Furthermore, he stated, as artistic and historical objects they appear "to us closely comparable with that of the many Christian reliquaries included in the collections of this and other museums."[64]

 By the middle of September 1938, Mellor—clearly dismayed by the museum's response—informed Maclagan that he was launching a letter-writing campaign as "the first step of an agitation in India, Burma, and Ceylon, to obtain the return of the relics to Sanchi."[65] In response to the director's argument, he countered that "You are mistaken when you say

that their position is clearly comparable with that of Christian reliquaries in the museum," for those did not actually contain the ashes, for instance, of two of the first disciples of Jesus Christ. While allowing that the museum may have acted in good faith when they purchased the relics, he claimed that they were nevertheless "stolen property."[66] Mellor then followed through with his "campaign of agitation": in the months that followed, the museum received petitions from a Buddhist society in Berlin and the Amis du Bouddhisme in Paris and letters from the Maha Bodhi Society in Bombay and Burma, all objecting to having "the Buddhist relics exposed as curiosities" in the museum and supporting Mellor's demands for their return to Sanchi.[67] Even worse from the museum's perspective were the increasing number of inquiries from the press that fall. "I did what I could to discourage them," wrote a concerned museum official to Codrington in October, but, "as you will see, this agitation has spread abroad."[68]

The international visibility of the Maha Bodhi Society—itself an important organization in the reemergence of Indian Buddhism that had begun in the late nineteenth century—added to the museum's concerns. By the heyday of British rule there were scarcely any living practitioners of Buddhism in the subcontinent, except those situated at the periphery of India in Tibet, Nepal, Burma, and Ceylon (the last two now Myanmar and Sri Lanka).[69] The subsequent impetus to revive Indian Buddhism had come principally from Burmese and Ceylonese pilgrims, and from educated Indians from the emergent economic and professional elite, who turned to Buddhism as a way of reclaiming a distinctively Indian identity, one that was rooted in an ancient past. In the late nineteenth century this neo-Buddhist revival had gained momentum through the specific goal of rehabilitating India's ancient Buddhist monuments, thereby reviving the long-lost identity of Indian Buddhism and gaining solidarity and support from a growing international Buddhist community. As the museum came to understand all too well, by the early decades of the twentieth century this emergent religious community— English-educated, transnational, and professionally elite—had become highly effective in mobilizing an "international agitation" against it. In response to the Buddhist campaign, the museum became even more suspicious about "this society, of which we know nothing," as one official put it. The museum rejected Mellor's legitimacy and influence (the correspondence would suggest that his "combative attitude" was the real crux of the problem), and it insisted, contrary to experience, that "there is no unity of Buddhist opinion" with respect to the relics.[70]

Among those who worked for the museum, one of the greatest fears was that returning any of the relics would set an unwanted precedent that could be extended to the large collection of Christian relics they also held. "If we agree to give back Buddhist relics to Buddhists, I can see no justification for not giving back Christian relics to Christian churches," warned one official in the discussion, envisioning a scenario that could potentially deplete their sizable holdings in this area.[71] Rejecting that reasoning for his own ends, Mellor had argued that the Buddhist relics were in no way comparable to their Christian counterparts, drawing on the ancient Buddhist tradition of relic veneration to insist on the uniquely sacred qualities of these fragments of human bone. Despite his sensitivity to this issue, Codrington announced that "I have no intention of being dragged into an argument about the relative sanctity or authenticity of Buddhist and Christian relics," his cultural relativism and larger faith in the ideal of humanism also seemingly under threat by Mellor's logic. "We must avoid applying the assumptions of Bloomsbury to Santiniketan and vice-versa," he later wrote. "Humanity is universal, but the idiom varies, and its variations must not be allowed to obscure the issues."[72]

Against the setting of the imminent outbreak of the Second World War, on January 6, 1939, Maclagan, at his wit's end, wrote once again to the British Museum (as he had done seven years earlier) with apologies for persisting on such a trivial matter, but "a small English Buddhist community is badgering me" to return certain relics exhibited in the Indian Section "on the ground that their presence in a Museum outrages the sensibilities of the devout Buddhist. . . . Have you ever had similar complaints with regard to your major relics?"[73] An employee at the British Museum replied the next day that they had indeed received similar appeals from the Maha Bodhi Society, but were not prepared to return historical objects to "the first people who happen to ask for them."[74] They were also in possession of the bones of other Buddhists, the employee added sarcastically, "but perhaps no one knows about these, or they are not saintly enough for the society."[75] Both museums, then, seemed to agree that, in Maclagan's words, what the Buddhists failed to see is that "it is a tribute to Buddhist civilization that we wish to have such objects in our Museums."[76]

For his part, Codrington, feeling increasingly pressured by Buddhist groups, Frank Mellor's insistent appeals, and eventually the intervention of the colonial government (the India Office in Whitehall), began to think that they should consider returning the relics. Although Maclagan did not agree and went on record as "strongly opposed to the suggested

transfer," a deal was nevertheless struck between the museum and the Buddhist society: the former agreed to hand over the relics—but not the miniature caskets that contained them—to the India Office, who would assume responsibility for negotiating their return with the Indian and Burmese governments. Although Buddhist groups remained uninformed of the decision, Codrington proceeded to remove the relics from the exhibit, to store them temporarily in a safe, and to commission wooden reproductions of the caskets. Frank Mellor, in the meantime, announced his revised position on the issue due to the onset of World War II: under normal circumstances, he explained, "I would have caused an alteration, but in the present crisis I hesitate to do this. There, for the present, the matter ends."[77]

In fact, what Mellor referred to as "the matter" would only become even more complicated as the present crisis facing Europe—namely, the expansionist threat posed by Nazi Germany—raised new issues surrounding the repatriation of stolen property and works of art "illegally" acquired under historical conditions of political domination. In any case, the intended return of the Buddhist relics in 1939 was quickly preempted by more urgent events. In the face of fears that the Germans would bomb London, the entire museum was evacuated as a safety measure, and most of its collections were relocated off-site. While the South Court of the Victoria and Albert Museum was converted to a wartime canteen for the Royal Air Force, and the west side of the building was destroyed by a bomb—the marks of which still exist today—the sizable trail of correspondence regarding the fate of the Buddhist relics was placed in a file stamped "Noted For Precedent" and put away temporarily for the duration of the war.

SCENE IV: THE POSTINDEPENDENCE CLIMATE

Following the conclusion of the war, at the stroke of midnight on August 15, 1947—as Salman Rushdie has famously narrated—India achieved its independence from Britain and the subcontinent was partitioned into the two nation-states known today as India and Pakistan.[78] India's new freedom from British governance would transform the identity of many institutions established during the colonial period, and the museums of London were no exception. By the time the war was over Leigh Ashton had succeeded Eric Maclagan as the Victoria and Albert Museum's new director, and Codrington had moved from keeper of the Indian collections to a professorship at the School of Oriental and African Studies

(SOAS). Codrington's successor, W. G. Archer, had been a member of the Indian Civil Service who, like many British civil servants in India, had found his career abruptly terminated with the arrival of independence. Although Archer, according to his memoirs, did not see himself as a "museum man," he nevertheless embarked on a radical reshaping of the Indian collection when he took it over in 1945. He strove to make it a "true art museum" through a new emphasis on painting, sculpture, and other fine arts, and through a purging of the collection's ethnological and industrial samples—which Archer referred to as "mountains of rubbish"—accumulated over decades of colonial trade exhibitions.[79]

Although the decision to return the relics of Sariputta and Moggallana back to their historical Buddhist site in the Indian subcontinent had essentially been made in 1939, the transfer itself, postponed as a result of the war, was inherited by Archer and the Victoria and Albert Museum's still reluctant director, Leigh Ashton. In February 1947, in keeping with Archer's ambitious deaccessioning of objects, museum officials began preparations for a "handing over" ceremony in London, but there was disagreement over whether such an event should take the form of a large public ceremony with press and photographers or a small private affair without the presence of the media. Eventually, the relics—housed not in their original caskets but in the wooden reproductions that Codrington had commissioned—were presented quietly to the Maha Bodhi Society in London, who had planned their return to India via Ceylon. The relics reached Ceylon in March 1947, where they were reported to have received a great welcoming reception. The plan was to transfer them in October 1948 to India, where they would be enshrined in a newly erected *vihara* at Sanchi. The new government of India, however, then in the middle of independence celebrations, vehemently objected to the casket reproductions and applied renewed political pressure on the museum to obtain the original reliquary containers, citing the "enormous religious and archaeological importance attached to the original caskets."[80] "It was a most sacrilegious act to remove the relics from the casket" in the first place, agreed the Maha Bodhi Society of Ceylon in a statement, adding that the Buddhists of Ceylon were "greatly pained and agitated" by the museum's unwillingness to part with the caskets.[81]

Leigh Ashton was outraged by the last-minute rejection of the casket reproductions: "I do not myself see why they want the original caskets," he wrote impatiently. "I remain completely and absolutely opposed to the transfer of the actual caskets."[82] Ashton, resentful that his predeces-

sors had hurried a decision in the early months of the war, was not shy about expressing his opinions about the whole issue of repatriation. "It seems to me that once we have given something up in this way there is no end to demands that may be made upon us," he wrote. "The Indians may ask for anything that they say has come out of a temple; the French may want our Virgins and Child restored to their Cathedrals; the Italians may demand back our Donatellos; and in fact to carry it to an extreme, once the trickle has started it may well become a flood."[83]

Archer, on the other hand, saw how the new political relationships of the Commonwealth demanded a different posture from the museum in relation to the collections of the former British colonies. While he complained that "nobody cared a fig for what the caskets contained" when they had been acquired in the nineteenth century, "least of all the Buddhists," he also recognized that the revival of Buddhism in the Indian subcontinent had transformed the caskets into a hot political symbol of the times, and he suggested that the museum should return *all* of its bone relics, "thereby forestalling any further claims and, I trust, ensuring that all caskets are left with us in peace."[84] Thus emerged a new and paradoxical position for the museum in relation to its Buddhist relics in the postwar era: the museum sought to maintain good relations with the subcontinent by divesting itself of the remaining relics, but such a strategy was ultimately intended to protect the caskets in Britain's possession, reflecting a division in the curators' minds between the artistic value of the caskets and the less important religious value associated with the tiny bone relics.

Not surprisingly, this confused policy was unsuccessful. Under pressure from a number of sides and unable to retract the promise made in 1939, Leigh Ashton reluctantly agreed that the museum "must release these caskets" but stated categorically that the museum refused to accept the incident as a precedent for any future claims by "India and Pakistan for the release of further objects from our Indian collections."[85] Meanwhile, the government of India announced its own goal, one that was directly contrary to that of the museum: "to repatriate all articles of antiquity and artistic value, which have been removed from India to foreign countries."[86] In a 1948 memo to the museum's treasury department about the return of the relics, a member of the museum's accounting department reflected the widely divergent viewpoints on the matter: should the transaction be classified as a gift, he wondered, or should it be recorded as a loss? "Indeed, Leigh Ashton would certainly not describe the transaction as a gift," he noted, "but as a violent expropriation under

insidious political pressure!"[87] Gift, loss, or violent expropriation? Tellingly, the transaction also proved to be troublesome for the bookkeeping categories of the museum.

SCENE V: THE RETURN

After the relics' stopover in Ceylon, it would take another four years for them to complete their journey back to Sanchi, during which time they were displayed and venerated in numerous ways, marking a dramatic departure from their long residency in South Kensington and inaugurating their emancipation from the confines of the museum. From Ceylon they were transported to Calcutta and exhibited at the headquarters of the Maha Bodhi Society, where an unbroken stream of people was reported to file past the shrine from morning until night. From there, the relics traveled to Burma at the request of the Burmese government. They were transported from Mandalay to Rangoon up the great Irrawaddy River, a waterway running through the center of the country, on a steamer accompanied by decorated boats. At every town along the river the tiny calcite remains of Sariputta and Moggallana were brought ashore for worship, drawing enormous crowds from neighboring villages and attracting pilgrims from all over Burma. Following their Burmese reception, the relics went on to Nepal and Ladakh, where they were similarly displayed for public homage.[88]

On November 30, 1952, the relics, now reunited with their original caskets, were finally reenshrined at Sanchi in the new Chethiyagiri Vihara, which had been built to receive the sacred objects by the Maha Bodhi Society, with substantial support from the Indian government. The lavish homecoming ceremony, in which the relics were placed into an altar in the new temple, was attended by numerous Indian and foreign leaders, including the Burmese premier, representatives from Ceylon and Cambodia, and even Jawaharlal Nehru, the first prime minister of independent India. "The ceremonies at Sanchi," read one report in the Indian press, "can play a notable part in strengthening India's friendship with other nations in Asia . . . [and] are in tune with the ideal of preserving our glorious heritage and initiating a cultural renaissance after years of foreign domination."[89] Thus, by the time of their reinterment at Sanchi, for many Indians the relics had come to represent several of the emergent ideals of the new nation-state. No longer seen merely as archaeological loot lifted by Maisey and Cunningham during the previous century, or as purely religious or sacred forms, the remains of Sariputta

and Moggallana had also come to symbolize India's newly established freedom from foreign domination, its national commitment to preserving the precolonial past, and its optimistic forging of a pan-Asian identity in the second half of the twentieth century. Now performing as ambassadors of the nation-state, the relics would become invested with historical memory and collective emotion, and galvanize a sense of national belonging. As patriotic symbols of an empowered nation, these small pieces of burnt bone would also become like magnets for the political leaders of independent India, who valorized their intrinsic "Indianness" and the depth of their rootedness in Indian soil.

These symbolic links between Buddhism and the modern culture of the nation-state were further reinforced by the conversion to Buddhism of the nationalist leader B. R. Ambedkar, one of the authors of the Indian constitution and champion of the *dalit* (untouchable) castes.[90] In 1956, almost a decade after independence, Ambedkar, having renounced Hinduism in the 1930s as an unfair system of caste oppression, turned to Buddhism as an instrument of social justice for India's so-called scheduled castes and led half a million followers in a highly public conversion ceremony. Although he died within months of his conversion, and his monumental work on the life and teaching of the Buddha, *The Buddha and His Dhamma* (1957), was published posthumously, Ambedkar's role in constructing the legal scaffolding of the Indian nation also led to the selection of the Buddhist icons of the Sarnath lion and the Asokan wheel as key symbols for the new republic, the former serving as the official seal of the government of India and the latter as the emblem on the Indian national flag. The 1959 arrival of the Dalai Lama in India as a refugee from China's takeover of Tibet was yet another significant factor in the rebirth of Buddhism during this postindependence period, contributing to increased Buddhist immigration to India and to a cultural revival that continues today.

The search for a contemporary social orientation, the newly imagined relationship to ancient imagery, and the ongoing reinvention of symbols and practices suitable for the nation-state that marks Ambedkar's undeniably modern form of Buddhism seem to resonate with the processes at work in the extended historical bid for the return of the relics at the Victoria and Albert Museum. In one sense, it is possible to view the lengthy and often heated negotiations between museum officials and Buddhist groups over the relics as a contest between secular and religious sensibilities, as embodied by rationalist institutions or faith-based ones (the museum versus the *vihara*, in this case), a division that was itself often

insinuated in the rhetorical structure of the dispute. Buddhist complaints about the display of the holy relics in the profane spaces of the public museum, on the one hand, and the museum's secularized notion of art for its own sake, on the other, would seem to confirm this oppositional theme. Indeed, viewing this curatorial problem in terms of sacred objects / secular spaces is something that many museums practice today, particularly in relation to the sacred cultural patrimony of Native North American groups.[91] But the presumed stability of this opposition tends to overlook the ongoing "invention of tradition" that is also at work in these modern processes of self-legitimation. For the meaning and value of the relics were continually produced and reproduced through the microprocesses of social interaction—in overt acts of judgment, for instance, as well as in more informal exchanges and expressions of personal preference that emerge in the museum's explanations and memos. Moreover, the claims to the "ancient religious value" of the relics by the presumably secular Nehruvian state resulted in an often contradictory mix of religious and secular rhetorical strategies. In spite of each party's insistence that the value of the relics resided in themselves, as an inherent, essential property of either the bones or their containers, it was the explanations, contradictions, and acts of appropriation—in sum, the sphere of valuation through social interaction—through which the meaning, and ultimately the fate, of the relics was to be transformed over time.

At the very least, the custody battle I have recounted in this chapter between a religious minority in the former colony and the dominant institutions of art in the British metropolis—one that was settled, for once, in favor of the weaker party—presents a parable for the problem of postcolonial return. The reconfiguration of social and historical conditions around the relics, and the new environments for the inscription of meanings we have seen, serve to shatter any lingering desire for a journey back to a pure place called "home." The impossibility of returning home, and the bite of nostalgia that accompanies this loss, has itself emerged in the past two decades as a constitutive theme of postcolonial writing and literary criticism. In Salman Rushdie's reformulation of the famous dictum from *The Wizard of Oz,* it is not that there is "no place like home" for the migrant subject displaced from his homeland, but that "there is no longer any such place as home."[92] Rushdie's revision transforms this powerful mythology of home, produced in part by Hollywood cinema in the early decades of the twentieth century, into a troubling paradox of self and belonging. For the displaced or exiled subject, home is no longer a secure dwelling but a place of dissonance, haunted by loss, to which

one can never return: "Home is anywhere, and everywhere, except the place from which we began."[93]

These thematics of displacement and belonging can usefully be extended to the realm of material culture because the discourses of restitution are similarly fraught with such problems of origin and return. Scholars and museum professionals have increasingly accepted the idea that objects have "biographies" or "social lives" as they have begun to highlight the dynamic circuits through which objects travel and accrue meaning over time. And yet, in spite of their journeys from their places of origin, and their circulation through different contexts of value, objects too often continue to stand as indelible signs of authenticity. An account of the dynamic processes of reinscription and reconfiguration that objects put into play is one way to challenge the powerful assumptions regarding objects, places, and permanent "homes" that persist in determining our contemporary paradigms of museology and its discourses of return.

These observations bring us back to the questions of ownership and possession with which this chapter opened: To whom *should* such cultural property belong? And what is the role of restitution and repatriation in a world so displaced by the colonial past? Such questions faced by museums today remain difficult ones, and, unlike in the case described here, they are rarely resolved. In South Asia, for example, scholars have yet to construct a compelling account of the impact of the 1947 partition of the subcontinent into India and Pakistan—an event that saw the forced migration of some twelve million people within the space of a few months—upon the shared ancient cultural patrimony of the region. Significantly, the collections of several South Asian museums were divided at partition, like that of the Lahore Museum in Punjab, the great *ajaib-gher,* or "wonderhouse," established by the British referred to by Kipling in his novel *Kim.* On April 10, 1948, the art objects, paintings, sculptures, and decorative arts housed here since the nineteenth century were split 60–40: 60 percent of the objects, along with the museum and the city that housed them, were retained by Pakistan, and the remaining 40 percent of the collection, consisting mainly of Gandharan sculptures and Mughal and Pahari miniature paintings, were granted to India. The Indian portion of the collection was subsequently housed in Amritsar, Shimla, and then Patiala before it was reconstituted in 1968 in its current location at the Government Museum and Art Gallery in Chandigarh, designed by the French modernist master Le Corbusier.[94] Perhaps more significant than the splitting of museum collections and their identities was the division of private property: the homes of families and their

contents were also redistributed in a compensatory plan, undertaken by
a bureaucracy established for this purpose, in the same apparently irra-
tional way as the exchange of the inmates of lunatic asylums in Sadat
Hassan Manto's satiric short story from the era, "Toba Tekh Singh."
While the historiography of partition has increasingly begun to focus on
the violent experiences of these events and their damage to the social and
emotional fabric of the subcontinent, the constitutive place of material
culture in such a history—in particular, its loss, division, exchange, bu-
reaucratization, and role in the reconstitution of identity—clearly awaits
a more detailed examination.[95]

As I noted earlier, the redrawing of these new national boundaries
would generate competing repatriation bids by India and Pakistan for an
object like the Koh-i-noor diamond, which currently remains on display
in the Tower of London.[96] But it would also implicate material culture
in the consolidation of a dominant Hindu India, in contrast to a domi-
nant Muslim Pakistan, within the emerging national imaginaries of
these two nation-states. For it is not merely the territorial border that re-
mains under dispute between these embattled nations, but the construc-
tion and representation of history itself, and the control over the rhetor-
ical and material narratives of the past. The centrality of the notion of
cultural property in the processes of "othering" between religious groups
was brought home in yet another painful way in the violent physical de-
struction of a mosque, the Babri Masjid, in Ayodhya, India, in 1992. Said
to have occupied the site of the birthplace of the Hindu god Ram, the
event and the physical site have, over time, become *the* prime signifier for
India's Hindu-Muslim communal politics, and a source of great con-
sternation to scholars watching the political deployment of historical and
archaeological "evidence" in the authentication of "truth" about the re-
ligious past.[97] Significantly, the claims upon the site by the dominant,
right-wing Hindu Ramjanmabhuni campaign replay some of the argu-
ments we have seen in the discourses of museological restitution: for
them, the repossession and repatriation of a long-lost piece of cultural
property, namely an ancient Rama Temple imagined to predate the ill-
fated mosque, was necessary to redress a perceived historical injustice,
and justified the destruction of the Babri Masjid.

The retentionists who argue for a concept of a "universal museum"
seem unable to grasp the complexities of meaning making around cul-
tural objects in postcolonial societies such as I have described, for their
argument justifies and validates the rights of the Euro-Western museum
within a self-affirming narrative of universal justice at the same time as

Figure 48. Maha Bodhi Society Vihara at Sanchi, August 2005. © Shunya.

it explicitly rejects historical continuity with a colonial past. The case of the Buddhist relics from Sanchi can help to challenge such a narrative because it exposes the limitations of museological authority, and how social consensus about value can shift during the transition from colonial to nationalist to postcolonial sensibilities. As such, it is a history that may begin to assist in the project of imagining new possibilities for the future. After all, the return of the relics to Sanchi, contrary to what the museum's directors had feared, did not turn the "trickle" into a "flood." Instead, this largely forgotten story of postcolonial restitution shows that different museological postures can emerge from within the history of the institution itself—postures that acknowledge the colonial roots of metropolitan collections and the changing conditions of meaning around them. Repatriation is only one aspect of new curatorial approaches to objects, in which artifacts are no longer seen as static relics to be collected, catalogued, and preserved, but as repositories of meanings within dynamic cultures whose own stories and values change over time. And museums must be receptive to such approaches if they wish to be more relevant to culture in the twenty-first century.

Finally, what happened to the bits of charred bone belonging to Sariputta and Moggallana that were triumphantly reinstalled at Sanchi on November 30, 1952? That is where they remain today, enshrined in

glass on a platform in the inner sanctum of the Chethiyagiri Vihara at the foot of the Sanchi hill (figure 48). In 1989 the entire complex was declared a World Heritage Site by the International Council on Monuments and Sites (ICOMOS), a nongovernmental organization dedicated to the conservation of global historical monuments. Every November the Chethiyagiri Vihara Festival attracts hundreds of Buddhist monks and pilgrims who come from Bhopal by bus, taxi, and train to celebrate and worship the disciples of the Buddha. It is clear that the relics have had a full life since their return to independent India. And the next chapter in their story of loss and restitution, like the story of the postcolonial nation itself, is yet to unfold.

Epilogue

Historical Afterimages

It may be necessary to do more than keep saying that most of
the images . . . [that] ratify an imperialist and capitalist
order . . . are demonstrably false, in their characteristic selec-
tivity and uncritical transference. That is a quiet point; quiet
and perhaps insufficient, while these brutal images range.

> Raymond Williams, *Problems in Materialism
> and Culture,* 1982

Neither past nor present, any more than any poet or artist,
has a complete meaning alone.

> Edward Said, *Culture and Imperialism,* 1993

The phenomenon of the Festival of India in the 1980s, with its mega-
exhibitions and department store promotions, was widely criticized at the
time for its clever repackaging of art and culture to serve the ideological
interests of the nation-state. The discussions generated by this event have
assumed a somewhat canonical status in a scholarly literature at the inter-
section of cultural studies and the visual arts.[1] The Festival of India was an
early sign of a new era of cultural representation that has been insepara-
ble from the processes of neoliberal globalization. The debates it inaugu-
rated also marked a new critical consciousness in South Asian studies that
has assisted in navigating this uncertain terrain. A decade later, in 1997,
we again witnessed a spectacle of high-profile art exhibitions, this time to
commemorate the fiftieth anniversary of Indian independence from British
rule, at museums like the Metropolitan Museum of Art in New York, the
Sackler Gallery of the Smithsonian Institute, and the Philadelphia Art Mu-
seum. This event, described by Holland Cotter as "a visual dazzler,"[2] was
a strange replay of the ideological role of art and culture in supporting the
interests of the nation-state witnessed during the Festival of India.

This renewed and spectacular visibility of India in the West, a phe-
nomenon dubbed "Indo Chic" by the *New York Times,* seems a fitting
subject for the conclusion of this book, for it dramatizes what James Clif-
ford has called the "predicament of culture," elsewhere referred to as the
"postcolonial predicament."[3] The predicament is precisely that culture
and its representations remain in important ways rooted in the assump-
tions of the colonial modern in spite of the complex processes in the
twentieth century of political independence and decolonization. My
study has established three different historical moments in which the
problems of visual culture and its modes of representation have been ar-
ticulated: imperial, nationalist, and postcolonial. Taken together these
moments signal the fraught relationships between past and present, and
the continuities, ruptures, and contradictions that have given modern
aesthetic expression in South Asia its distinctive, unmistakable shape.

The first moment, that of "high empire," which occurred for the most
part in the second half of the nineteenth century, has been the primary
concern of each chapter in this book. The cultural institutions and phe-
nomena of this period—from the honored public spaces of the museum,
to the high art practices of imperial portraiture, the "dreamworld" of the
Victorian department store, and the realm of mass production inhabited
by the postcard—have had a powerful role in dictating the terms through
which India has been imagined and immortalized in the urban centers of
the West. Shaped by the discourses and infrastructures of the colonial
state and the emerging disciplinary knowledges of history and anthro-
pology, the categories and identities of caste, village, craftsman, and
artist received their modern articulations during this period. The second
moment, that of nationalism in India, was characterized by a radical ap-
propriation of not only the categories—the "cult of the craftsman" is the
exemplary case—but also the practices of visual representation, such as
the contest over the indignities of living ethnological display, the adop-
tion of oil painting by Indians, or the rejection of the Western museum's
right to possession of cultural property collected during the colonial era.
This contest between colonialism and nationalism, what Frantz Fanon
has referred to as the "grandiose battle," was irrepressible from the
1880s on, and the modalities of representation that emerged over the
next several decades are impossible to conceive outside of its terms. My
account of the story of Tulsi Ram, the unfortunate villager who was
placed on display in a London exhibition, further suggests some of the
ways in which the rejection of colonial authority played out for a mar-

ginal or subaltern actor removed from the terms of the elite nationalist script. Finally, the third moment, the postcolonial, to which I alluded at the outset, has been defined by the conjuncture of present crises and contradictions shaping the discourses of representation for visual culture in South Asia. The realities of the present have not been directly under study, but they have impelled me toward this history in the first place, and it is therefore now appropriate to return to a few features of our contemporary "exhibitionary complex."

No longer simply showcases of imperial possession, nor an appropriation of the latter by agents of nationalism, the spectacles of culture in the postcolonial present are increasingly mediated by the ideological conditions of the production of "heritage," the tension and competition between the local and global, and the mediations of the South Asian diaspora in a transnational landscape of cultural production. Today, the staging of exhibits of "indigenous Indian culture" are further complicated by India's need to compete and succeed in a globalized market of trade and consumption. Moreover, new visual technologies such as computer and satellite technologies, digital imaging, and the Internet have transformed the field of cultural representation. And yet, the categories of caste, tradition, village, and craftsman continue to reemerge in significant ways and often remain the primary precepts through which postcolonial culture is imagined and staged. The very language and imaginative structure that began with visual forms of representation in the colonial period have set the terms for the re-presentation of Indian culture, history, people, and objects in a myriad of postcolonial formations.

Indeed, the representational dilemmas of two decades ago—for example, the problem identified as "Raj nostalgia" in exhibitions and other cultural texts—appear to be reworked rather than resolved in the present global cultural landscape. Twenty-five years of economic liberalization in India have led to an unprecedented opening of the Indian economy to foreign investment and technology, exemplified by the dot-com culture of Bangalore, India's so-called Silicon Valley, or the outsourcing of jobs by multinational corporations and the rise of the phenomenon of call centers in India. While this has meant a new era of cosmopolitanism, it has also exacerbated the existing extremes of wealth and poverty, not only in third world countries such as India, but indeed everywhere. It has also inaugurated a new terrain for contemporary cultural practice within India, characterized, on one hand, by the paradoxes and contradictions of religious-political conservatism and a capitulation to market condi-

tions, and, on the other, by a distinctly invigorated environment for contemporary art practice and a renewed relevance of critical art practices in the political domain.

Walter Benjamin cautioned against the "appreciation of heritage," describing it as a greater "catastrophe" than indifference or disregard.[4] Perhaps more than any other writer, it was he who foresaw the pressures that modernity's representational forms brought to bear on culture and tradition, past and future, at the beginning of the twentieth century. Benjamin was of course writing at a different time, during which a particular set of cataclysmic events—among them the rise of fascism in Europe—signaled a catastrophic conjuncture in the most literal sense. For our purposes, his concern with "how a particular form of tradition"[5] comes into representation remains a relevant concern: how, in other words, "heritage"—a mode of cultural production in the present that lays claim to the past—is mediated and transformed by the act of display.[6] In India, as elsewhere, there has emerged in recent years a "heritage industry" that has effectively converted locations, sites, artifacts, and architecture into cultural objects for touristic consumption. The Dakshin Chitra Complex, a recreated village–cum–theme park near Chennai representing the folk traditions of South India, and the National Crafts Museum in New Delhi, with its mandate of bettering the economic circumstances of Indian artisans, are two attempts to revive and repackage India's folk and artisanal traditions for a predominantly urban clientele. They participate in a larger crafts–folk arts–heritage complex that includes a range of commercial activities seeking to bridge the industrial/preindustrial divide. Dilli Haat, for example, a permanent market and tourist destination in South Delhi that opened in 1994, promotes Indian regional handicrafts and cuisine; the state-controlled Cottage Industries Emporia sell products from the different states of India to shoppers in the heart of the capital; Delhi's upscale boutiques in Hauz Khas Village and Mehrauli market a rural ambience and designer labels to the Indian nouveau riche; and a store like Fabindia, described as India's version of Gap, offers folksy cotton apparel, fashionable prints, and trendy textiles for interior design.

The commercialization and museumization of craft have thus unfolded as intertwined phenomena that demand a sharpening of our analytical skills. However, these processes must also be situated in relation to the increasingly powerful role of museums in contemporary postcolonial society. India has not been excluded from the scramble to achieve the "Bilbao effect," or the economic regeneration, prestige, and global visi-

bility that comes with the opening of a major museum such as the Guggenheim in Bilbao, Spain. The Khalsa Heritage Complex currently under construction in the holy city of Anandpur Sahib, in Punjab, is a sprawling seventy-five-acre museological site that celebrates five hundred years of Sikh history with a large theater and auditorium, a two-story library, and two separate complexes of exhibition space connected by a ceremonial bridge. Its sleek, modernist architecture and curved rooftops of stainless steel even recall the style of Frank Gehry's Guggenheim Museum in Bilbao. The architect selected for this project, however, is Moshe Safdie, which has an added significance. Safdie was chosen in part for his contribution to the Yad Vashem site in Jerusalem, the premier Holocaust memorial museum in Israel, revealing a connection between the remembering of Sikh histories of suffering and the memorial model of the Holocaust museum. How the museological paradigms of the Holocaust may enhance or hinder the operations or memory of Sikh history, and the violent experiences of partition in Punjab in particular, remains to be seen. However, the new nexus of entanglements between history, religion, and heritage represented by this initiative, as well as the very different deployments of the museum we observe (for example, as a tool for prestige on a global stage), suggests some of the myriad emergent formations and cultural representations that we are likely to encounter in the future.

Contemporary artists in South Asia have articulated and responded to the cultural dilemmas of the present in increasingly self-conscious and sophisticated ways, even as they remain caught in the discrepancies generated by colonial history and its paradigms. These legacies have themselves been thematized in a variety of contemporary art practices, from the poetic meditations on museological space in the photographs of Dayanita Singh, the ironic commentaries on ethnology and visual documentation in the playful work of Pushpamala N, the radical reworking of archaic painting traditions by Pakistani artists like Shahzia Sikander, and the deep engagements with the colonial archive and historical memory in a range of works by Vivan Sundaram.[7] And yet even vanguard artists such as these, who are increasingly interpolated into the international biennial and triennial exhibitions of the global art world and have received recognition for their innovations in India and abroad, remain beset by the problems of mimesis and belatedness, at times judged for adopting and emulating the terms of the West or dismissed for the lateness of their arrival on the international stage. They are also forced to navigate the ever-present forms of containment presented by fashions like "Indo chic," and the ambivalent space in multicultural society we

recognize as the "ethnic slot." The quandaries and dilemmas faced by Indian artists, while obviously specific to the present environment, do not merely recall the problems of the first generation of painters such as Ravi Varma, who adopted oil and easel for the first time in the colonial period. They are the dubious inheritance of the postcolonial artist: a set of epistemological repercussions derived from an earlier era of imperialism and internationalism that continue to be felt in the contemporary art world.

This book has sought to historicize these cultural and epistemological dilemmas by tracking a range of practices, ideas, and discourses of display through which our modern understandings of the Indian subcontinent have been formed. By presenting a series of case studies and events that foreground a range of nineteenth-century representational phenomena (department stores, exhibitions, postcards, painting, and museums), I have attempted to critique the specific arrangements by which India has been made visible through its encounters with the West, and the interpretive frameworks of modernity through which it has been received and consumed. Specific images of Indian objects, people, culture, and history have been constituted through different political arenas; and "India" itself has emerged as an unfixed entity created and re-created through different historical phases. Each of the chapters has provided a series of crystallizing moments in the complex experience of modernity itself. And as the prism of modern international relationships has shifted between imperialism, nationalism, and postcolonialism, so too has it been reflected in the constructed image of India.

Notes

INTRODUCTION. COLONIAL PATTERNS, INDIAN STYLES

1. *Observer*, Sunday, November 13, 2005.
2. Yashodhara Dalmia, *The Making of Modern Indian Art: The Progressives* (New Delhi: Oxford University Press, 2001).
3. Geeta Kapur, *When Was Modernism? Essays on Contemporary Cultural Practice in India* (New Delhi: Tulika Press, 2000), p. 124.
4. Ibid., p. 147.
5. For a discussion of some of these problems, see Susan Bean, *Timeless Visions: Contemporary Art of India from the Chester and Davida Herwitz Collection* (Salem, MA: Peabody Essex Museum, n.d.).
6. Ajit Mookerjee, ed., *5000 Designs and Motifs from India* (New York: Dover Publications, 1996).
7. Hal Foster, *Design and Crime (and Other Diatribes)* (London and New York: Verso, 2002).
8. Ibid., p. 4.
9. Ibid., p. 18.
10. Ibid., p. 21.
11. See Anandi Ramamurthy, "Orientalism and the 'Paisley' Pattern," in Mary Schoeser and Christine Boydell, eds., *Disentangling Textiles: Techniques for the Study of Designed Objects* (London: Middlesex University Press, 2002), pp. 121–33.
12. Ibid.
13. Homi Bhabha, *The Location of Culture* (New York: Routledge, 1994), p. 70.
14. Selected works include Timothy Barringer and Tom Flynn, eds., *Colonialism and the Object: Empire, Material Culture, and the Museum* (London: Routledge, 1998); Jill Beaulieu and Mary Roberts, eds., *Orientalism's Inter-*

locutors: Painting, Architecture, Photography (Durham, NC: Duke University Press, 2002); Roger Benjamin, Orientalist Aesthetics: Art, Colonialism, and French North Africa 1880–1930 (Berkeley: University of California Press, 2003); Zeynep Celik, Displaying the Orient: Architecture of Islam at Nineteenth-Century World's Fairs (Berkeley: University of California Press, 1992), and Urban Forms and Colonial Confrontations: Algiers under French Rule (Berkeley: University of California Press, 1998); Deborah Cherry, Beyond the Frame: Feminism and Visual Culture, Britain 1850–1900 (London: Routledge, 2001); James Clifford, The Predicament of Culture (Cambridge, MA: Harvard University Press, 1988); Julie Codell and Dianne Sachko Macleod, eds., Orientalism Transposed: The Impact of the Colonies on British Culture (London: Ashgate, 1998); Annie Coombes, Reinventing Africa: Museums, Material Culture, and Popular Imagination (New Haven, CT: Yale University Press, 1994); Richard Davis, The Lives of Indian Images (Princeton, NJ: Princeton University Press, 1997); Vidya Dehejia, ed., India through the Lens: Photography, 1840–1911 (Washington, DC: Freer and Sackler Galleries, Smithsonian Institution Press, 2000); Stephen Eisenman, Gauguin's Skirt (New York and London: Thames and Hudson, 1997); Shelly Errington, The Death of Authentic Primitive Art and Other Tales of Progress (Berkeley: University of California Press, 1998); Paul Greenhalgh, Ephemeral Vistas: The Expositions Universelles, Great Exhibitions, and Worlds Fairs 1851–1939 (Manchester: Manchester University Press, 1988); James Herbert, Paris 1937: Worlds on Exhibition (Ithaca, NY: Cornell University Press, 1998); Peter Hoffenberg, An Empire on Display: English, Indian, and Australian Exhibitions from the Crystal Palace to the Great War (Berkeley: University of California Press, 2001); John Mackenzie, Orientalism: History, Theory, and the Arts (Manchester: Manchester University Press, 1995); Thomas Metcalf, An Imperial Vision: Indian Architecture and Britain's Raj (London: Faber and Faber, 1989); Timothy Mitchell, Colonising Egypt (Cambridge: Cambridge University Press, 1988); Partha Mitter, Much Maligned Monsters: History of European Reactions to Indian Art (Chicago: University of Chicago Press, 1992); Douglas R. Nickel, Francis Frith in Egypt and Palestine: A Victorian Photographer Abroad (Princeton, NJ: Princeton University Press, 2004); Maria Antonella Pelizzari, ed., Traces of India: Photography, Architecture, and the Politics of Representation, 1850–1900 (Montreal and New Haven, CT: Canadian Centre for Architecture and the Yale Center for British Art, 2003); Christopher Pinney, Camera Indica: The Social Life of Indian Photographs (London: Reaktion Books, 1997); Deborah Poole, Vision, Race, and Modernity: A Visual Economy of the Andean Image World (Princeton, NJ: Princeton University Press, 1997); Sally Price, Primitive Art in Civilized Places (Chicago: University of Chicago Press, 1989); James Ryan, Picturing Empire: Photography and the Visualisation of the British Empire (Chicago: University of Chicago Press, 1998); George Stocking, ed., Objects and Others: Essays on Museums and Material Culture (Madison: University of Wisconsin Press, 1985); Nicholas Thomas, Possessions: Indigenous Art / Colonial Culture (London: Thames and Hudson, 1999).

15. Edward Said, Orientalism (1978; repr., New York and London: Penguin Books, 1991), and Culture and Imperialism (New York: Vintage, 1993).

16. Said, *Culture and Imperialism*, p. xxii.

17. Ibid., p. 36; Antoinette Burton, *At the Heart of Empire: Indians and the Colonial Encounter in Late Victorian Britain* (Berkeley: University of California Press, 1998), and *Burdens of History: British Feminists, Indian Women and Imperial Culture 1865–1915* (Chapel Hill: University of North Carolina Press, 1994); Ann Stoler and Fred Cooper, eds., *Tensions of Empire: Colonial Cultures in a Bourgeois World* (Berkeley: University of California Press, 1997); Catherine Hall, *Civilising Subjects: Metropole and Colony in the English Imagination 1830–1867* (Chicago: University of Chicago Press, 2002).

18. Said, *Culture and Imperialism*, p. 19.

19. Carole Breckenridge, "The Aesthetics and Politics of Colonial Collecting: India at World's Fairs," *Comparative Studies of Society and History* 31 (1989): 195–216.

20. Arjun Appadurai, ed., *The Social Life of Things: Commodities in Cultural Perspective* (Cambridge: Cambridge University Press, 1986).

21. The volume's interdisciplinarity and the links it forged between colonial knowledge and material culture also reveal the influence of Bernard Cohn, the distinguished scholar of South Asia. See Bernard Cohn, *An Anthropologist among the Historians and Other Essays* (New Delhi: Oxford University Press, 1987), and *Colonialism and Its Forms of Knowledge: The British in India* (Princeton, NJ: Princeton University Press, 1986).

22. For a discussion of these themes, see Fred Myers, ed., *The Empire of Things: Regimes of Value and Material Culture* (Santa Fe, NM: School of American Research Press, 2001).

23. See Ranjit Hoskote, "The Anxiety of Influence," *Art India* 2, no. 2 (1999): 32–34.

24. James Clifford, *The Predicament of Culture* (Cambridge, MA: Harvard University Press, 1988).

25. Jean Fisher, ed., *Global Visions: Towards a New Internationalism in the Visual Arts* (London: Institute of International Visual Arts, 1994); Kobena Mercer, ed., *Cosmopolitan Modernisms* (Cambridge, MA, and London: MIT Press and Institute of International Visual Arts, 2005).

26. Akhil Gupta and James Ferguson, eds., *Anthropological Locations: Boundaries and Grounds of a Field Science* (Berkeley: University of California Press, 1997); Aihwa Ong, *Flexible Citizenship: The Cultural Logics of Transnationality* (Durham, NC: Duke University Press, 1999).

27. Frantz Fanon, "Algeria Unveiled," in *A Dying Colonialism* (New York: Grove Press, 1959), p. 36.

28. T. J. Clark, *The Painting of Modern Life: Paris in the Art of Manet and His Followers* (Princeton, NJ: Princeton University Press, 1984), p. 2.

29. Tony Bennett, *The Birth of the Museum: History, Theory, Politics* (London and New York: Routledge, 1995), p. 61.

30. Mildred Archer and Ronald Lightbown, *India Observed: India as Viewed by British Artists, 1760–1860* (London: Victoria and Albert Museum, 1982); Stephen Bann, "William Hodge's A Dissertation," in Antonella Pelizzari, ed., *Traces of India: Photography, Architecture, and the Politics of Representation* (Montreal and New Haven: Canadian Centre for Architecture and the Yale

Center for British Art, 2003), pp. 60–85; G. H. R. Tillotson, *The Artificial Empire: The Indian Landscapes of William Hodges* (Richmond, UK: Curzon Press, 2000).

31. Mildred Archer, *Early Views of India: The Picturesque Journeys of Thomas and William Daniell* (London: Thames and Hudson, 1980).

32. Vidya Dehejia, with Allen Staley, *Impossible Picturesqueness: Edward Lear's Indian Watercolours, 1873–1875* (New York: Columbia University Press, 1989); Nicholas Dirks, "Guiltless Spoliations: Picturesque Beauty, Colonial Knowledge, and Colin Mackenzie's Survey of India," in Catherine Asher and Thomas Metcalf, eds., *Perceptions of South Asia's Visual Past* (New Delhi: Oxford University Press, 2004); Kim Ian Michasiw, "Nine Revisionist Theses on the Picturesque," *Representations* 38 (1992): 76–100.

33. W. J. T. Mitchell, "Introduction," in Mitchell, ed., *Landscape and Power* (Chicago: University of Chicago Press, 1994), p. 1.

34. Tapati Guha-Thakurta, *Monuments, Objects, Histories: Institutions of Art in Colonial and Postcolonial India* (New York: Columbia University Press, 2004), p. 7.

35. Timothy Mitchell, "The World as Exhibition," in Donald Preziosi, ed., *The Art of Art History: A Critical Anthology* (Oxford: Oxford University Press, 1998).

36. Tim Barringer, *Men at Work: Art and Labour in Victorian Britain* (New Haven, CT: Yale University Press, 2005); Carol Breckenridge, "The Aesthetics and Politics of Colonial Collecting: India at World's Fairs," *Comparative Studies of Society and History* 31 (1989): 195–216; Lara Kriegel, "Narrating the Subcontinent in 1851: India at the Crystal Palace," in Louise Purbrick, ed., *The Great Exhibition of 1851: New Interdisciplinary Essays* (Manchester, UK: Manchester University Press, 2001), pp. 146–78; Thomas Richards, *The Commodity Culture of Victorian England: Advertising and Spectacle, 1851–1914* (Stanford, CA: Stanford University Press, 1990).

37. Walter Benjamin, *Charles Baudelaire: A Lyric Poet in the Era of High Capitalism* (London and New York: Verso, 1983), pp. 165–66.

38. George Stocking, *Victorian Anthropology* (New York: Free Press, 1987), p. 1.

39. Donald Preziosi, *Brain of the Earth's Body: Art, Museums, and the Phantasms of Modernity* (Minneapolis: University of Minnesota Press, 2003), pp. 14, 96.

40. Breckenridge, "The Aesthetics and Politics of Colonial Collecting," p. 202.

41. *Bombay Times*, July 1, 1851.

42. Cited in Ray Desmond, *The India Museum, 1801–1879* (London: H.M.S.O., 1982), p. 73.

43. Cited in Bernard Cohn, *Colonialism and Its Forms of Knowledge* (Princeton, NJ: Princeton University Press, 1996), p. 81. See also Nicholas Dirks, "Guiltless Spoliations."

44. Cohn, *Colonialism and Its Forms of Knowledge.*

45. Guha-Thakurta, *Monuments, Objects, Histories;* Gyan Prakash, *Another Reason: Science and the Imagination of Modern India* (Princeton, NJ: Princeton University Press, 1999).

46. Guha-Thakurta, *Monuments, Objects, Histories,* esp. chapter 2.

47. Prakash, *Another Reason.*

48. See Vinayak Chaturvedi, ed., *Mapping Subaltern Studies and the Postcolonial* (London: Verso, 2000); Ranajit Guha, ed., *Subaltern Studies,* vols. 1–6, *Writings on South Asian History and Society* (New Delhi: Oxford University Press, 1982–89), and *A Subaltern Studies Reader, 1986–1995* (Minneapolis: University of Minnesota Press, 1997); Ranajit Guha and Gayatri Spivak, eds., *Selected Subaltern Studies* (New Delhi: Oxford University Press, 1988).

49. Saloni Mathur, "History and Anthropology in South Asia: Rethinking the Archive," *Annual Review of Anthropology* 29 (2000): 89–106.

50. The phrase is from Guha, *Subaltern Studies,* vol. 2, p. vii. See also Homi Bhabha, *The Location of Culture* (New York: Routledge, 1994); Thomas Richards, *The Imperial Archive: Knowledge and the Fantasy of Empire* (New York: Verso, 1993); Gayatri Spivak, *In Other Worlds: Essays in Cultural Politics* (London: Routledge, 1988).

51. Owen Jones, *The Grammar of Ornament* (New York: J. W. Bouton, 1880).

52. Ralph Wornum, "The Exhibition as a Lesson in Taste," *Special Issue of the Art Journal* (1851): vii.

53. Ibid., xix.

54. James Mill, *The History of British India,* 3 vols. (London: Baldwin, Cradock, and Joy, 1818), p. 243.

55. The Royal Commission, ed., *The Official Descriptive and Illustrated Catalogue of the Great Exhibition, 1851,* 3 vols. (London: Spicer Brothers, 1851), p. 858.

56. See Johannes Fabian, *Time and the Other: How Anthropology Makes Its Object* (New York: Columbia University Press, 1983).

57. Sir Henry Maine, *Village Communities of the East and West* (New York: Henry Holt and Company, 1880), p. 9.

58. Ibid., p. 12.

59. Alan Diamond, ed., *The Victorian Achievement of Sir Henry Maine: A Centennial Reappraisal* (Cambridge: Cambridge University Press, 1991); Uday Singh Mehta, *Liberalism and Empire: A Study in Nineteenth-Century British Liberal Thought* (Chicago: University of Chicago Press, 1999); Eric Stokes, *The English Utilitarians and India* (Oxford: Clarendon Press, 1959); Thomas Metcalf, *Ideologies of the Raj* (Cambridge: Cambridge University Press, 1995).

60. R. C. Dutt, *The Economic History of India,* vol. 2 (London: Kegan Paul, Trench, Trubner & Co., 1904).

61. Sara Suleri, *The Rhetoric of English India* (Chicago: University of Chicago Press, 1992); John Falconer, "A Pure Labor of Love: A Publishing History of *The People of India,*" in Gary Sampson, ed., *Colonialist Photography: Imag(in)ing Race and Place* (London: Routledge, 2002).

62. My version of this phrase is borrowed from an essay by Jordana Bailkin, "Indian Yellow: Making and Breaking the Imperial Palette," *Journal of Material Culture* 10, no. 2 (2005): 197–214.

63. Saloni Mathur, *An Indian Encounter: Portraits for Queen Victoria* (London: National Gallery Company, 2003).

64. For a history of the National Gallery, see Carol Duncan, "From the Princely Gallery to the Public Art Museum: The Louvre Museum and the National Gallery, London," in Donald Preziosi and Claire Farago, eds., *Grasping the World: The Idea of the Museum* (London: Ashgate, 2004).

65. Malek Alloula, *The Colonial Harem* (Minneapolis: University of Minnesota Press, 1986).

CHAPTER 1. THE INDIAN VILLAGE IN VICTORIAN SPACE

1. Brian Wallis, "Selling Nations: International Exhibitions and Cultural Diplomacy," in D. Sherman and I. Rogoff, eds., *Museum Culture: Histories, Discourses, Spectacles* (Minneapolis: University of Minnesota Press, 1994), p. 265.

2. Richard Kurin, "Cultural Conservation through Representation: Festival of India Folklife Exhibitions at the Smithsonian Institute," in I. Karp and S. Lavine, eds., *Exhibiting Culture: The Poetics and Politics of Museum Display* (Washington, DC: Smithsonian Institution Press, 1991), pp. 328, 340.

3. Ibid., p. 325.

4. Ibid., p. 318.

5. Ibid.

6. Ibid., p. 320.

7. Ibid., p. 322.

8. Alison Adburgham, *Liberty's: A Biography of a Shop* (London: Unwin Hyman, 1975); Rachel Bowlby, *Carried Away: The Invention of Modern Shopping* (London: Faber, 2000); Stephen Calloway, *The House of Liberty: Masters of Style and Decoration* (London: Thames and Hudson, 1992); Geoffrey Crossick and S. Jauman, eds., *Cathedrals of Consumption: The European Department Store, 1850–1939* (Aldershot, UK: Ashgate, 1999); Neil Harris, *Cultural Excursions: Marketing Appetites and Cultural Tastes in Modern America* (Chicago: University of Chicago Press, 1990); Michael Miller, *The Bon Marche: Bourgeois Culture and the Department Store, 1869–1920* (Princeton, NJ: Princeton University Press, 1982); Mica Nava, "The Cosmopolitanism of Commerce and the Allure of Difference: Selfridge's, the Russian Ballet, and the Tango, 1911–1914," *International Journal of Cultural Studies* 1, no. 2 (1998): 163–96; Erika Rappaport, *Shopping for Pleasure: Women in the Making of London's West End* (Princeton, NJ: Princeton University Press); and Rosalind Williams, *Dreamworlds: Mass Consumption in Late Nineteenth-Century France* (Berkeley: University of California Press, 1982).

9. George Birdwood, *The Arts of India* (1880; repr., Calcutta: Rupa, 1992), p. 130.

10. Ibid., p. 142.

11. Ibid., p. 131.

12. Ibid., p. 312.

13. Ibid., p. 301.

14. Ibid., pp. 311–12.

15. Ibid., p. 132.

16. Ibid., p. 134.

17. Ibid., pp. 132–34.

18. George Birdwood, *Competition and the Indian Civil Service* (London: Henry S. King, 1872), p. 23.

19. Ibid.

20. Ibid., pp. 23–24.

21. See Partha Mitter, *Art and Nationalism in Colonial India, 1850–1922* (Cambridge: Cambridge University Press, 1994), pp. 311–13, and Tapati Guha-Thakurta, *The Making of a New Indian Art: Artists, Aesthetics and Nationalism in Bengal, c. 1850–1920* (Cambridge: Cambridge University Press, 1992), pp. 163–65, for the historical significance of this meeting.

22. James Clifford, "Of Other Peoples: Beyond the 'Salvage Paradigm,'" in Hal Foster, ed., *Discussions in Contemporary Culture* (Seattle: Bay Press, 1987), pp. 121–29.

23. On the relevance of India to the medievalism that prevailed in late Victorian architecture and the visual arts, see Timothy Barringer, *Men at Work: Art & Labour in Victorian Britain* (New Haven, CT: Yale University Press, 2005); Patrick Brantlinger, "A Postindustrial Prelude to Postcolonialism: John Ruskin, William Morris and Gandhism," *Critical Inquiry* 22, no. 3 (1996): 466–85; Raymond Head, *The Indian Style* (Chicago: University of Chicago Press, 1986); Guha-Thakurta, *The Making of a New Indian Art*; Thomas Metcalf, *An Imperial Vision: Indian Architecture and Britain's Raj* (London: Faber and Faber, 1989); Partha Mitter, *Much Maligned Monsters: History of European Reactions to Indian Art* (Chicago: University of Chicago Press, 1992).

24. See, for instance, Stephen Calloway, "Arthur Lasenby Liberty: Artistic Entrepreneur," *The Magazine Antiques* (January 1993), pp. 184–93.

25. Cited in *Liberty Art Fabrics and Personal Specialties* (London: Liberty & Co., 1887), pp. 50–54.

26. Michael Moss and A. Turton, *A Legend of Retailing: House of Fraser* (London: Weidenfeld and Nicolson, 1989), pp. 272–77.

27. Williams, *Dreamworlds*.

28. Cited in *Liberty Art Fabrics and Personal Specialties*, p. 55.

29. Ibid., p. 50.

30. *The Queen*, cited in ibid., p. 4.

31. Ibid., p. 66.

32. Ibid., p. 65.

33. Ibid., p. 64.

34. Ibid., p. 67.

35. *Catalogue of Liberty's Art Fabrics* (London: Liberty & Co., 1883), p. 3.

36. *Le Follet*, cited in ibid., p. 12.

37. Adburgham, *Liberty's*, p. 59.

38. Ibid., p. 60.

39. *The Indian Mirror*, March 24, 1886.

40. *The Indian Mirror*, April 6, 1886.

41. India Office Library and Records (hereafter cited as IOLR) L/P&J/274, Letter from Nanda Lal Ghosh to J. A. Godley, Home Office, February 19, 1886.

42. Quoted in *Indian Mirror*, April 6, 1886.

43. *Times of India*, March 18, 1886.

44. See Gareth Stedman Jones, *Outcast London: A Study in the Relationship*

between Classes in Victorian Society (Oxford: Oxford University Press, 1971); Judith Walkowitz, *City of Dreadful Delights: Narrations of Sexual Danger in Late Victorian London* (Chicago: University of Chicago Press, 1992).

45. *Indian Mirror,* January 9, 1886.

46. *Indian Mirror,* January 15, 1886.

47. *Hindoo Patriot,* April 5, 1886.

48. *Hindoo Patriot,* February 15, 1886.

49. *Indian Mirror,* January 31, 1886.

50. IOLR, Letter from Arthur Lasenby Liberty to Sir George Birdwood, March 24, 1983, MSS Eur F216/55.

51. See Arthur Liberty, "Spitalfields Brocades," *The Studio* 1 (1893): 20–24.

52. *The British Silk Renaissance: Recent Exclusive Specialties Introduced by Messrs. Liberty* (London: Liberty & Co., 1892).

53. Karl Marx, excerpt from *Capital,* vol. 3, in *Marx and Engels on Colonialism* (Honolulu, HI: University Press of the Pacific, 2001), p. 305. See also C. A. Bayly, "The Origins of Swadeshi (Home Industry): Cloth and Indian Society, 1700–1930," in Arjun Appadurai, ed., *The Social Life of Things: Commodities in Cultural Perspective* (Cambridge: Cambridge University Press, 1986), pp. 285–321.

54. R. C. Dutt, *The Economic History of India,* vol. 2 (1904; repr. New York: Burt Franklin, 1970), p. v.

55. Ibid., p. xix.

56. Ibid., pp. 518–19.

57. Lisa Trivedi, "Visually Mapping the 'Nation': Swadeshi Politics in Nationalist India, 1920–1930," *Journal of Asian Studies* 62, no. 1 (2003): 11–41.

58. See Kathryn Hansen, *Grounds for Play: The Nautanki Theatre of North India* (Berkeley: University of California Press, 1993).

59. See Benedict Anderson, *Imagined Communities: Reflections on the Origins and Spread of Nationalism* (New York: Verso, 1991); Partha Chatterjee, *Nationalist Thought and the Colonial World: A Derivative Discourse* (Minneapolis: University of Minnesota Press, 1993); Christopher Pinney, *Photos of the Gods: The Printed Image and Political Struggle in India* (London: Reaktion Books, 2004); Trivedi, "Visually Mapping the 'Nation.'"

60. Trivedi, "Visually Mapping the 'Nation,'" p. 16.

61. See Sumit Sarkar, *The Swadeshi Movement in Bengal, 1903–1908* (New Delhi: People's Publishing House, 1973).

62. George Watt, *Indian Art at Delhi, 1903* (repr., New Delhi: Motilal Banarsidass, 1987). On the relationship of this exhibition to Lord Curzon's Delhi Durbar of 1903, see Julie Codell, "Gentlemen Connoisseurs and Capitalists: Modern British Imperial Identity in the 1903 Delhi Durbar Exhibition of Indian Art," in David Arnold, ed., *Cultural Identities and the Aesthetics of Britishness* (Manchester: Manchester University Press, 2004), pp. 134–63.

63. Ananda K. Coomaraswamy, *The Indian Craftsman* (1909; repr., New Delhi: Munshiram Manoharlal Publishers, 1989), p. 58.

64. Ibid., p. 45.

65. Ibid., p. 48.

66. Ibid., p. 1.

67. E. B. Havell, *The Basis for Artistic and Industrial Revival in India* (1912; repr., New Delhi: Usha Publications, 1986), pp. 12–14.

68. Ibid., p. 173.

69. Ibid., p. 45.

70. Ananda Coomaraswamy, *Art and Swadeshi* (1912; repr., New Delhi: Munshiram Manoharlal Publishers, 1994), p. 17.

71. Ibid., p. 17.

72. Mohandas K. Gandhi, *An Autobiography: The Story of My Experiments with Truth* (Boston: Beacon Press, 1993), p. 489.

73. Ibid.

74. C. A. Bayly, "The Origins of Swadeshi (Home Industry)," pp. 285–321; Susan Bean, "Gandhi and Khadi: The Fabric of Independence," in A. Weiner and J. Schneider, eds., *Cloth and Human Experience* (Washington, DC: Smithsonian Institution Press, 1989), pp. 355–76; Bernard Cohn, "Cloth, Clothes, and Colonialism: India in the Nineteenth Century," in *Colonialism and Its Forms of Knowledge: The British in India* (Princeton, NJ: Princeton University Press, 1996), pp. 106–62; Emma Tarlow, *Clothing Matters: Dress and Identity in India* (Chicago: University of Chicago Press, 1996).

75. Christopher Bayly, *The Raj: India and the British, 1600–1947* (London: National Portrait Gallery, 1990); Pinney, *Photos of the Gods;* Trivedi, "Visually Mapping the 'Nation.' "

76. Shahid Amin, *Event, Metaphor, Memory: Chauri Chaura 1922–1992* (Berkeley: University of California Press, 1995).

77. Shahid Amin, "Gandhi as Mahatma," in Ranajit Guha and Gayatri Spivak, eds., *Selected Subaltern Studies* (New York and Oxford: Oxford University Press, 1988), p. 294.

78. Gandhi, *An Autobiography*, p. 76.

79. See M. K. Gandhi, *Hind Swaraj and Other Writings* (Cambridge: Cambridge University Press, 1997), and *An Autobiography*. See also Barringer, *Men at Work;* Patrick Brantlinger, "A Postindustrial Prelude to Postcolonialism," 466–85; and Chatterjee, *Nationalist Thought and the Colonial World.*

80. Coomaraswamy, *Art and Swadeshi*, p. 8.

81. Chatterjee, *Nationalist Thought and the Colonial World.*

82. Timothy Barringer, *Men at Work;* Debora Silverman, *Van Gogh and Gaugin: The Search for Sacred Art* (New York: Farrar, Straus and Giroux, 2000).

83. See Geeta Kapur, *When Was Modernism? Essays on Contemporary Cultural Practice in India* (New Delhi: Tulika, 2000), esp. pp. 87–144.

84. See K. G. Subramanyam, *The Living Tradition: Perspectives on Modern Indian Art* (Calcutta: Seagull Books, 1987).

CHAPTER 2. "TO VISIT THE QUEEN"

1. Ian Hacking, *The Taming of Chance* (Cambridge: Cambridge University Press, 1990).

2. Edward Said, *Orientalism* (1978; repr., New York and London: Penguin Books, 1991), p. 92.

3. Sumit Sarkar, *Modern India, 1885–1947* (New Delhi: Macmillan India, 1983).

4. See Dipesh Chakrabarty, *Provincializing Europe: Postcolonial Thought and Historical Difference* (Princeton, NJ: Princeton University Press, 2000); Partha Chatterjee, *A Princely Imposter: The Strange and Universal History of the Kumar of Bhawal* (Princeton, NJ: Princeton University Press, 2002); Nicholas Dirks, *Castes of Mind: Colonialism and the Making of Modern India* (Princeton, NJ: Princeton University Press, 2001); Ranajit Guha, *Elementary Aspects of Peasant Insurgency in Colonial India* (Durham, NC: Duke University Press, 1999); Lata Mani, *Contentious Traditions: The Debate on Sati in Colonial India* (Berkeley: University of California Press, 1998); Gyan Prakash, *Another Reason: Science and the Imagination of Modern India* (Princeton, NJ: Princeton University Press, 1999); Gayatri Spivak, "Can the Subaltern Speak?" in C. Nelson and L. Grossberg, eds., *Marxism and the Interpretation of Culture* (Chicago: University of Illinois Press, 1988), pp. 271–311.

5. Guha, *Elementary Aspects of Peasant Insurgency*, p. 11.

6. See Antoinette Burton, *At the Heart of Empire: Indians and the Colonial Encounter in Late Victorian Britain* (Berkeley: University of California Press, 1998); and James Clifford, *Routes: Travel and Translation in the Late Twentieth Century* (Cambridge, MA: Harvard University Press, 1997).

7. Letter from Curzon to Lord Hamilton, August 27, 1902, quoted in Rozina Visram, *Ayahs, Lascars, and Princes: Indians in Britain, 1700–1947* (London: Pluto Press, 1986), p. 175.

8. See Arindam Dutta, "The Politics of Display: India 1886 and 1986," *Journal of Arts and Ideas* 30–31 (1997): 115–45; Peter Hoffenberg, *An Empire on Display: English, Indian, and Australian Exhibitions from the Crystal Palace to the Great War* (Berkeley: University of California Press, 2001).

9. Frank Cundall, *Reminiscences of the Colonial and Indian Exhibition* (London: William Clowes & Sons, 1886), pp. 7–9.

10. Cited in Nirad Chaudhuri, *Scholar Extraordinary: The Life of Friedrich Max Muller* (New Delhi: Orient Paperbacks, 1974), p. 199.

11. *Indian Mirror*, May 16, 1886.

12. *Hindoo Patriot*, May 10, 1886.

13. Carol Breckenridge, "The Aesthetics and Politics of Colonial Collecting: India at World's Fairs," *Comparative Studies of Society and History* 31 (1989): 195–216.

14. See also Zeynep Celik, *Displaying the Orient: Architecture of Islam at Nineteenth-Century World's Fairs* (Berkeley: University of California Press, 1992).

15. *Times*, May 22, 1886, p. 5, quoted in Thomas Metcalf, *An Imperial Vision: Indian Architecture and Britain's Raj* (London: Faber & Faber, 1989), p. 146.

16. George Birdwood, *The Arts of India* (1880; repr. Calcutta: Rupa, 1992), p. 312.

17. *Indian Mirror*, March 28, 1886.

18. *Indian Mirror*, May 28, 1886.

19. *Indian Mirror*, August 4, 1886.

20. *Indian Mirror,* August 10, 1886.

21. *Hindoo Patriot,* August 2, 1886.

22. *Indian Mirror,* August 26, 1886.

23. *Indian Mirror,* August 10, 1886.

24. T. N. Mukharji, *A Visit to Europe* (London: Edward Stanford, 1889), p. 206.

25. Ibid., p. 207.

26. Ibid.

27. See Judith Walkowitz, *City of Dreadful Night: Narratives of Sexual Danger in Late Victorian London* (Chicago: University of Chicago Press, 1992), p. 26.

28. Chaim Bermant, *Point of Arrival: A Study of London's East End* (London: Eyre Methuen, 1975), p. 290; see also Gareth Stedman Jones, *Outcast London: A Study in the Relationship between Classes in Victorian Society* (Oxford: Oxford University Press, 1971).

29. See Deborah Epstein Nord, "The Social Explorer as Anthropologist: Victorian Travellers among the Urban Poor," in William Sharpe and Leonard Wollock, eds., *Visions of the Modern City: Essays in History, Art, and Literature* (New York: Heyman Center for the Humanities, Columbia University, 1983), pp. 118–130; Peter Keating, ed., *Into Unknown England: Selections from the Social Explorers, 1866–1913* (Manchester, UK: Manchester University Press, 1976); Anne McClintock, *Imperial Leather: Race, Gender, and Sexuality in the Colonial Conquest* (New York: Routledge, 1995); Walkowitz, *City of Dreadful Night.*

30. Cited in Keating, *Into Unknown England,* p. 14.

31. Cited in ibid., p. 65.

32. Cited in ibid., p. 114.

33. Cited in ibid., p. 150.

34. See Ann Stoler, *Race and the Education of Desire: Foucault's History of Sexuality and the Colonial Order of Things* (Durham, NC: Duke University Press, 1995).

35. Cited in Stedman Jones, *Outcast London,* p. 330.

36. See Homi Bhabha, *The Location of Culture* (London and New York: Routledge, 1994); Burton, *At the Heart of Empire*; Mrinalini Sinha, *Colonial Masculinity: The Manly Englishman and the Effeminate Bengali in the Late Nineteenth Century* (Manchester, UK: Manchester University Press, 1995).

37. *The Times,* July 20, 1852, cited in Visram, *Ayahs, Lascars, and Princes,* p. 19.

38. Report from Henry S. King and Company, Official Agents to the Royal Commission, Jan. 5, 1887, in *Report of the Royal Commission for the Colonial and Indian Exhibition, 1886* (London: William Clowes and Sons, 1887), pp. 283–90.

39. The portion of their so-called wages left with the district magistrates in India was likely the "security deposit" required by any European bringing an Indian to England. See page 73 for a discussion of this security deposit system and its role in preventing Indian emigration to Britain.

40. Report from Henry S. King and Company, Official Agents to the Royal Commission, Jan. 5, 1887, in *Report of the Royal Commission,* pp. 283–90.

41. Cundall, *Reminiscences of the Colonial and Indian Exhibition*, p. 5.

42. Statement of Receipts and Payments and Approximate Balance Sheet, November 18, 1884, to April 23, 1887, in *Report of the Royal Commission*, p. lx.

43. *Report of the Royal Commission*, p. xlv.

44. See Thomas Metcalf, *Ideologies of the Raj* (Cambridge: Cambridge University Press, 1995), p. 77.

45. *The Art Journal* 48 (May 1886): 14.

46. See David Arnold, *Police Power and Colonial Rule, Madras, 1859–1947* (Delhi: Oxford University Press, 1986); Rachel Tolen, "Colonizing and Transforming the Criminal Tribesman: The Salvation Army in British India," *American Ethnologist* 18, no. 1 (1991): 106–25; and Anand Yang, ed., *Crime and Criminality in British India* (Tucson: University of Arizona Press, 1985).

47. *Indian Mirror*, June 6, 1886.

48. Ibid.

49. Ibid.

50. Mukharji, *A Visit to Europe*, p. 31.

51. Ibid., p. 1.

52. Ibid., p. 40.

53. Ibid., p. 196.

54. Ibid., pp. 99–100.

55. Ibid., p. 102.

56. Ibid., p. 105.

57. Ibid.

58. Ibid., p. 101.

59. Ibid., p. 99; emphasis mine.

60. Ibid., p. 79. For more about T. N. Mukharji, see Hoffenberg, *An Empire on Display*.

61. India Office Library and Records, Public and Judicial Papers (hereafter cited as IOLR: L/P&J) 271, February 25, 1886.

62. IOLR: L/P&J/417, March 17, 1886.

63. Walkowitz, *City of Dreadful Night*.

64. IOLR: L/P&J/417, March 15, 1886.

65. IOLR: L/P&J/417, March 20, 1886.

66. IOLR: L/P&J/539, April 3, 1886.

67. IOLR: L/P&J/539, April 6, 1886.

68. Telegram from Home Office to Allahabad, IOLR: L/P&J/539, March 27, 1886.

69. Telegram from Viceroy in Allahabad to the Secretary of State, Home Office, IOLR: L/P&J/539, April 8, 1886.

70. Pauper Natives of India in the United Kingdom, Draft of Memo from Home Office to Local Government Board, IOLR: L/P&J/432, March 23, 1886.

71. IOLR: L/P&J/432, April 8, 1886.

72. Ibid.

73. See Visram, *Ayahs, Lascars, and Princes*.

74. Joseph Salter, *The Asiatic in England* (London: Seeley, Jackson, and Halliday, 1873), p. 39.

75. Ibid., p. i.

76. Joseph Salter, *The East in the West or Work among the Asiatics and Africans in London* (London: S. W. Partridge and Co., 1894), p. 14.

77. For an analysis of Joseph Salter's autobiographical writings, see Ruth Lindeborg, "The Asiatic and the Boundaries of Victorian Englishness," *Victorian Studies* 37, no. 3 (1994): 381–404.

78. Resolution regarding Emigration Act, in *Government of India Public Despatches*, No. 52, Home Department, June 24, 1869.

79. Cited in Visram, *Ayahs, Lascars, and Princes*, p. 228.

80. Ibid., p. 20.

81. Letter from Joseph Salter to the Secretary of State at the India Office, IOLR: L/P&J/2122, December 21, 1886.

82. Letter from J. Freeman to Joseph Salter, IOLR: L/P&J/2122, December 10, 1886.

83. Letter from F. S. Fitzgerald to J. Salter, IOLR: L/P&J/2122, December 24, 1886.

84. IOLR: L/P&J/6/281/1270, August 28, 1890.

85. IOLR: L/P&J/2/59, File 567/No. 7, January 24, 1879.

86. IOLR: L/P&J/2325, December 12, 1885.

87. Reference Paper on the Petitioner Class by Sir Charles Bernard, IOLR: L/P&J/6/281/1270, August 1, 1890.

88. Statement by Tulsi Ram, from the Whitechapel Infirmary, IOLR: L/P&J/417, March 15, 1886.

89. Ibid.

90. Measures against the Petitioner Class, IOLR: L/P&J/6/281/1270, August 28, 1890.

91. Cited in Visram, *Ayahs, Lascars, and Princes*, pp. 28–29.

92. IOLR: L/P&J/769, May 24, 1886.

93. Letter from Mr. Phillips of West Ham Police Court to Home Office, IOLR: L/P&J/910, June 25, 1886.

94. IOLR: L/P&J/910, June 29, 1886.

95. Signed Statement by Tulsi Ram Morn, IOLR: L/P&J/271, September 1, 1885.

96. See Richard Smith, *Rule by Records: Land Registration and Village Custom in Early British Punjab* (Delhi: Oxford University Press, 1996).

CHAPTER 3. THE DISCREPANT PORTRAITURE OF EMPIRE

1. David MacDougall, "Photo Hierarchicus: Signs and Mirrors in Indian Photography," *Visual Anthropology* 5, no. 2 (1992): 103–29. For a slightly different account, see Sara Suleri, *The Rhetoric of English India* (Chicago: University of Chicago Press, 1992). Suleri's argument is that the volume "serves a highly fraught interpretive function," that despite its unrelenting authority, the interplay between the image and its captions opens up contradictions and reifies the "racial and cultural unreadability of India" (p. 104).

2. Allan Sekula, "The Body and the Archive," *October* 39 (Winter 1986): 3–64.

3. Ibid., p. 7.

4. See Saloni Mathur, *An Indian Encounter: Portraits for Queen Victoria* (London: National Gallery, 2003).

5. One exception is the reference work by Oliver Millar, *The Victorian Pictures in the Collection of Her Majesty the Queen* (Cambridge: Cambridge University Press, 1992).

6. Edward Said, *Culture and Imperialism* (New York: Vintage, 1993), p. 58.

7. The phrase "politics of the palette" comes from an essay by Jordanna Bailkin, who has shown how the paint pigment *purree,* or "Indian yellow," which was made from cow urine in India and used by nineteenth-century European painters to depict darker flesh tones, itself became a contested material in the colonial economy with the Cow Protection Act. Jordanna Bailkin, "Indian Yellow: Making and Breaking the Imperial Palette," *Journal of Material Culture* 10, no. 2: 197–214.

8. The term is Partha Mitter's from his book *Art and Nationalism in Colonial India, 1850–1922* (Cambridge: Cambridge University Press, 1994).

9. See Shivaji Panikkar et al., eds., *Towards a New Art History: Studies in Indian Art* (New Delhi: D. K. Printworld, 2003).

10. Several important works along these lines to which I am indebted include Ratnabali Chatterjee, *From the Karkhana to the Studio: A Study of the Changing Social Roles of Patron and Artist in Bengal* (New Delhi: Books and Books, 1990); Yashodhara Dalmia, *The Making of Modern Indian Art: The Progressives* (New Delhi: Oxford University Press, 2001); Tapati Guha-Thakurta, *The Making of a New Indian Art: Artists, Aesthetics and Nationalism in Bengal 1850–1920* (Cambridge: Cambridge University Press, 1992); Geeta Kapur, *When Was Modernism? Essays on Contemporary Cultural Practice in India* (New Delhi: Tulika Press, 2000); Mitter, *Art and Nationalism in Colonial India*; Gulammohammed Sheikh, ed., *Contemporary Art in Baroda* (New Delhi: Tulika, 1997); Gayatri Sinha, ed., *Indian Art: An Overview* (New Delhi: Rupa, 2003).

11. Mildred Archer, *Company Paintings: Indian Paintings of the British Period* (London: Victoria and Albert Museum, 1992).

12. Jyotindra Jain, *Kalighat Painting: Images from a Changing World* (Ahmedabad: Mapin Publishing, 1999).

13. Royal Archives QVJ 22 April 1886.

14. *Indian Mirror,* June 6, 1886.

15. Letter from Sir Fleetwood Edwards, October 1886, quoted in Oliver Millar, *The Victorian Pictures in the Collection of Her Majesty the Queen,* p. 245.

16. Mildred Archer, *India and British Portraiture, 1770–1825* (London: Oxford University Press, 1979); Beth Fowkes Tobin, *Picturing Imperial Power: Colonial Subjects in Eighteenth-Century British Painting* (Durham, NC: Duke University Press, 1999).

17. Val Prinsep, *Imperial India: An Artist's Journal* (London: Chapman and Hall, 1879), p. 350.

18. Archer, *India and British Portraiture,* p. 100.

19. Mildred Archer and Ronald Lightbown, *India Observed: India as Viewed by British Artists, 1760–1860* (London: Victoria and Albert Museum,

1982); Pratapaditya Pal and Vidya Dehejia, *From Merchants to Emperors: British Artists and India, 1757–1930* (Ithaca, NY: Cornell University Press, 1986).

20. Prinsep, *Imperial India*.

21. Millar, *The Victorian Pictures in the Collection of Her Majesty the Queen*, 245.

22. Royal Archives PP/VIC/1886/6420.

23. Mahrukh Tarapor, "John Lockwood Kipling and British Art Education in India," *Victorian Studies* (Fall 1980): 53–81. See also chapter 2 in Gyan Prakash, *Another Reason: Science and the Imagination of Modern India* (Princeton, NJ: Princeton University Press, 1999).

24. For a persuasive reading of Kim's racial ambiguity, see Prakash, *Another Reason*, especially chapter 1.

25. Rudyard Kipling to Edmonia Hill, February 24, 1889, in Thomas Pinney, ed., *The Letters of Rudyard Kipling*, vol. 1, *1872–1889* (London: Macmillan Press, 1990), 297–98.

26. John Mackenzie, *Orientalism: History, Theory and the Arts* (Manchester, UK: Manchester University Press, 1995); Linda Nochlin, *The Politics of Vision: Essays on Nineteenth-Century Art and Society* (New York: Harper and Row, 1989); Roger Benjamin, *Orientalist Aesthetics: Art, Colonialism, and French North Africa, 1880–1930* (Berkeley: University of California Press, 2003).

27. Thomas Macaulay, "Minute on Indian Education (1835)," in Barbara Harlow and Mia Carter, eds., *Archives of Empire*, vol. 1, *From the East India Company to the Suez Canal* (Durham, NC: Duke University Press, 2003), p. 237. See also Gauri Viswanathan, *Masks of Conquest: Literary Study and British Rule in India* (New York: Columbia University Press, 1989).

28. Timothy Barringer, *Men at Work: Art and Labor in Victorian England* (New Haven, CT: Yale Center for British Art, 2005).

29. Guha-Thakurta, *The Making of a New Indian Art*; Partha Mitter, *Art and Nationalism in Colonial India*.

30. Deepali Dewan, "Scripting South Asia's Visual Past: *The Journal of Indian Art and Industry* and the Production of Knowledge in the Late Nineteenth Century," in Julie Codell, ed., *Imperial Co-Histories: National Identities and the British and Colonial Press* (London: Associated University Presses, 2003), pp. 29–44.

31. Mitter, *Art and Nationalism in Colonial India*, p. 13.

32. Ibid., p. 68.

33. Richard Temple, *Oriental Experience* (1883), p. 485, cited in Mitter, *Art and Nationalism in Colonial India*, p. 32.

34. John Griffiths, *Report on the Work of Copying the Paintings of the Ajanta Caves* (London, 1872–85).

35. Mitter, *Art and Nationalism in Colonial India*, p. 54.

36. Homi Bhabha, *The Location of Culture* (New York: Routledge, 1994).

37. For further information on these artists, see Guha-Thakurta, *The Making of a New Indian Art*; and Mitter, *Art and Nationalism in Colonial India*.

38. Val Prinsep, *Imperial India*, p. 1. See also Mitter, *Art and Nationalism in Colonial India*, p. 52.

39. The paintings were *Judith*, a copy of a picture by Jean-Joseph Benjamin Constant (the version by Constant is now housed in the Maharaja Fateh Singh Museum in Baroda), and *Portrait of T. P. Mudhuswamy Ayyar*, the first native appointed as a high court judge in India. See Erwin Neumayer and Christine Schelberger, *Raja Ravi Varma: Portrait of an Artist—The Diary of C. Raja Raja Varma* (New Delhi: Oxford University Press, 2005), p. 303.

40. Rudyard Kipling to Edmonia Hill, February 24, 1889, in Pinney, ed., *The Letters of Rudyard Kipling*, 1:298.

41. Millar, *The Victorian Pictures in the Collection of Her Majesty the Queen*, p. 245.

42. Raymond Head, *The Indian Style* (Chicago: University of Chicago Press, 1986).

43. Millar, *The Victorian Pictures in the Collection of Her Majesty the Queen*, p. 244.

44. Naazish Ata-Ullah, "Stylistic Hybridity and Colonial Art and Design Education: A Wooden Carved Screen by Ram Singh," in T. Barringer and T. Flynn, eds., *Colonialism and the Object: Empire, Material Culture, and the Museum* (London: Routledge, 1998), pp. 68–81.

45. Gandhi later wrote of his distress at seeing such medals on the Indian princes, referring to them as "badges of impotence" and symbols "not of their royalty, but of their slavery." See M. K. Gandhi, *An Autobiography: The Story of My Experiments with Truth* (Boston: Beacon Press, 1993), p. 230.

46. Timothy Barringer, "Imperial Visions: Responses to India and Africa in Victorian Art and Design," in John Mackenzie, ed., *The Victorian Vision: Inventing New Britain* (London: V & A Publications, 2001), pp. 315–33; Christopher Lloyd, *The Queen's Pictures: Royal Collectors through the Centuries* (London: National Gallery Publications, 1991), p. 212.

47. Cited in Wolfgang Schivelbusch, *The Railway Journey: The Industrialization and Perception of Time and Space* (Berkeley: University of California Press, 1987), pp. 54–55.

48. Johannes Fabian, *Time and the Other: How Anthropology Makes Its Object* (New York: Columbia University Press, 1983).

49. Kapur, *When Was Modernism?*; Guha-Thakurta, "The Period of Colonialism and Nationalism, 1757–1947," in Fred Asher, ed., *Art of India: Prehistory to the Present* (Hong Kong: Encyclopedia Britannica, 2003), pp. 109–28; Mitter, *Art and Nationalism in Colonial India*; Christopher Pinney, *Photos of the Gods: The Printed Image and Political Struggle in India* (London: Reaktion Books, 2004); A. Ramachandran, "Raja Ravi Varma: The Marketing Strategies of a Modern Indian Artist," in G. Sinha, ed., *Indian Art: An Overview* (New Delhi: Rupa, 2003); Erwin Neumayer and Christine Schelberger, *Raja Ravi Varma: Portrait of an Artist* (New Delhi: Oxford University Press, 2005).

50. For detailed investigations of the Bengal School, see Guha-Thakurta, *The Making of a New Indian Art;* and Mitter, *Art and Nationalism in Colonial India*.

51. Kapur, *When Was Modernism?* p. 146.

52. Pinney, *Photos of the Gods,* p. 67.

53. Guha-Thakurta, "The Period of Colonialism and Nationalism," p. 118.

54. E. M. J. Venniyoor, *Raja Ravi Varma* (Kerala: Kerala Lalit Kala Academy, 1981), p. 30.

55. Neumayer and Schelberger, eds., *Raja Ravi Varma*, p. 6.

56. Cited in Venniyoor, *Raja Ravi Varma*, p. 32.

57. Ibid., p. 33.

58. Ibid., p. 30.

59. Kapur, *When Was Modernism?* p. 161.

60. Ibid., p. 163.

61. Ibid., p. 171.

CHAPTER 4. COLLECTING COLONIAL POSTCARDS

1. David Cannadine, "The Context, Performance, and Meaning of Ritual: The British Monarchy and the Invention of Tradition 1820–1977," in Eric Hobsbawm and Terence Ranger, eds., *The Invention of Tradition* (Cambridge: Cambridge University Press, 1983), pp. 101–64.

2. Deborah Poole, *Vision, Race, and Modernity: A Visual Economy of the Andean Image World* (Princeton, NJ: Princeton University Press, 1997).

3. Malek Alloula, *The Colonial Harem* (Minneapolis: University of Minnesota Press, 1986); C. Geary and V. Webb, eds., *Delivering Views: Distant Cultures in Early Postcards* (Washington, DC: Smithsonian Institution Press, 1998); Saloni Mathur, "Revisualizing the Missionary Subject: History, Modernity, and Indian Women," *Third Text* 37 (1997): 53–61; David Prochaska, "The Archive of *Algerie Imaginaire*," *History and Anthropology* 4 (1990): 373–420.

4. Alloula, *The Colonial Harem*, pp. 105, 5.

5. Ibid., p. 5.

6. Ibid.

7. Anne Maxwell, "Native Women and Tourism: A Contested Site of Orientalism," *Third Text* 25 (1993–94): 21–32. See also Deborah Cherry, *Beyond the Frame: Feminism and Visual Culture, Britain, 1850–1900* (London and New York: Routledge, 2000).

8. See Lata Mani, *Contentious Traditions: The Debate on Sati in Colonial India* (Berkeley: University of California Press, 1998); and Gayatri Spivak, "Can the Subaltern Speak?" in Cary Nelson and Lawrence Grossberg, eds., *Marxism and the Interpretation of Cultures* (Chicago: University of Illinois Press, 1988), pp. 271–311.

9. See Frank Staff, *The Picture Postcard and Its Origins* (New York: Frederick A. Praeger, 1966).

10. Notice Issued by the Postmaster General, June 1872, in Staff, *The Picture Postcard and Its Origins*, appendix IV, p. 85.

11. Ibid.

12. Austrian Post Office Regulation, Vienna, 1869, in Staff, *The Picture Postcard and Its Origins*, appendix II, p. 84.

13. Staff, *The Picture Postcard and Its Origins*, p. 63.

14. J. Laver, "Foreword," in Staff, *The Picture Postcard and Its Origins*, p. 7.

15. Staff, *The Picture Postcard and Its Origins,* p. 47.

16. C. Lauterbach and A. Jakovsky, *Postcard Album: Also a Cultural History* (New York: Universe Books, 1961).

17. "A Sign of the Times," *The Picture Postcard: A Magazine of Travel, Philately, Art* 2, no. 7 (January 1901): 9.

18. See Suren Lalvani, *Photography, Vision, and the Production of Modern Bodies* (Albany, NY: SUNY Press, 1996); Poole, *Vision, Race, and Modernity;* and Vidya Dehejia, ed., *India through the Lens: Photography, 1840–1911* (Washington, DC: Freer and Sackler Galleries, Smithsonian Institution, 2000).

19. *The Picture Postcard Budget and Collector's Magazine* 1, no. 2 (February 1904).

20. Prochaska, "The Archive of *Algerie Imaginaire.*"

21. A. W. Coysh, *The Dictionary of Picture Postcards in Britain 1894–1939* (London: Baron Publishing, 1984).

22. Lauterbach and Jakovsky, *Postcard Album: Also a Cultural History.*

23. "Mr. Geo. R. Sims on Picture Postcards," *The Picture Postcard: A Magazine of Travel, Philately, Art* 1, no. 2 (August 1900): 22.

24. Naomi Schor, "Collecting Paris," in J. Elsner and R. Cardinal, eds., *The Cultures of Collecting* (Cambridge, MA: Harvard University Press, 1994), pp. 252–74.

25. For an attempt to reassemble this historical portrait, see the collection of essays in Geary and Webb, eds., *Delivering Views.*

26. Alloula, *The Colonial Harem,* p. 4.

27. Marian Klamkin, *Picture Postcards* (London: David and Charles [Holdings], 1974), p. 44.

28. See also James Ryan, *Picturing Empire: Photography and the Visualization of the British Empire* (Chicago: University of Chicago Press, 1998).

29. G. Watson Cole, *Postcards: The World in Miniature. A Plan for their Systematic Arrangement* (privately published, 1935), p. 3.

30. Susan Stewart, *On Longing: Narratives of the Miniature, the Gigantic, the Souvenir, the Collection* (Durham, NC: Duke University Press, 1993), p. 138.

31. One known postcard artist was Ellen H. Clapsaddle, a woman born in New York in 1865. She began her career illustrating greeting cards and children's books, and later entered postcard design in 1905, when the craze hit the United States. Unlike most postcard artists, she signed her work, and her name is associated with hundreds of postcard paintings and sketches. Numerous other artists were likely hired to color or finish the images she designed. She worked for several publishers at one time, including Raphael Tuck and Sons. See Klamkin, *Picture Postcards.*

32. For examples, see Geary and Webb, eds., *Delivering Views;* and Prochaska, "The Archive of *Algerie Imaginaire.*"

33. Nicholas Dirks, *Castes of Mind: Colonialism and the Making of Modern India* (Princeton, NJ: Princeton University Press, 2001).

34. Christopher Pinney, "Classification and Fantasy in the Photographic Construction of Caste and Tribe," *Visual Anthropology* 3 (1990): 259–88.

35. Inderpal Grewal, *Home and Harem: Nation, Gender, Empire, and the Cultures of Travel* (Durham, NC: Duke University Press, 1996).

36. Antoinette Burton, *Burdens of History: British Feminists, Indian Women and Imperial Culture 1865–1915* (Chapel Hill: University of North Carolina Press, 1994); and Kumari Jayawardena, *The White Woman's Other Burden: Western Women and South Asia during British Rule* (New York: Routledge, 1995).

37. Schor, "Collecting Paris," p. 301.

38. Ibid., p. 252.

39. I refer here to the basic premise of Andreas Huyssen's important argument in "Mass Culture as Woman: Modernism's Other," in *After the Great Divide: Modernism, Mass Culture, Postmodernism* (Bloomington: Indiana University Press, 1986), pp. 44–62.

40. "A Chat with the Foundress of a Ladies' Postcard Club," *The Picture Postcard: A Magazine of Travel, Philately, Art* 1, no. 5 (1900): 71–72.

41. Cited in Schor, "Collecting Paris," p. 262.

42. One exception is Miss A. Brackett from Portland, USA, a member of the Asian Exchange Club, who wrote to *The Indian Philocartist* requesting "just a line of description on all historic cards sent to me. . . . As a teacher, I shall get much interesting help from it." *The Indian Philocartist* 1, no. 4 (1908): 75.

43. Schor, "Collecting Paris," p. 262.

44. That the heterosexual logic of Alloula's drama generates homophobia should not be surprising. The suggestion of intimacy between women on the postcards brings forth a vocabulary of disgust in his account: "lascivious," "contamination," "noxiousness," "perniciousness"; see Alloula, *The Colonial Harem*, p. 103.

CHAPTER 5. A PARABLE OF POSTCOLONIAL RETURN

1. Jawaharlal Nehru, *The Discovery of India* (1946; repr., New Delhi: Oxford University Press, 1989), p. 297.

2. Richard Davis, *Lives of Indian Images* (Princeton, NJ: Princeton University Press, 1997), p. 5.

3. Ibid., pp. 6–7.

4. Tapati Guha-Thakurta, *Monuments, Objects, Histories: Institutions of Art in Colonial and Postcolonial India* (New York: Columbia University Press, 2004), p. 205.

5. On the "biography of objects" approach to the history of South Asian material culture, see Arjun Appadurai, ed., *The Social Life of Things: Commodities in Cultural Perspective* (Cambridge: Cambridge University Press, 1986); Tim Barringer and T. Flynn, eds., *Colonialism and the Object: Empire, Material Culture and the Museum* (London and New York: Routledge, 1998); Bernard Cohn, *Colonialism and its Forms of Knowledge: The British in India* (Princeton, NJ: Princeton University Press, 1996).

6. Jordanna Bailkin, *The Culture of Property: The Crisis of Liberalism in Modern Britain* (Chicago: University of Chicago Press, 2004).

7. Ibid., p. 77.

8. On the historical conditions of Nazi-era looting, see Hector Feliciano, *The Lost Museum: The Nazi Conspiracy to Steal the World's Greatest Works of Art*

(New York: Basic Books, 1998); Peter Harclerode and Brendan Pittaway, *The Lost Masters: The Looting of Europe's Treasurehouses* (London: Orion Books, 1999); Lynn Nicholas, *The Rape of Europa: The Fate of Europe's Art Treasures in the Third Reich and the Second World War* (New York: Knopf, 1994); Jonathan Petropoulos, *Art as Politics in the Third Reich* (Durham: University of North Carolina Press, 1999); Elizabeth Simpson, ed., *The Spoils of War: The Loss, Reappearance and Recovery of Cultural Property* (New York: Abrams, 1997).

9. The statement is by Elan Steinberg, head of the U.S.-based World Jewish Congress, cited in Harclerode and Pittaway, *The Lost Masters*, p. 344.

10. James Clifford, "Of Other Peoples: Beyond the 'Salvage Paradigm,' " in Hal Foster, ed., *Discussions in Contemporary Culture* (Seattle: Bay Press, 1987), pp. 121–30.

11. See Devon Mihesuah, ed., *Repatriation Reader: Who Owns American Indian Remains?* (Lincoln: University of Nebraska Press, 2000).

12. See, for example, Hakim Adi, "Offence Taken," *Museums Journal*, May 2005.

13. See "Declaration on the Importance and Value of Universal Museums," in Ivan Karp et al., *Museum Frictions: Public Cultures/Global Transformations* (Durham, NC: Duke University Press, 2006).

14. Christopher Hitchens, *Imperial Spoils: The Curious Case of the Elgin Marbles* (New York: Hill and Wang, 1988); Elazar Barkan and Ronald Bush, eds., *Claiming the Stones, Naming the Bones: Cultural Property and the Negotiation of National and Ethnic Identity* (Los Angeles: Getty Research Institute, 2002); Russell Chamberlain, *Loot! The Heritage of Plunder* (London: Thames and Hudson, 1983); William St. Clair, *Lord Elgin and the Marbles: The Controversial History of the Parthenon Sculptures* (Oxford: Oxford University Press, 1998).

15. On the Benin sculptures, see Annie Coombes, *Reinventing Africa: Museums, Material Culture and Popular Imagination in Late Victorian and Edwardian England* (New Haven, CT: Yale University Press, 1994).

16. See Davis, *The Lives of Indian Images*, especially chapter 5.

17. Jeannette Greenfield, *The Return of Cultural Treasures* (Cambridge: Cambridge University Press, 1989), pp. 148–51.

18. See Guha-Thakurta, *Monuments, Objects, Histories*, especially chapters 1 and 2.

19. Ibid.

20. Alexander Cunningham, "Preface," in F. C. Maisey, *Sanchi and Its Remains* (London: Kegan Paul, Trench, Trubner & Co., 1892), p. xi.

21. Alexander Cunningham, *The Bhilsa Topes; or Buddhist Monuments of Central India* (1854; repr., New Delhi: Munshiram Manoharlal, 1997), p. 295.

22. F. C. Maisey, *Sanchi and Its Remains*, pp. 110–11.

23. Ibid., p. 111.

24. Ibid.

25. Sir John Marshall and Alfred Foucher, *The Monuments of Sanchi*, vol. 1 (1940; repr., Delhi: Swati Publications, 1983), p. 8.

26. Ibid.

27. Ibid.

28. Ibid., p. 9.

29. See Michael Willis, *Buddhist Reliquaries from Ancient India* (London: British Museum Press, 2000), p. 8.

30. The history of the India Museum, which first opened in 1801 as an eccentric "cabinet of curiosities" located within the headquarters of the East India Company in London, is by now well established. The Indian Mutiny of 1857, which resulted in the dismantling of the Company and its offices in London, would leave the collection essentially homeless for almost two decades. During this time, the collection was transported from place to place as experts, collectors, and colonial officials debated the question of its permanent home. Eventually, in 1875, the bulk of this collection—some twenty thousand objects and artifacts—was acquired by the South Kensington Museum, which would in 1899 be renamed the Victoria and Albert Museum, the name by which it is known today. See note 35 for the historical scholarship in this area.

31. Cunningham, *The Bhilsa Topes*, p. xi.

32. See Tim Barringer, "The South Kensington Museum and the Colonial Project," in Barringer and Flynn, eds., *Colonialism and the Object*, pp. 11–27; and Deborah Swallow, "Colonial Architecture, International Exhibitions and Official Patronage of the Indian Artisan: The Case of a Gateway from Gwalior in the Victoria and Albert Museum," in Barringer and Flynn, eds., *Colonialism and the Object*, pp. 52–67.

33. Cunningham, "Preface," p. xv.

34. Ibid.

35. See Malcolm Baker and Brenda Richardson, eds., *A Grand Design: The Art of the Victoria and Albert Museum* (New York: Harry Abrams, 1997); Barringer, "The South Kensington Museum and the Colonial Project," pp. 11–27; Davis, *The Lives of Indian Images;* Ray Desmond, *The India Museum 1801–1879* (London: H.M.S.O., 1982); Partha Mitter, "The Imperial Collections: Indian Art," in Baker and Richardson, eds., *A Grand Design,* pp. 222–29; Kavita Singh, "The Jewel and the Crown: The Politics of Display of Indian Art at the V&A, 1935–51," unpublished paper, 2003; Swallow, "Colonial Architecture, International Exhibitions and Official Patronage of the Indian Artisan." I am grateful to Kavita Singh for sharing with me her unpublished work on the V&A during the period of Indian independence from British rule.

36. Letter from Maha Bodhi Society, April 17, 1932. Victoria and Albert Museum Nominal File, Buddhist Relics, part I, V&A Museum Archives, Blythe House, London (hereafter cited as V&A Nominal File, Buddhist Relics).

37. Ibid.

38. Letter from E. Maclagan, V&A, to British Museum, April 20, 1932. V&A Nominal File, Buddhist Relics, part I.

39. Letter from A. Esdaile, British Museum, to E. Maclagan, V&A, April 26, 1932. V&A Nominal File, Buddhist Relics, part I.

40. Ibid.

41. Letter from E. Maclagan, V&A, to A. Esdaile, British Museum, April 29, 1932. V&A Nominal File, Buddhist Relics, part I.

42. Memo from E. Maclagan to Director, V&A, May 9, 1932. V&A Nominal File, Buddhist Relics, part I.

43. Singh, "The Jewel and the Crown."

44. Kenneth de Burgh Codrington, *The Study of Indian Art* (London: Luzac & Co., 1944), p. 7.

45. On the history of the Koh-i-noor diamond and other disputed Indian objects in British collections, see Ian Balfour, *Famous Diamonds* (London: Christie's, 1997); Davis, *The Lives of Indian Images;* Stephen Weil, "Who Owns the Nataraj?" in *Rethinking the Museum and Other Meditations* (Washington, DC: Smithsonian Institution Press, 1990), pp. 156–60; Greenfield, *The Return of Cultural Treasures.*

46. Tapati Guha-Thakurta, "The Museumised Relic: Archaeology and the First Museum of Colonial India," *The Indian Economic and Social History Review* 34, no. 1 (1997): 21–51.

47. Letter from B. Rackham for the Director, V&A, to the Maha Bodhi Society, London, May 11, 1932. V&A Nominal File, Buddhist Relics, part I.

48. Letter from E. W. Adikaram, Hon. Secretary of the Buddhist Mission, to Director of the Indian Section, V&A, October 18, 1932. V&A Nominal File, Buddhist Relics, part I.

49. Ibid.

50. Memo from A. D. Campbell to E. Maclagan, October 20, 1932. V&A Nominal File, Buddhist Relics, part I.

51. E. Maclagan to the Board of Education, October 21, 1932. V&A Nominal File, Buddhist Relics, part I.

52. Ibid.

53. Ibid.

54. Ibid.

55. Internal memo from A. D. Campbell, November 22, 1932. V&A Nominal File, Buddhist Relics, part I.

56. Ibid.

57. Craig Clunas, "Oriental Antiquities / Far Eastern Art," *Positions* 2, no. 2 (1994): 318–55.

58. Singh, "The Jewel and the Crown." See also Codrington's memoir of his childhood, *Cricket in the Grass* (London: Faber & Faber, 1959).

59. Codrington, *The Study of Indian Art*, pp. 8–9.

60. Partha Mitter, "The Imperial Collections," pp. 222–29; Singh, "The Jewel and the Crown."

61. Singh, "The Jewel and the Crown."

62. Letter from Frank Mellor to Keeper of Indian Collections, V&A, August 19, 1938. V&A Nominal File, Buddhist Relics, part I.

63. Letter from Frank Mellor to Keeper of Indian Collections, V&A, August 27, 1938. V&A Nominal File, Buddhist Relics, part I.

64. Letter from Eric Maclagan to Frank Mellor, September 12, 1938. V&A Nominal File, Buddhist Relics, part I.

65. Letter from Frank Mellor to Eric Maclagan, September 13, 1938. V&A Nominal File, Buddhist Relics, part I.

66. Ibid.

67. Letter from Amis du Bouddhisme, Paris, to Keeper of Indian Collections, V&A, October 25, 1938. V&A Nominal File, Buddhist Relics, part I.

68. Internal memo to Codrington, October 28, 1938. V&A Nominal File, Buddhist Relics, part I.

69. See Gary Michael Tartakav, "New Paths to Sanchi," in Vidya Dehejia, ed., *Unseen Presence: The Buddha and Sanchi* (Mumbai: Marg Publications, 1996), pp. 113–30.

70. Internal memos from AD Howell Smith, Assistant Keeper of the Indian Section, November 22, 1938, and February 1, 1939. V&A Nominal File, Buddhist Relics, part I.

71. Internal Memo, V&A, April 24, 1939. V&A Nominal File, Buddhist Relics, part I.

72. Codrington, *The Study of Indian Art*, p. 13.

73. Letter from Eric Maclagan to the British Museum, January 6, 1939. V&A Nominal File, Buddhist Relics, part I.

74. Letter from British Museum to Eric Maclagan, January 7, 1939. V&A Nominal File, Buddhist Relics, part I.

75. Ibid.

76. Letter from Eric Maclagan to the Government of Ceylon, November 27, 1939. V&A Nominal File, Buddhist Relics, part I.

77. Letter from Frank Mellor to Eric Maclagan, September 26, 1938. V&A Nominal File, Buddhist Relics, part I.

78. Salman Rushdie, *Midnight's Children* (London: Picador, 1982).

79. William and Mildred Archer, *Served and Observed* (London: BACSA, 1994), p. 128, cited in Singh, "The Jewel and the Crown."

80. Letter from Deputy High Commissioner of India to Commonwealth Relations Office, June 5, 1948. V&A Nominal File, Buddhist Relics, part II.

81. Letter from Maha Bodhi Society of Ceylon, August 1, 1948. V&A Nominal File, Buddhist Relics, part II.

82. Memo from Leigh Ashton, July 12, 1948. V&A Nominal File, Buddhist Relics, part II.

83. Minute from Leigh Ashton, April 16, 1946. V&A Nominal File, Buddhist Relics, part II.

84. Letter from W. G. Archer, December 24, 1957. V&A Nominal File, Buddhist Relics, part I.

85. Statement issued by Leigh Ashton, July 31, 1948. V&A Nominal File, Buddhist Relics, part II.

86. Ibid.

87. Memo from Accounting Department to Treasury Department, November 30, 1998. V&A Nominal File, Buddhist Relics, part II.

88. In the early 1950s portions of the relics were given permanently to Burma and Ceylon, where they remain housed today near Rangoon and in Colombo.

89. *The Hindu*, December 3, 1952.

90. On Ambedkar's conversion to Buddhism, see Nicholas Dirks, *Castes of Mind: Colonialism and the Making of Modern India* (Princeton, NJ: Princeton University Press, 2001); A. K. Narain and D. C. Ahir, eds., *Dr. Ambedkar, Buddhism and Social Change* (New Delhi: B. R. Publishing, 1994); M. L. Ranga, ed., *B. R. Ambedkar: Life, Work and Relevance* (New Delhi: Manohar, 2000); Gary Michael Tartakov, "Art and Identity: The Rise of a New Buddhist Imagery," in

Narain and Ahir, eds., pp. 175–94; Gauri Viswanathan, *Outside the Fold: Conversion, Modernity, and Belief* (Princeton, NJ: Princeton University Press, 1998).

91. See Moira Simpson, *Making Representations: Museums in the Postcolonial Era* (London and New York: Routledge, 1996). Interestingly, Buddhist bone relics are now among the objects included in a new British Museum policy on human remains instituted in 2005. The opposite of NAGPRA, the policy essentially argues that the museum's collections "should remain intact" and that claims for remains over five hundred years are "highly unlikely" to be considered.

92. Salman Rushdie, "Out of Kansas," in *Step across This Line: Collected Nonfiction, 1992–2002* (New York: Random House, 2002). On the theme of "home" in postcolonial writing, see also Aamir Mufti and Ella Shohat, "Introduction," in A. McClintock, A. Mufti, and E. Shohat, eds., *Dangerous Liaisons: Gender, Nation, and Postcolonial Perspectives* (Minneapolis: University of Minnesota Press, 1997), pp. 1–12.

93. Rushdie, "Out of Kansas."

94. On the clash between different visions and experiences of the "modern" in Le Corbusier's Indian projects, see Vikramaditya Prakash, *Chandigarh's Le Corbusier: The Struggle for Modernity in Postcolonial India* (Seattle: University of Washington Press, 2002).

95. Urvashi Butalia, *The Other Side of Silence: Voices from the Partition of India* (New York: Oxford University Press, 1998); Mushirul Hasan, ed., *India's Partition: Process, Strategy and Mobilization* (Delhi: Oxford University Press, 1993); Ritu Menon and Kamla Bhasin, *Borders and Boundaries: Women in India's Partition* (New Delhi: Kali for Women, 1998).

96. Davis, *The Lives of Indian Images,* p. 181.

97. See chapter 9, "Archaeology and the Monument: On Two Contentious Sites of Faith and History," in Guha-Thakurta, *Monuments, Objects, Histories,* pp. 268–303.

EPILOGUE. HISTORICAL AFTERIMAGES

1. Daniel Sherman and Irit Rogoff, eds., *Museum Culture: Histories, Discourses, Spectacles* (Minneapolis: University of Minnesota Press, 1991); Ivan Karp and S. Lavine, eds., *Exhibiting Others: The Poetics and Politics of Museum Display* (Washington, DC: Smithsonian Institution Press, 1991).

2. Holland Cotter, *New York Times,* August 30, 1997.

3. See James Clifford, *The Predicament of Culture* (Cambridge, MA: Harvard University Press, 1988); and Carol Breckenridge and Peter van der Veer, eds., *Orientalism and the Postcolonial Predicament: Perspectives on South Asia* (Delhi: Oxford University Press, 1994).

4. Susan Buck-Morss, *The Dialectic of Seeing: Walter Benjamin and the Arcades Project* (Cambridge, MA: MIT Press, 1995), p. 331.

5. Ibid.

6. See Barbara Kirshenblatt-Gimblett, *Destination Culture: Tourism, Museums, and Heritage* (Berkeley: University of California Press, 1998).

7. Yashodhara Dalmia, *Contemporary Indian Art: Other Realities* (New

Delhi: Marg Publications, 2002); Chaitanya Sambrani, ed., *Edge of Desire: Recent Art in India* (New York: Asia Society, 2005); Dayanita Singh, *Privacy* (Berlin: Steidl, 2003); Gayatri Sinha, ed., *Indian Art: An Overview* (New Delhi: Rupa, 2003); Hammad Nasar and Anita Dawood-Nasar, eds., *Karkhana: A Contemporary Collaboration* (Ridgefield, CT: Aldrich Contemporary Art Museum, 2005); Vishaka Desai, *Conversations with Traditions: Nilima Sheikh, Shahzia Sikander* (New York: Asia Society, 2001); Salima Hashmi, *Unveiling the Invisible: Lives and Works of Women Artists in Pakistan* (Lahore: Sang-e-Meel Publications, 2002); Gayatri Sinha, ed., *Expressions and Evocations: Contemporary Women Artists of India* (Mumbai: Marg Publications, 1996); Homi Bhabha, "Miniaturizing Modernity: Shahzia Sikander in Conversation with Homi Bhabha," *Public Culture* 11, no. 1 (1999): 146–51.

Bibliography

Adburgham, Alison. *Liberty's: A Biography of a Shop*. London: Unwin Hyman, 1975.

Alloula, Malek. *The Colonial Harem*. Minneapolis: University of Minnesota Press, 1986.

Amin, Shahid. *Event, Metaphor, Memory: Chauri Chaura, 1922–1992*. Berkeley: University of California Press, 1995.

———. "Gandhi as Mahatma." In *Selected Subaltern Studies*, edited by Ranajit Guha and Gayatri Spivak, p. 294. New York and Oxford: Oxford University Press, 1998.

Anderson, Benedict. *Imagined Communities: Reflections on the Origin and Spread of Nationalism*. New York: Verso, 1991.

Appadurai, Arjun. *Modernity at Large: Cultural Dimensions of Globalization*. Minneapolis: University of Minnesota Press, 1996.

———, ed. *The Social Life of Things: Commodities in Cultural Perspective*. Cambridge: Cambridge University Press, 1986.

Archer, Mildred. *Company Paintings: Indian Paintings of the British Period*. London: Victoria and Albert Museum, 1992.

———. *Early Views of India: The Picturesque Journeys of Thomas and William Daniell*. London: Thames and Hudson, 1980.

———. *India and British Portraiture, 1770–1825*. London: Oxford University Press, 1979.

Archer, Mildred, and Ronald Lightbown. *India Observed: India as Viewed by British Artists, 1760–1860*. London: Victoria and Albert Museum, 1982.

Arnold, David. *Police Power and Colonial Rule, Madras, 1859–1947*. Delhi: Oxford University Press, 1986.

Asher, Catherine, and Thomas Metcalf, eds. *Perceptions of South Asia's Visual Past*. New Delhi: Oxford University Press, 2004.

Asher, Fred, ed. *Art of India: Prehistory to the Present.* Hong Kong: Encyclopedia Britannica, 2003.

Ata-Ullah, Naazish. "Stylistic Hybridity and Colonial Art and Design Education: A Wooden Carved Screen by Ram Singh." In *Colonialism and the Object: Empire, Material Culture, and the Museum,* edited by T. Barringer and T. Flynn, pp. 68–81. London: Routledge, 1998.

Bailkin, Jordanna. *The Culture of Property: The Crisis of Liberalism in Modern Britain.* Chicago: University of Chicago Press, 2004.

———. "Indian Yellow: Making and Breaking the Imperial Palette." *Journal of Material Culture* 10, no. 2 (2005): 197–214.

Baker, Malcolm, and Brenda Richardson, eds. *A Grand Design: The Art of the Victoria and Albert Museum.* New York: Harry Abrams, 1997.

Bann, Stephen. "William Hodge's *A Dissertation.*" In *Traces of India: Photography, Architecture, and the Politics of Representation,* edited by Antonella Pelizzari, pp. 60–85. Montreal and New Haven, CT: Canadian Centre for Architecture and the Yale Center for British Art, 2003.

Barkan, Elazar, and Ronald Bush, eds. *Claiming the Stones, Naming the Bones: Cultural Property and the Negotiation of National and Ethnic Identity.* Los Angeles: Getty Research Institute, 2002.

Barringer, Timothy. *Men at Work: Art and Labour in Victorian Britain.* New Haven, CT: Yale University Press, 2005.

Barringer, Timothy, and Tom Flynn, eds. *Colonialism and the Object: Empire, Material Culture and the Museum.* London and New York: Routledge, 1998.

Bayly, C. A. "The Origins of Swadeshi (Home Industry): Cloth and Indian Society, 1700–1930." In *The Social Life of Things: Commodities in Cultural Perspective,* edited by Arjun Appadurai, pp. 285–321. Cambridge: Cambridge University Press, 1986.

Bayly, Christopher. *The Raj: India and the British, 1600–1947.* London: National Portrait Gallery, 1990.

Bean, Susan. "Gandhi and Khadi: The Fabric of Independence." In *Cloth and Human Experience,* edited by A. Weiner and J. Schneider, pp. 355–76. Washington, DC: Smithsonian Institution Press, 1989.

———. *Timeless Visions: Contemporary Art of India from the Chester and Davida Herwitz Collection.* Salem, MA: Peabody Essex Museum, n.d.

Beaulieu, Jill, and Mary Roberts, eds. *Orientalism's Interlocutors: Painting, Architecture, Photography.* Durham, NC: Duke University Press, 2002.

Benjamin, Roger. *Orientalist Aesthetics: Art, Colonialism, and French North Africa, 1880–1930.* Berkeley: University of California Press, 2003.

Benjamin, Walter. *The Arcades Project.* Cambridge, MA: Belknap Press of Harvard University Press, 2002.

———. *Charles Baudelaire: A Lyric Poet in the Era of High Capitalism.* London and New York: Verso, 1983.

Bennett, Tony. *The Birth of the Museum: History, Theory, Politics.* London and New York: Routledge, 1995.

Bermant, Chaim. *Point of Arrival: A Study of London's East End.* London: Eyre Methuen, 1975.

Bhabha, Homi. *The Location of Culture*. New York: Routledge, 1994.
———. "Miniaturizing Modernity: Shahzia Sikander in Conversation with Homi Bhabha." *Public Culture* 11, no. 1 (1999): 146–51.
Birdwood, George. *The Arts of India*. 1880. Reprint, Calcutta: Rupa, 1992.
———. *Competition and the Indian Civil Service*. London: Henry S. King, 1872.
Bowlby, Rachel. *Carried Away: The Invention of Modern Shopping*. London: Faber, 2000.
Brantlinger, Patrick. "A Postindustrial Prelude to Postcolonialism: John Ruskin, William Morris and Gandhism." *Critical Inquiry* 22, no. 3 (1996): 466–85.
Breckenridge, Carol. "The Aesthetics and Politics of Colonial Collecting: India at World's Fairs." *Comparative Studies of Society and History* 31 (1989): 195–216.
Breckenridge, Carol, and Peter van der Veer, eds. *Orientalism and the Postcolonial Predicament: Perspectives on South Asia*. Delhi: Oxford University Press, 1994.
Buck-Morss, Susan. *The Dialectic of Seeing: Walter Benjamin and the Arcades Project*. Cambridge, MA: MIT Press, 1995.
Burton, Antoinette. *At the Heart of Empire: Indians and the Colonial Encounter in Late Victorian Britain*. Berkeley: University of California Press, 1998.
———. *Burdens of History: British Feminists, Indian Women, and Imperial Culture, 1865–1915*. Chapel Hill: University of North Carolina Press, 1994.
Butalia, Urvashi. *The Other Side of Silence: Voices from the Partition of India*. New York: Oxford University Press, 1998.
Calloway, Stephen. "Arthur Lasenby Liberty: Artistic Entrepreneur." *The Magazine Antiques* (January 1993): 184–93.
———. *The House of Liberty: Masters of Style and Decoration*. London: Thames and Hudson, 1992.
Celik, Zeynep. *Displaying the Orient: Architecture of Islam at Nineteenth-Century World's Fairs*. Berkeley: University of California Press, 1992.
———. *Urban Forms and Colonial Confrontations: Algiers under French Rule*. Berkeley: University of California Press, 1998.
Chakrabarty, Dipesh. *Provincializing Europe: Postcolonial Thought and Historical Difference*. Princeton, NJ: Princeton University Press, 2000.
Chamberlain, Russell. *Loot! The Heritage of Plunder*. London: Thames and Hudson, 1983.
Chandrasekhar, Indira, and Peter Seel, eds. *Body/City: Siting Contemporary Culture in India*. New Delhi: Tulika Books, 2003.
Chatterjee, Partha. *Nationalist Thought and the Colonial World: A Derivative Discourse*. Minneapolis: University of Minnesota Press, 1993.
———. *A Princely Imposter: The Strange and Universal History of the Kumar of Bhawal*. Princeton, NJ: Princeton University Press, 2002.
Chatterjee, Ratnabali. *From the Karkhana to the Studio: A Study of the Changing Social Roles of Patron and Artist in Bengal*. New Delhi: Books and Books, 1990.
Chaturvedi, Vinayak, ed. *Mapping Subaltern Studies and the Postcolonial*. London: Verso, 2000.
Chaudhuri, Nirad. *Scholar Extraordinary: The Life of Friedrich Max Muller*. New Delhi: Orient Paperbacks, 1974.

Cherry, Deborah. *Beyond the Frame: Feminism and Visual Culture, Britain 1850–1900.* London: Routledge, 2001.

Clark, T. J. *The Painting of Modern Life: Paris in the Art of Monet and His Followers.* Princeton, NJ: Princeton University Press, 1984.

Clifford, James. "Of Other Peoples: Beyond the 'Salvage Paradigm.'" In *Discussions in Contemporary Culture,* edited by Hal Foster, pp. 121–30. Seattle: Bay Press, 1987.

———. *The Predicament of Culture.* Cambridge, MA: Harvard University Press, 1988.

———. *Routes: Travel and Translation in the Late Twentieth Century.* Cambridge, MA: Harvard University Press, 1997.

Clunas, Craig. "Oriental Antiquities / Far Eastern Art." *Positions* 2, no. 2 (1994): 318–55.

Codell, Julie. "Gentlemen Connoisseurs and Capitalists: Modern British Imperial Identity in the 1903 Delhi Durbar Exhibition of Indian Art." In *Cultural Identities and the Aesthetics of Britishness,* edited by David Arnold, pp. 134–63. Manchester: Manchester University Press, 2004.

Codell, Julie, and Dianne Sachko Macleod, eds. *Orientalism Transposed: The Impact of the Colonies on British Culture.* London: Ashgate, 1998.

Codrington, Kenneth de Burgh. *Cricket in the Grass.* London: Faber & Faber, 1959.

———. *The Study of Indian Art.* London: Luzac & Co., 1944.

Cohn, Bernard. *An Anthropologist among the Historians and Other Essays.* New Delhi: Oxford University Press, 1987.

———. *Colonialism and Its Forms of Knowledge: The British in India.* Princeton, NJ: Princeton University Press, 1996.

Coomaraswamy, Ananda K. *Art and Swadeshi.* New Delhi: Munshiram Manoharlal Publishers, 1994.

———. *The Indian Craftsman.* 1909. Reprint, New Delhi: Munshiram Manoharlal Publishers, 1989.

Coombes, Annie. *Reinventing Africa: Museums, Material Culture, and Popular Imagination in Late Victorian and Edwardian England.* New Haven, CT: Yale University Press, 1994.

Crossick, Geoffrey, and S. Jauman, eds. *Cathedrals of Consumption: The European Department Store, 1850–1939.* Aldershot, UK: Ashgate, 1999.

Cundall, Frank. *Reminiscences of the Colonial and Indian Exhibition.* London: William Clowes & Sons, 1886.

Cunningham, Alexander. *The Bhilsa Topes; or Buddhist Monuments of Central India.* 1854. Reprint, New Delhi: Munshiram Manoharlal, 1997.

Dalmia, Yashodhara. *Contemporary Indian Art: Other Realities.* New Delhi: Marg Publications, 2002.

———. *The Making of Modern Indian Art: The Progressives.* New Delhi: Oxford University Press, 2001.

Davis, Richard. *Lives of Indian Images.* Princeton, NJ: Princeton University Press, 1997.

Dehejia, Vidya. *Indian Art.* London: Phaidon, 1997.

———, ed. *India through the Lens: Photography, 1840–1911.* Washington, DC: Freer and Sackler Galleries, Smithsonian Institution, 2000.

————, ed. *Unseen Presence: The Buddha and Sanchi.* Mumbai: Marg Publications, 1996.

Dehejia, Vidya, with Allen Staley. *Impossible Picturesqueness: Edward Lear's Indian Watercolours, 1873–1875.* New York: Columbia University Press, 1989.

Desai, Vishaka. *Conversations with Traditions: Nilima Sheikh, Shahzia Sikander.* New York: Asia Society, 2001.

Desmond, Ray. *The India Museum, 1801–1879.* London: H.M.S.O., 1982.

Dewan, Deepali. "Scripting South Asia's Visual Past: *The Journal of Indian Art and Industry* and the Production of Knowledge in the Late Nineteenth Century." In *Imperial Co-Histories: National Identities and the British and Colonial Press,* edited by Julie Codell, pp. 29–44. London: Associated University Presses, 2003.

Diamond, Alan, ed. *The Victorian Achievement of Sir Henry Maine: A Centennial Reappraisal.* Cambridge: Cambridge University Press, 1991.

Dirks, Nicholas. *Castes of Mind: Colonialism and the Making of Modern India.* Princeton, NJ: Princeton University Press, 2001.

————. "Guiltless Spoilations: Picturesque Beauty, Colonial Knowledge, and Colin Mackenzie's Survey of India." In *Perceptions of South Asia's Visual Past,* edited by Catherine Asher and Thomas Metcalf, pp. 211–32. New Delhi: Oxford University Press, 2004.

————. *The Scandal of Empire: India and the Creation of Imperial Britain.* Cambridge, MA: Harvard University Press, 2006.

Duncan, Carol. *Civilizing Rituals: Inside Public Art Museums.* London and New York: Routledge, 1995.

Dutt, R. C. *The Economic History of India.* Vol. 2. London: Kegan Paul, Trench, Trubner & Co., 1904.

Dutta, Arindam. "The Politics of Display: India 1886 and 1986." *Journal of Arts and Ideas* 30–31 (1997): 115–45.

Eisenman, Stephen. *Gauguin's Skirt.* New York and London: Thames and Hudson, 1997.

Elsner, J., and R. Cardinal, eds. *The Cultures of Collecting.* Cambridge, MA: Harvard University Press, 1994.

Epstein Nord, Deborah. "The Social Explorer as Anthropologist: Victorian Travellers among the Urban Poor." In *Visions of the Modern City: Essays in History, Art, and Literature,* ed. William Sharpe and Leonard Wollock, pp. 118–130. New York: Heyman Center for the Humanities, Columbia University, 1983.

Errington, Shelly. *The Death of Authentic Primitive Art and Other Tales of Progress.* Berkeley: University of California Press, 1998.

Fabian, Johannes. *Time and the Other: How Anthropology Makes Its Object.* New York: Columbia University Press, 1983.

Falconer, John. "A Pure Labor of Love: A Publishing History of *The People of India.*" In *Colonialist Photography: Imag(in)ing Race and Place,* edited by Gary Sampson, pp. 51–83. London: Routledge, 2002.

Fanon, Frantz. *A Dying Colonialism.* New York: Grove Press, 1959.

Feliciano, Hector. *The Lost Museum: The Nazi Conspiracy to Steal the World's Greatest Works of Art.* New York: Basic Books, 1998.

Fisher, Jean, ed. *Global Visions: Towards a New Internationalism in the Visual Arts*. London: Institute of International Visual Arts, 1994.

Foster, Hal. *Design and Crime (and Other Diatribes)*. London and New York: Verso, 2002.

Gandhi, Mohandas K. *An Autobiography: The Story of My Experiments with Truth*. Boston: Beacon Press, 1993.

———. *Hind Swaraj and Other Writings*. Cambridge: Cambridge University Press, 1997.

Geary, C., and V. Webb. *Delivering Views: Distant Cultures in Early Postcards*. Washington, DC: Smithsonian Institution Press, 1998.

Greenfield, Jeannette. *The Return of Cultural Treasures*. Cambridge: Cambridge University Press, 1989.

Greenhalgh, Paul. *Ephemeral Vistas: The Expositions Universelles, Great Exhibitions, and World's Fairs, 1851–1939*. Manchester, UK: Manchester University Press, 1998.

Grewal, Inderpal. *Home and Harem: Nation, Gender, Empire, and the Cultures of Travel*. Durham, NC: Duke University Press, 1996.

———. *Transnational America: Feminisms, Diaspora, Neoliberalisms*. Durham, NC: Duke University Press, 2005.

Griffiths, John. *Report on the Work of Copying the Paintings of the Ajanta Caves*. London, 1872–85.

Guha, Ranajit. *Elementary Aspects of Peasant Insurgency in Colonial India*. Durham, NC: Duke University Press, 1999.

———, ed. *A Subaltern Studies Reader, 1986–1995*. Minneapolis: University of Minnesota Press, 1997.

———, ed. *Subaltern Studies, Volumes I–VI: Writings on South Asian History and Society*. Delhi: Oxford University Press, 1982–89.

Guha, Ranajit, and Gayatri Spivak, eds. *Selected Subaltern Studies*. Delhi: Oxford University Press, 1988.

Guha-Thakurta, Tapati. *The Making of a New Indian Art: Artists, Aesthetics and Nationalism in Bengal, c. 1850–1920*. Cambridge: Cambridge University Press, 1992.

———. *Monuments, Objects, Histories: Institutions of Art in Colonial and Postcolonial India*. New York: Columbia University Press, 2004.

Gupta, Akhil, and James Fergusson, eds. *Anthropological Locations: Boundaries and Grounds of a Field Science*. Berkeley: University of California Press, 1997.

———. *Culture, Power, Place: Explorations in Critical Anthropology*. Durham, NC: Duke University Press, 1997.

Hacking, Ian. *The Taming of Chance*. Cambridge: Cambridge University Press, 1990.

Hall, Catherine. *Civilising Subjects: Metropole and Colony in the English Imagination 1830–1867*. Chicago: University of Chicago Press, 2002.

Hannerz, Ulf. *Transnational Connections: Culture, People, Places*. London: Routledge, 1996.

Hansen, Kathryn. *Grounds for Play: The Nautanki Theatre of North India*. Berkeley: University of California Press, 1993.

Harclerode, Peter, and Brendan Pittaway. *The Lost Masters: The Looting of Europe's Treasurehouses*. London: Orion Books, 1999.

Harlow, Barbara, and Mia Carter, eds. *Archives of Empire*, vol. 1, *From the East India Company to the Suez Canal*. Durham, NC: Duke University Press, 2003.

Harris, Neil. *Cultural Excursions: Marketing Appetites and Cultural Tastes in Modern America*. Chicago: University of Chicago Press, 1990.

Hasan, Mushirul, ed. *India's Partition: Process, Strategy and Mobilization*. Delhi: Oxford University Press, 1993.

Hashmi, Salima. *Unveiling the Invisible: Lives and Works of Women Artists in Pakistan*. Lahore: Sang-e-Meel Publications, 2002.

Havell, E. B. *The Basis for Artistic and Industrial Revival in India*. 1912. Reprint, New Delhi: Usha Publications, 1986.

Head, Raymond. *The Indian Style*. Chicago: University of Chicago Press, 1986.

Herbert, James. *Paris 1937: Worlds on Exhibition*. Ithaca, NY: Cornell University Press, 1998.

Hitchens, Christopher. *Imperial Spoils: The Curious Case of the Elgin Marbles*. New York: Hill and Wang, 1988.

Hobsbawm, Eric, and Terence Ranger, eds. *The Invention of Tradition*. Cambridge: Cambridge University Press, 1983.

Hoffenberg, Peter. *An Empire on Display: English, Indian, and Australian Exhibitions from the Crystal Palace to the Great War*. Berkeley: University of California Press, 2001.

Hoskote, Ranjit. "The Anxiety of Influence." *Art India* 2, no. 2 (1999): 32–34.

Huyssen, Andreas. *After the Great Divide: Modernism, Mass Culture, Postmodernism*. Bloomington: Indiana University Press, 1986.

———. *Twilight Memories: Marking Time in a Culture of Amnesia*. New York and London: Routledge, 1995.

Jain, Jyotindra. *Kalighat Painting: Images from a Changing World*. Ahmedabad: Mapin Publishing, 1999.

Jayawardena, Kumari. *The White Woman's Other Burden: Western Women and South Asia during British Rule*. New York: Routledge, 1995.

Jones, Gareth Stedman. *Outcast London: A Study in the Relationship between Classes in Victorian Society*. Oxford: Oxford University Press, 1971.

Jones, Owen. *The Grammar of Ornament*. New York: J. W. Bouton, 1880.

Kapur, Geeta. *When Was Modernism? Essays on Contemporary Cultural Practice in India*. New Delhi: Tulika Press, 2000.

Karp, Ivan, and S. Lavine, eds. *Exhibiting Others: The Poetics and Politics of Museum Display*. Washington, DC: Smithsonian Institution Press, 1991.

Karp, Ivan, et al. *Museum Frictions: Public Cultures/Global Transformations*. Durham, NC: Duke University Pess, 2006.

Keating, Peter, ed. *Into Unknown England: Selections from the Social Explorers, 1866–1913*. Manchester, UK: Manchester University Press, 1976.

Kirshenblatt-Gimblett, Barbara. *Destination Culture: Tourism, Museums, and Heritage*. Berkeley: University of California Press, 1998.

Kriegel, Lara. "Narrating the Subcontinent in 1851: India at the Crystal Palace."

In *The Great Exhibition of 1851: New Interdisciplinary Essays,* edited by Louise Purbrick, pp. 146–78. Manchester, UK: Manchester University Press, 2001.

Kurin, Richard. "Cultural Conservation through Representation: Festival of India Folklife Exhibitions at the Smithsonian Institute." In *Exhibiting Culture: The Poetics and Politics of Museum Display,* edited by I. Karp and S. Lavine. Washington, DC: Smithsonian Institution Press, 1991.

Lalvani, Suren. *Photography, Vision, and the Production of Modern Bodies.* Albany, NY: SUNY Press, 1996.

Liberty, Arthur. "Spitalfields Brocades." *The Studio* 1 (1893): 20–24.

Lindeborg, Ruth. "The Asiatic and the Boundaries of Victorian Englishness." *Victorian Studies* 37, no. 3 (1994): 381–404.

Lloyd, Christopher. *The Queen's Pictures: Royal Collectors through the Centuries.* London: National Gallery Publications, 1991.

MacDougall, David. "Photo Hierarchicus: Signs and Mirrors in Indian Photography." *Visual Anthropology* 5, no. 2 (1992): 103–29.

Mackenzie, John. *Orientalism: History, Theory and the Arts.* Manchester, UK: Manchester University Press, 1995.

——, ed. *The Victorian Vision: Inventing New Britain.* London: V & A Publications, 2001.

Maine, Sir Henry. *Village Communities of the East and West.* New York: Henry Holt and Company, 1880.

Maisey, F. C. *Sanchi and Its Remains.* London: Kegan Paul, Trench, Trubner & Co., 1892.

Mani, Lata. *Contentious Traditions: The Debate on Sati in Colonial India.* Berkeley: University of California Press, 1998.

Mankekar, Purnima. *Screening Culture, Viewing Politics: An Ethnography of Television, Womanhood and Nation in Postcolonial India.* Durham, NC: Duke University Press, 1999.

Marshall, John, and Foucher, Alfred. *The Monuments of Sanchi.* Vol. 1. 1940. Reprint, Delhi: Swati Publications, 1983.

Marx, Karl, and Frederick Engels. *On Colonialism.* Honolulu: University Press of the Pacific, 2001.

Mathur, Saloni. "History and Anthropology in South Asia: Rethinking the Archive." *Annual Review of Anthropology* 29 (2000): 89–106.

——. *An Indian Encounter: Portraits for Queen Victoria.* London: National Gallery, 2002.

——. "Living Ethnological Exhibits: The Case of 1886." *Cultural Anthropology* 15, no. 4 (2000): 492–524.

——. "Revisualizing the Missionary Subject: History, Modernity, and Indian Women." *Third Text* 37 (1997): 53–61.

——. "Wanted Native Views: Collecting Colonial Postcards of India." In *Gender, Sexuality, and Colonial Modernities,* edited by A. Burton, pp. 95–115. London: Routledge, 1999.

Maxwell, Anne. *Colonial Photography and Exhibitions: Representations of the Native and the Making of European Identities.* Leicester, UK: Leicester University Press, 2000.

———. "Native Women and Tourism: A Contested Site of Orientalism." *Third Text* 25 (1993–94): 21–32.

McClintock, Anne. *Imperial Leather: Race, Gender, and Sexuality in the Colonial Conquest*. New York: Routledge, 1995.

McClintock, Anne, Aamir Mufti, and Ella Shohat, eds. *Dangerous Liaisons: Gender, Nation, and Postcolonial Perspectives*. Minneapolis: University of Minnesota Press, 1997.

Mehta, Uday Singh. *Liberalism and Empire: A Study in Nineteenth-Century British Liberal Thought*. Chicago: University of Chicago Press, 1999.

Menon, Ritu, and Kamla Bhasin. *Borders and Boundaries: Women in India's Partition*. New Delhi: Kali for Women, 1998.

Mercer, Kobena, ed. *Cosmopolitan Modernisms*. Cambridge, MA, and London: MIT Press and Institute of International Visual Arts, 2005.

Metcalf, Thomas. *Ideologies of the Raj*. Cambridge: Cambridge University Press, 1995.

———. *An Imperial Vision: Indian Architecture and Britain's Raj*. London: Faber & Faber, 1989.

Michasiw, Kim Ian. "Nine Revisionist Theses on the Picturesque." *Representations* 38 (1992): 76–100.

Mihesuah, Devon, ed. *Repatriation Reader: Who Owns American Indian Remains?* Lincoln: University of Nebraska Press, 2000.

Mill, James. *The History of British India*. 3 vols. London: Baldwin, Cradock, and Joy, 1818.

Millar, Oliver. *The Victorian Pictures in the Collection of Her Majesty the Queen*. Cambridge: Cambridge University Press, 1992.

Miller, Michael. *The Bon Marche: Bourgeois Culture and the Department Store, 1869–1920*. Princeton, NJ: Princeton University Press, 1982.

Mirzoeff, Nicholas, ed. *The Visual Culture Reader*. London and New York: Routledge, 1998.

Mitchell, Timothy. *Colonising Egypt*. Cambridge: Cambridge University Press, 1988.

———. "The World as Exhibition." In *The Art of Art History: A Critical Anthology*, ed. Donald Preziosi. Oxford: Oxford University Press, 1998.

Mitchell, W. J. T., ed. *Landscape and Power*. Chicago: University of Chicago Press, 1994.

Mitter, Partha. *Art and Nationalism in Colonial India, 1850–1922*. Cambridge: Cambridge University Press, 1994.

———. *Indian Art*. London: Oxford University Press, 2001.

———. *Much Maligned Monsters: History of European Reactions to Indian Art*. Chicago: Chicago University Press, 1992.

Mukharji, T. N. *Art Manufactures of India*. 1888. Reprint, New Delhi: Aryan Books International, 2000.

———. *A Visit to Europe*. London: Edward Stanford, 1889.

Myers, Fred, ed. *The Empire of Things: Regimes of Value and Material Culture*. Santa Fe, NM: School of American Research Press, 2001.

Narain, A. K., and D. C. Ahir, eds. *Dr. Ambedkar, Buddhism and Social Change*. New Delhi: B. R. Publishing, 1994.

Nasar, Hammad, and Anita Dawood-Nasar, eds. *Karkhana: A Contemporary Collaboration.* Ridgefield, CT: Aldrich Contemporary Art Museum, 2005.

Nava, Mica. "The Cosmopolitanism of Commerce and the Allure of Difference: Selfridge's, the Russian Ballet, and the Tango, 1911–1914." *International Journal of Cultural Studies* 1, no. 2 (1998): 163–96.

Nehru, Jawaharlal. *The Discovery of India.* 1946. Reprint, New Delhi: Oxford University Press, 1989.

Neumayer, Erwin, and Christine Schelberger. *Raja Ravi Varma: Portrait of an Artist—the Diary of C. Raja Raja Varma.* New Delhi: Oxford University Press, 2005.

Nicholas, Lynn. *The Rape of Europa: The Fate of Europe's Art Treasures in the Third Reich and the Second World War.* New York: Knopf, 1994.

Nickel, Douglas R. *Francis Frith in Egypt and Palestine: A Victorian Photographer Abroad.* Princeton, NJ: Princeton University Press, 2004.

Nochlin, Linda. *The Politics of Vision: Essays on Nineteenth-Century Art and Society.* New York: Harper and Row, 1989.

Ong, Aihwa. *Flexible Citizenship: The Cultural Logics of Transnationality.* Durham, NC: Duke University Press, 1999.

Pal, Pratapaditya, and Vidya Dehejia. *From Merchants to Emperors: British Artists and India, 1757–1930.* Ithaca, NY: Cornell University Press, 1986.

Panikkar, Shivaji, et al., eds. *Towards a New Art History: Studies in Indian Art.* Delhi: D. K. Printworld, 2003.

Pelizzari, Maria Antonella, ed. *Traces of India: Photography, Architecture, and the Politics of Representation, 1850–1900.* Montreal and New Haven, CT: Canadian Centre for Architecture and the Yale Center for British Art, 2003.

Petropoulos, Jonathan. *Art as Politics in the Third Reich.* Durham: University of North Carolina Press, 1999.

Pinney, Christopher. *Camera Indica: The Social Life of Indian Photographs.* London: Reaktion Books, 1997.

———. "Classification and Fantasy in the Photographic Construction of Caste and Tribe." *Visual Anthropology* 3 (1990): 259–88.

———. *Photos of the Gods: The Printed Image and Political Struggle in India.* London: Reaktion Books, 2004.

Pinney, Thomas, ed. *The Letters of Rudyard Kipling,* vol. 1, 1872–1889. London: Macmillan Press, 1990.

Poole, Deborah. *Vision, Race, and Modernity: A Visual Economy of the Andean Image World.* Princeton, NJ: Princeton University Press, 1997.

Prakash, Gyan. *Another Reason: Science and the Imagination of Modern India.* Princeton, NJ: Princeton University Press, 1999.

Prakash, Vikramaditya. *Chandigarh's Le Corbusier: The Struggle for Modernity in Postcolonial India.* Seattle: University of Washington Press, 2002.

Preziosi, Donald. *Brain of the Earth's Body: Art, Museums, and the Phantasms of Modernity.* Minneapolis: University of Minnesota Press, 2003.

Preziosi, Donald, and Claire Farago, eds. *Grasping the World: The Idea of the Museum.* London: Ashgate, 2004.

Price, Sally. *Primitive Art in Civilized Places.* Chicago: Chicago University Press, 1989.

Prinsep, Val. *Imperial India: An Artist's Journal*. London: Chapman and Hall, 1879.

Prochaska, David. "The Archive of *Algerie Imaginaire*." *History and Anthropology* 4 (1990): 373–420.

Ramamurthy, Anandi. "Orientalism and the 'Paisley' Pattern." In *Disentangling Textiles: Techniques for the Study of Designed Objects*, edited by Mary Schoeser and Christine Boydell. London: Middlesex University Press, 2002.

Ranga, M. L., ed. *B. R. Ambedkar: Life, Work and Relevance*. New Delhi: Manohar, 2000.

Rappaport, Erika. *Shopping for Pleasure: Women in the Making of London's West End*. Princeton, NJ: Princeton University Press, 2000.

Report of the Royal Commission for the Colonial and Indian Exhibition, 1886. London: William Clowes and Sons, 1887.

Richards, Thomas. *The Commodity Culture of Victorian England: Advertising and Spectacle, 1851–1914*. Stanford, CA: Stanford University Press, 1990.

———. *The Imperial Archive: Knowledge and the Fantasy of Empire*. New York: Verso, 1993.

Robbins, Bruce, and Pheng Chea, eds. *Cosmopolitics: Thinking and Feeling Beyond the Nation*. Minneapolis: University of Minnesota Press, 1998.

The Royal Commission, ed. *The Official Descriptive and Illustrated Catalogue of the Great Exhibition, 1851*. 3 vols. London: Spicer Brothers, 1851.

Rushdie, Salman. *Imaginary Homelands: Essays and Criticism, 1981–1991*. New York: Viking, 1991.

———. *Midnight's Children*. London: Picador, 1982.

———. *Step across this Line: Collected Non-fiction, 1992–2002*. New York: Random House, 2002.

Ryan, James. *Picturing Empire: Photography and the Visualization of the British Empire*. Chicago: University of Chicago Press, 1998.

Said, Edward. *Culture and Imperialism*. New York: Vintage, 1993.

———. *Orientalism*. 1978. Reprint, New York and London: Penguin Books, 1991.

St. Clair, William. *Lord Elgin and the Marbles: The Controversial History of the Parthenon Sculptures*. Oxford: Oxford University Press, 1998.

Salter, Joseph. *The Asiatic in England*. London: Seeley, Jackson, and Halliday, 1873.

———. *The East in the West, or Work among the Asiatics and Africans in London*. London: S. W. Partridge and Co., 1894.

Sambrani, Chaitanya, ed. *Edge of Desire: Recent Art in India*. New York: Asia Society, 2005.

Sarkar, Sumit. *Modern India, 1885–1947*. New Delhi: Macmillan India, 1983.

———. *The Swadeshi Movement in Bengal, 1903–1908*. New Delhi: People's Publishing House, 1973.

Schivelbusch, Wolfgang. *The Railway Journey: The Industrialization and Perception of Time and Space in the Nineteenth Century*. Berkeley: University of California Press, 1987.

Sekula, Allan. "The Body and the Archive." *October* 39 (Winter 1986): 3–64.

Sen, Geeti, ed. *India: A National Culture?* New Delhi: India International Centre, 2003.

Sheikh, Gulammohammed, ed. *Contemporary Art in Baroda*. New Delhi: Tulika, 1997.

Sherman, Daniel, and Irit Rogoff, eds. *Museum Culture: Histories, Discourses, Spectacles*. Minneapolis: University of Minnesota Press, 1991.

Silverman, Debora. *Van Gogh and Gaugin: The Search for Sacred Art*. New York: Farrar, Straus and Giroux, 2000.

Simpson, Elizabeth, ed. *The Spoils of War: The Loss, Reappearance and Recovery of Cultural Property*. New York: Abrams, 1997.

Simpson, Moira. *Making Representations: Museums in the Postcolonial Era*. London and New York: Routledge, 1996.

Singh, Dayanita. *Privacy*. Berlin: Steidl, 2003.

Singh, Kavita. "The Jewel and the Crown: The Politics of Display of Indian Art at the V&A, 1935–51." Unpublished paper, 2003.

Sinha, Gayatri, ed. *Expressions and Evocations: Contemporary Women Artists of India*. Mumbai: Marg Publications, 1996.

———. *Indian Art: An Overview*. New Delhi: Rupa, 2003.

Sinha, Mrinalini. *Colonial Masculinity: The Manly Englishman and the Effeminate Bengali in the Late Nineteenth Century*. Manchester, UK: Manchester University Press, 1995.

Smith, Richard. *Rule by Records: Land Registration and Village Custom in Early British Punjab*. Delhi: Oxford University Press, 1996.

Spivak, Gayatri. "Can the Subaltern Speak?" In *Marxism and the Interpretation of Culture*, edited by C. Nelson and L. Grossberg, pp. 271–311. Chicago: University of Illinois Press, 1988.

———. *In Other Worlds: Essays in Cultural Politics*. London: Routledge, 1988.

Staff, Frank. *The Picture Postcard and Its Origins*. New York: Frederick A. Praeger, 1966.

Stewart, Susan. *On Longing: Narratives of the Miniature, the Gigantic, the Souvenir, the Collection*. Durham, NC: Duke University Press, 1993.

Stocking, George, ed. *Objects and Others: Essays on Museums and Material Culture*. Madison: University of Wisconsin Press, 1985.

———. *Victorian Anthropology*. New York: Free Press, 1987.

Stokes, Eric. *The English Utilitarians and India*. Oxford: Clarendon Press, 1959.

Stoler, Ann. *Carnal Knowledge and Imperial Power: Race and the Intimate in Colonial Rule*. Berkeley: University of California Press, 2002.

———. *Race and the Education of Desire: Foucault's History of Sexuality and the Colonial Order of Things*. Durham, NC: Duke University Press, 1995.

Stoler, Ann, and Fred Cooper, eds. *Tensions of Empire: Colonial Cultures in a Bourgeois World*. Berkeley: University of California Press, 1997.

Subramanyam, K. G. *The Living Tradition: Perspectives on Modern Indian Art*. Calcutta: Seagull Books, 1987.

Suleri, Sara. *The Rhetoric of English India*. Chicago: University of Chicago Press, 1992.

Tarapor, Mahrukh. "John Lockwood Kipling and British Art Education in India." *Victorian Studies* (Fall 1980): 53–81.

Tarlow, Emma. *Clothing Matters: Dress and Identity in India*. Chicago: University of Chicago Press, 1996.

Thomas, Nicholas. *Possessions: Indigenous Art / Colonial Culture*. London: Thames and Hudson, 1999.

Tillotson, G. H. R. *The Artificial Empire: The Indian Landscapes of William Hodges*. Richmond, UK: Curzon Press, 2000.

Tobin, Beth Fowkes. *Picturing Imperial Power: Colonial Subjects in Eighteenth-Century British Painting*. Durham, NC: Duke University Press, 1999.

Tolen, Rachel. "Colonizing and Transforming the Criminal Tribesman: The Salvation Army in British India." *American Ethnologist* 18, no. 1 (1991): 106–25.

Trivedi, Lisa. "Visually Mapping the 'Nation': Swadeshi Politics in Nationalist India, 1920–1930." *Journal of Asian Studies* 62, no. 1 (2003): 11–41.

Venniyoor, E. M. J. *Raja Ravi Varma*. Kerala: Kerala Lalit Kala Academy, 1981.

Vergo, Peter. *The New Museology*. London: Reaktion Books, 1997.

Visram, Rozina. *Ayahs, Lascars, and Princes: Indians in Britain, 1700–1947*. London: Pluto Press, 1986.

Viswanathan, Gauri. *Masks of Conquest: Literary Study and British Rule in India*. New York: Columbia University Press, 1989.

———. *Outside the Fold: Conversion, Modernity, and Belief*. Princeton, NJ: Princeton University Press, 1998.

Walkowitz, Judith. *City of Dreadful Night: Narratives of Sexual Danger in Late Victorian London*. Chicago: University of Chicago Press, 1992.

Wallis, Brian. "Selling Nations: International Exhibitions and Cultural Diplomacy." In *Museum Culture: Histories, Discourses, Spectacles*, edited by D. Sherman and I. Rogoff, p. 265. Minneapolis: University of Minnesota Press, 1994.

Watt, George. *Indian Art at Delhi, 1903*. Reprint. New Delhi: Motilal Banarsidass, 1987.

Weil, Stephen. *Rethinking the Museum and Other Meditations*. Washington, DC: Smithsonian Institution Press, 1990.

Williams, Rosalind. *Dreamworlds: Mass Consumption in Late Nineteenth-Century France*. Berkeley: University of California Press, 1982.

Willis, Michael. *Buddhist Reliquaries from Ancient India*. London: British Museum Press, 2000.

Wornum, Ralph. "The Exhibition as a Lesson in Taste." *Special Issue of the Art Journal* (1851): vii.

Yang, Anand, ed. *Crime and Criminality in British India*. Tucson: University of Arizona Press, 1985.

Index

Text:	10/13 Sabon
Display:	Sabon
Compositor:	Binghamton Valley Composition, LLC
Printer and Binder:	Maple-Vail Manufacturing Group